Battle of Britain Memorial Flight

1957 to date

OPERATIONS MANUAL

⊙ **ROYAL** Battle of Britain
AIR FORCE Memorial Flight

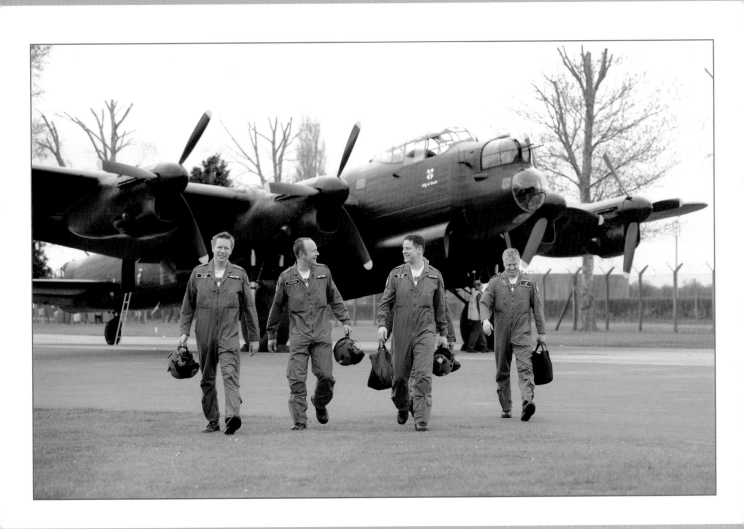

Behind the scenes at the RAF's premier historic aircraft display flight

Keith Wilson

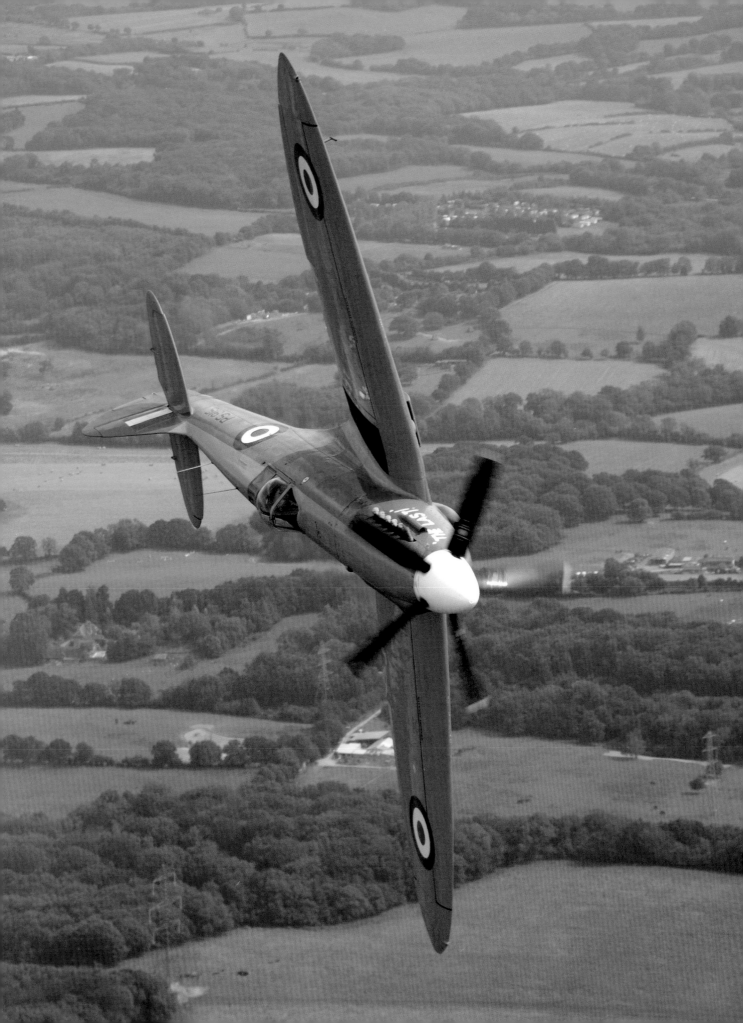

Community Learning & Libraries
Cymuned Ddysgu a Llyfrgelloedd

This item should be returned or renewed by the last date stamped below.

To renew visit:

www.newport.gov.uk/libraries

First published in March 2015

A catalogue record for this book is available from the British Library.

ISBN 978 0 85733 516 6

Published by Haynes Publishing,
Sparkford, Yeovil,
Somerset BA22 7JJ, UK.
Tel: 01963 442030 Fax: 01963 440001
Int. tel: +44 1963 442030
Int. fax: +44 1963 440001
E-mail: sales@haynes.co.uk
Website: www.haynes.co.uk

Haynes North America Inc.,
861 Lawrence Drive, Newbury Park,
California 91320, USA.

Printed in the USA by Odcombe Press LP,
1299 Bridgestone Parkway, La Vergne,
TN 37086.

Contents

OPPOSITE One of the Flight's two Spitfire PR XIX aircraft, PS915 was photographed near the south-east coast in August 2012 where it demonstrated its excellent manoeuvrability at the hands of the OC BBMF Squadron Leader Duncan Mason. *(Keith Wilson)*

Acknowledgements

The author wishes to thank the following for their kind help and enthusiasm. Without them, this book would not have been possible.

The team at the Royal Air Force Battle of Britain Memorial Flight, without whose help and support, the book would not have come to fruition. Special thanks go to OC BBMF, Squadron Leader Duncan 'Dunc' Mason; Operations Officer and Adjutant Flight Lieutenant Anthony 'Parky' Parkinson MBE; OC Operations at Coningsby Wing Commander Paul 'Godders' Godfrey; OC BBMF Designate Squadron Leader Paul 'Milli' Millikin; BBMF PRO Yvonne Masters; Jim Stewart (Flight Operations); Squadron Leader William 'Russ' Russell (Bomber Leader 2013); Flight Lieutenant Tim Dunlop (Bomber Leader 2014); Flight Lieutenant Roger Nichols; Flight Lieutenant Loz Rushmere; Squardon Leader Tony 'Sluf' Beresford (Navigator Leader 2013–14); Flight Lieutenant Ady Hargreaves; Flight Lieutenant James 'Big Jim' Furness; Loadmaster Flight Sergeant Paul Simmons; and SEngO Warrant Officer Kevin Ball – especially the latter whose patience and tolerance I tested on many occasions. Also, to all the members of the enthusiastic BBMF Engineering Team at Coningsby who were always willing to help with my requests – what an eager and supportive group of people you are!

The Photographic Section at RAF Coningsby: Sergeant Peter George MA ABIPP; Sergeant Pete Mobbs ABIPP, CertEd.; Corporal Paul Robertshaw; Senior Aircraftman Steve Buckley; Senior Aircraftman Daniel Herrick LBIPP and Senior Aircraftman Graham Taylor, who allowed me to access their archive, assisted with research and pointed me in the right direction at Coningsby on so many occasions.

Lee Barton and Sebastian Cox, for allowing me to access the excellent archives at the RAF Air Historical Branch at RAF Northolt.

For providing access to the spraying facilities with Vintage Fabrics Limited, while AB910 was enjoying its makeover, I would like to thank Clive, Linda and Andrew Denney, along with Robert Turpin and David Dawnay.

For providing access to the Aircraft Restoration Company at Duxford, as well as information on the restorations, I would like to thank Billy Fletcher and the team of engineers working on AB910.

For providing access to Retro Track and Air Limited, and for guiding me around the facility, my grateful thanks to Peter Watts, Rachel Watts and Robert Gardner, along with engineers Chris Mackie, Royston May, Neil Smart, Steve Walker, Fred Adams, Alistair Blackhall and Dave Hall.

For providing media facilities at airshows and events, and getting me close to the action, I would like to make acknowledgement to: Dave Poile at the BBC Children in Need Airshow at Little Gransden; Lindsey Askin at Waddington Air Show; and Richard Arquati at the Royal International Air Tattoo.

For providing the very special viewing facilities at Eyebrook Reservoir during the 70th anniversary of the Dambuster Raid I would like to express my appreciation to Marion Sweeney from Tata Steel, along with her staff at the reservoir. Watching the fly-by from a small boat moored on the middle of the water while the aircraft flew directly overhead was a most memorable occasion.

For providing a selection of images to help with illustrating the book I appreciate the assistance of: Stephen Rutherford at Cranfield Aerospace, Peter R. March, Geoffrey Lee, Clare Scott and Oliver Wilson.

At Haynes Publishing, I am grateful to Jonathan Falconer, Michelle Tilling, James Robertson and Penny Housden for keeping me on track.

My very special thanks must go to Squadron Leader Stuart Reid RAF (Retired), a superb mentor throughout my time at the Flight and without whose considerable help and cooperation, this book would not have been completed. Thank you Stu!

Finally, sincere thanks to my wife Carol and sons Sam and Oliver. Thank you for your patience and support throughout the project. I couldn't have done it without you.

The publishers gratefully acknowledge the original research by Jarrod Cotter into identifying the founder of the Battle of Britain Flight.

Introduction

Those who cannot remember the past are condemned to repeat it.

These often misquoted words were originally penned by George Santayana (1863–1952) in his *The Life of Reason: Reason in Common Sense* (Vol. 1). Yes, history is too easily forgotten.

Mark Twain wrote: 'Never let the truth get in the way of a great story.' Occasionally, history is rewritten; perhaps if the actual event does not fit the requirements – sometimes to spare the blushes of one nation or a particular group of people; and sadly, by others so that a feature film may have more of a commercial impact on the marketplace.

Let us consider the facts. A total of 544 aircrew were killed in the three months and three weeks of what we now refer to as the Battle of Britain. As well as those souls who sacrificed their lives, a further 422 aircrew were wounded and 1,547 Allied aircraft were lost. It was, however, a major turning point in the war against Germany.

Furthermore, during the whole of the Second World War there were 55,573 who died while in the service of RAF Bomber Command. After too many years of being forgotten, these brave souls were finally recognised more than 60 years later when Her Majesty the Queen unveiled the Bomber Command Memorial in Green Park, London, on 28 June 2012, which concluded with a spectacular and fitting poppy drop carried out by the Lancaster.

Since the end of the Second World War and even right up to today, there are valiant individuals losing their lives in conflicts around the world – Korea, Aden, the Falklands, the Gulf War, the Balkans, Iraq, Afghanistan, Libya – to name but a few. We owe each and every one of these courageous men and women a debt of gratitude and it is a debt that must never be forgotten. Our children and our children's children need to be aware of what might have been had it not been for those brave souls.

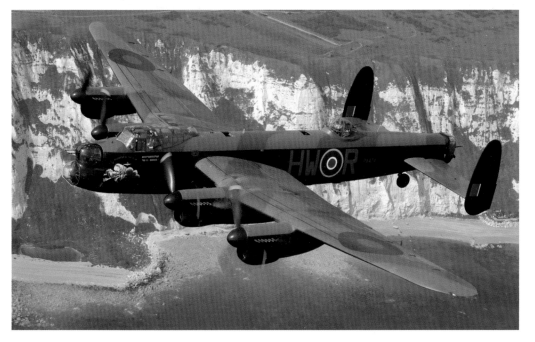

LEFT Lancaster PA474 is probably the most iconic aircraft on the Flight. It joined the Flight in 1973 and has been a welcome feature of its displays ever since. Once seen, who can ever forget the moving sight and sound of a poppy drop from the Lancaster? *(Keith Wilson)*

The Historic Aircraft Flight was formed in 1957 to ensure that a Spitfire and a Hurricane would lead the annual Battle of Britain commemorative flypast over London each and every year. It is a permanent reminder to what we all owe 'the few'. In those days, the Historic Aircraft Flight was a small organisation, operating without public funds and succeeding thanks to a small group of hard-working and dedicated volunteers. Thankfully, it has grown since then. It now has its own headquarters at RAF Coningsby, with a small group of full-time staff to maintain twelve wonderful and iconic aircraft. It is now the RAF Battle of Britain Memorial Flight.

From its early days with around just 50 individual displays a year, it has grown into a finely tuned display team that performs more than 700 individual displays and flypasts each year. But this is not just another display team. No, the BBMF is so much more! They arrive at your air display or event in wonderful old Second World War-era aircraft – Spitfire Mk IIa P7350 actually flew and fought during the Battle of Britain, while Spitfire Mk LFIXe MK356 was at D-Day. These aircraft are a living reminder to all watching and listening as to what the BBMF represents. And yes – listening. Who doesn't stop and look skyward when the sound of a Rolls-Royce Merlin engine can be heard in the distance? Is there a better sound in the world than six Rolls-Royce Merlin engines flying in formation? When I see and hear the BBMF formation of Lancaster, Spitfire and Hurricane, the hairs on the back of my neck stand up. I've seen people moved to tears as they watch the display. Most just stop what they are doing, before looking skyward and listening in silence while taking it all in. Afterwards, they often break out into spontaneous applause. How does the BBMF affect you?

During the time I spent researching and writing this book, along with my previous work *The Battle of Britain Memorial Flight in Camera*, I am privileged to have benefitted from (almost) an all-areas pass. I have seen at first hand a small, highly efficient and dedicated group of individuals who form the great team that is the BBMF. Especially the Engineering Team, led so effectively by the Flight's Senior Engineering Officer Kev Ball, since he took over

BELOW An atmospheric photograph of the Flight's two Chipmunk T.10 aircraft above an inversion layer on a photo-shoot over Lincolnshire in December 2012. *(Keith Wilson)*

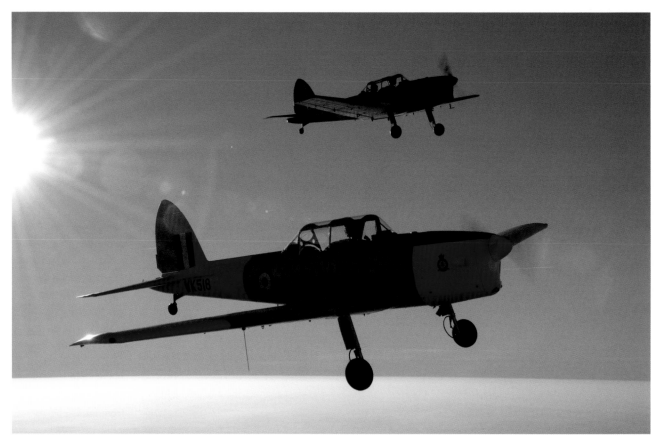

the responsibility for the Flight's engineering in October 2012. The engineers are a great bunch of hard-working men (and women) who keep the aircraft in the air – no mean feat when one considers the average age of the Lancaster, Dakota, Spitfires and Hurricanes is probably approaching 70. Without the considerable help and cooperation of the engineers, this book would not have been possible. You are all a credit to yourselves and the BBMF.

Then there are the volunteer aircrew. Aside from the boss, Squadron Leader 'Dunc' Mason, and his Operations Officer, Flight Lieutenant Anthony 'Parky' Parkinson MBE, all of the remaining members of the flightcrew – pilots, navigators, air engineers and air loadmasters – volunteer to serve with the Flight and usually give up three weekends out of every four during the season to display these wonderful and iconic aircraft at airshows and events right across the country. They all have full-time day jobs within the Royal Air Force, and many of them travel to Coningsby from other RAF stations including Marham, Waddington and Brize Norton. Interestingly, the Coningsby Station Commander, as well as the OC Operations Wing at the base, volunteer as fighter pilots on the Flight during their stay at Coningsby – to fly for the Flight in the Spitfires and Hurricanes. It must make a pleasant change from flying Typhoon aircraft, but it's a tough job and someone has to do it!

The 70th anniversary of the Dambuster Raid was celebrated in 2013. The Flight's Lancaster was in great demand and made numerous special appearances, accumulating more than 100 hours on the airframe and engines. This book features images from some of those celebrations, including the replication of 617 Squadron's low-level training flights from 70 years ago over the Derwent and Ladybower Reservoirs before moving south to the Eyebrook Reservoir. I watched the celebrations at the latter event from a small fishing boat in the middle of the reservoir as the two Spitfires made their low-level entrance. They were followed shortly afterwards by the Lancaster, making two low-level passes with its bomb doors wide open. The event was concluded by a pair of specially painted Tornado GR4 aircraft from 617 Squadron, making two low, loud and

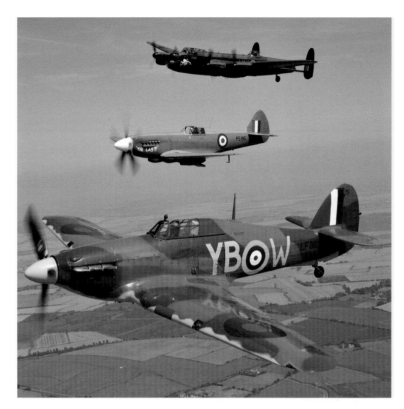

fast passes. I had a memorable, if somewhat unique, view of proceedings.

The year 2014 marked the 70th anniversary of D-Day, as well as the Arnhem landings. Consequently, it became the turn of the Flight's Dakota to take centre stage. It was certainly a busy season for ZA947.

RAF Coningsby boasts a wonderful visitor centre; open every weekday from 10am to 5pm, with the exception of public holidays and two weeks over Christmas. Aside from the well-stocked shop, visitors are able to take a guided tour around the BBMF hangar with a chance of seeing the aircraft up close and the engineering team hard at work maintaining them. If you haven't been to the visitor centre, please find the time; you certainly won't regret it.

The Battle of Britain Memorial Flight is a living reminder of the debt of gratitude we all owe to those who gave their lives during the Second World War, in both the Battle of Britain as well as with Bomber Command. We must all ensure that current and future generations learn about our past and remember what we all owe.

'Lest we forget.'

Keith Wilson
Ramsey, Cambridgeshire
October 2014

ABOVE The classic BBMF three-ship formation of Hurricane, Spitfire and Lancaster photographed over the Kent countryside on 11 August 2012.
(Keith Wilson)

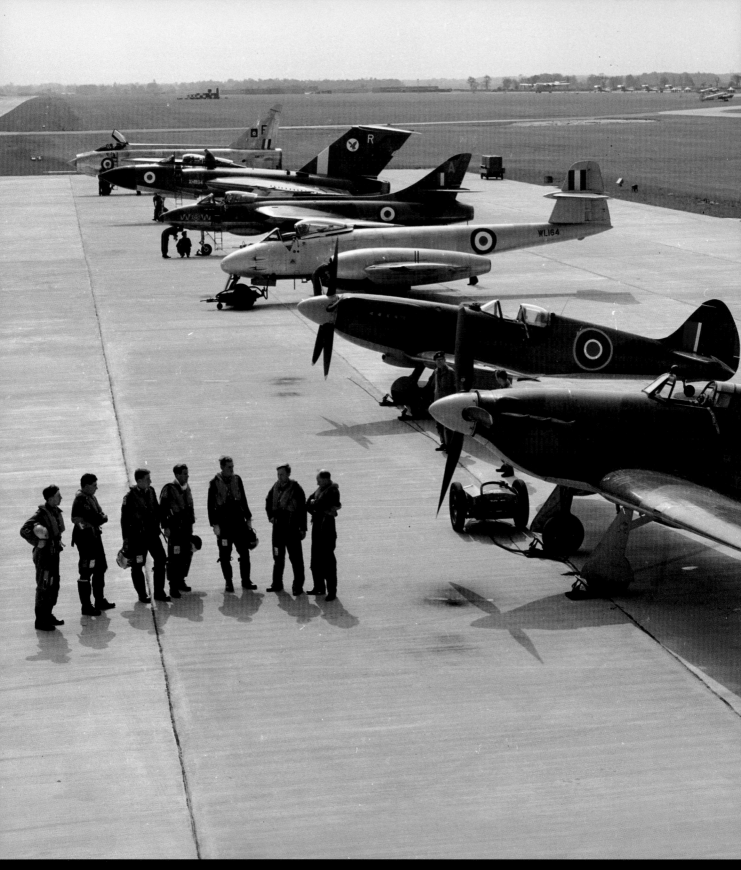

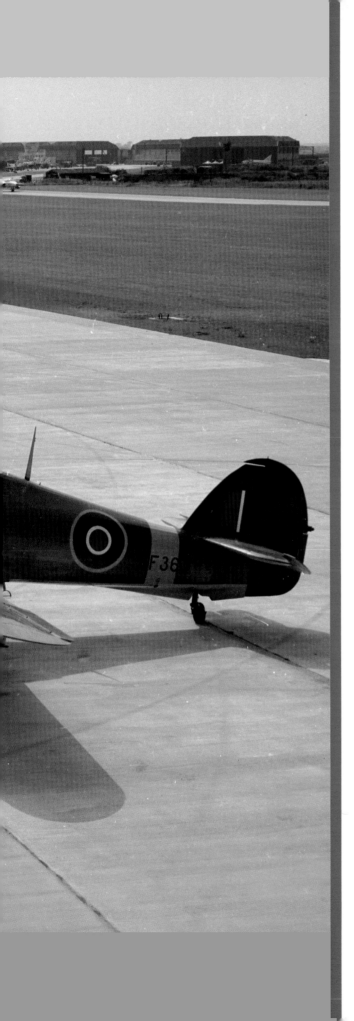

History of the BBMF

The Battle of Britain Memorial Flight is one of the world's foremost collections of historic aircraft. It maintains an airworthy fleet of six Spitfires, two Hurricanes and two Chipmunks, along with a Douglas Dakota and one of only two airworthy Lancasters in the world. Of course the aircraft are important, but what the BBMF actually represents is of far more importance! It is a living memorial to all those members of the Royal Air Force who paid the ultimate sacrifice in the service of their country.

OPPOSITE RAF fighters past and present pictured at Coltishall after a formation flight to mark the 20th anniversary of the Battle of Britain, September 1960. From nearest the camera: Hurricane IIC (LF363); Spitfire PR XIX (PM631); Meteor F8 (WL164); Hunter (XK136/A, 74 Squadron); Javelin FAW9R (XH894/R, 23 Squadron); Lightning F1 (XM137/F). *(Crown Copyright/Air Historical Branch image T-2088)*

BELOW The last three Spitfire PR XIXs of the former THUM Flight were flown to Biggin Hill to join the newly formed Historic Aircraft Flight by Grp Capt J.E. 'Johnnie' Johnson (PS853), Grp Capt James Rankin (PM631) and Wg Cdr Peter Thompson (PS915). They were escorted by a Hunter F5 of 41 Squadron (WN967) and a Javelin FAW1 from 46 Squadron (XA568/H). *(Crown Copyright/Air Historical Branch image PRB-1-13567)*

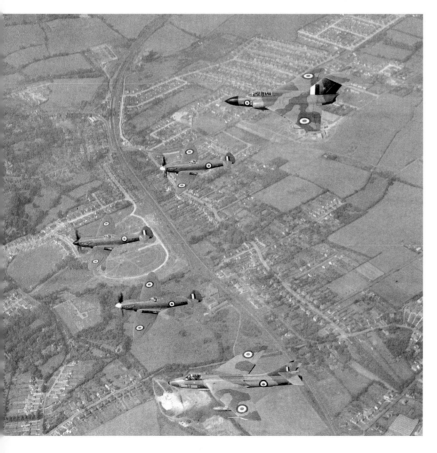

The motto of the Battle of Britain Memorial Flight – *'Lest we forget'* – clearly states their position.

What today is a household name (and a national institution) was created from humble beginnings, under very tight financial constraints. Thankfully, today it is a dedicated unit within the Royal Air Force, has its own headquarters and is trusted with caring for priceless British aviation assets on behalf of the nation. It provides us all with a wonderful opportunity to watch them perform in the air, while being a constant reminder of the debt of gratitude we all owe to 'the few'.

In the years immediately following the Second World War, it became traditional for a Spitfire and a Hurricane to lead the Victory Day flypast over London. The importance of seeing a Spitfire and a Hurricane at the head of the flypast was recognised, and knowing that both types were rapidly disappearing from RAF service, the need to form a historic collection of flyable aircraft to continue the commemorative duties was identified. At this time, Wing Commander Peter Thompson DFC was Station Commander at Biggin Hill, Kent. After gaining his pilot's wings in the summer of 1940, Peter flew Hurricanes during the Battle of Britain. By the mid-1950s Hurricane IIC LF363 was the only airworthy representative of its type with the RAF and was based at Biggin Hill – providing the basis for the formation of a Memorial Flight. Peter gained the necessary permissions to form a historic flight at Biggin Hill, although without public funding all manpower would have to be voluntary. The 'Historic Aircraft Flight' (HAF) would eventually develop and become what we know today as the RAF Battle of Britain Memorial Flight.

By 1957, the only three remaining airworthy Spitfires available to the RAF were being flown by the civilian-operated Temperature and Humidity Monitoring (THUM) Flight at RAF Woodvale. In June 1957, the THUM Flight made its final monitoring sortie (flown by PS853) and all three Spitfire PR XIXs – PM631, PS853 and PS915 – were flown to Duxford where they were handed back into RAF care. Their fate was secure as they had been allocated to the newly formed HAF.

They were scheduled to be delivered from Woodvale to Duxford on 12 June, but PS915 became unserviceable with engine trouble,

PS853 had an engine failure on take-off and crashed, and PM631 got airborne but returned to base when the pilot noticed that PS853 had 'failed to get off'. The trip was abandoned.

With the unserviceability of PS915 rectified and the damage to PS853 remedied, all three aircraft made their way to Duxford by the end of June 1957.

On 11 July 1957 the three aircraft flew in formation to a special ceremony at Biggin Hill with legendary wartime ace Group Captain J.E. 'Johnnie' Johnson DSO DFC in PS853, Group Captain James Rankin DSO in PM631 and Wing Commander Peter Thompson in PS915. En route to Duxford the formation had a jet escort when a Hawker Hunter of 41 Squadron from Biggin Hill and a Gloster Javelin of 46 Squadron from Odiham formed up with them. The group were welcomed to Biggin Hill by Air Officer Commanding-in-Chief of Fighter Command, AM Sir Thomas Pike KCB CBE DFC*.

There was a general consensus among former wartime pilots that it was not fitting to form a tribute to the Battle of Britain with a variant of the Spitfire that was not designed to fire guns. There were three Spitfire Mk XVIs on RAF strength – TE330, TE476 and SL574 – held in storage with a maintenance unit. All were being prepared for ground use at the 1957 Royal Tournament, to depict the Defence of Malta during the war. After having attended the event, Thompson made a formal application for the three aircraft to be added to the HAF. Although all were considered to be ground demonstration models only and no longer airworthy, it was thought that enthusiastic work by the groundcrew at Biggin Hill would soon get them flying once more. They were delivered to Biggin Hill, into the hands of OC Engineering at the base. Squadron Leader Howden inspected all six Spitfire airframes now located at Biggin Hill and – perhaps a little surprisingly – recommended that the Mk XVIs be given priority for a return to flying condition. Perhaps it was because at the time Mk XVI spares were more readily available? While the Spitfire PR XIXs were probably in better condition than the Mk XVIs (having been in operational service more recently), it was felt more appropriate that a fighter version of the type should lead the next Battle of Britain Day flypast.

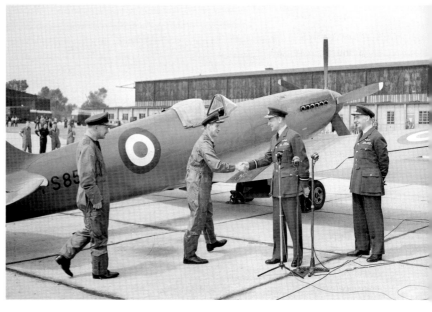

Given the limited availability of staff, it was decided to tackle the restoration of just one aircraft to flying condition. Howden selected TE330 as it was in better condition than the other two Mk XVIs, and his team of eight engineers set to work. Spitfire TE330 was air tested at Biggin Hill on Sunday

ABOVE After arriving safely at Biggin Hill on 11 July 1957, the pilots were welcomed by the C-in-C Fighter Command Sir Thomas Pike, with the AOC 11 Group, Air Vice-Marshal V.S. Bowling, looking on. *(Crown Copyright/Air Historical Branch image PRB-1-13572)*

LEFT Grp Capt 'Johnnie' Johnson (in the cockpit) photographed in conversation with Grp Capt James Rankin. *(Crown Copyright/Air Historical Branch image PRB-1-13575)*

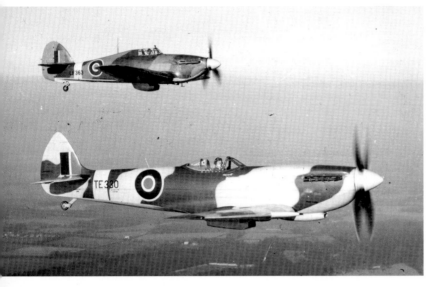

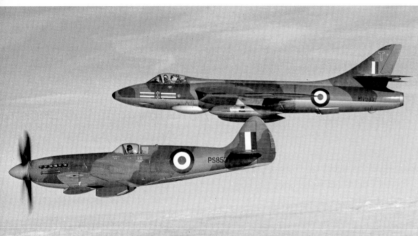

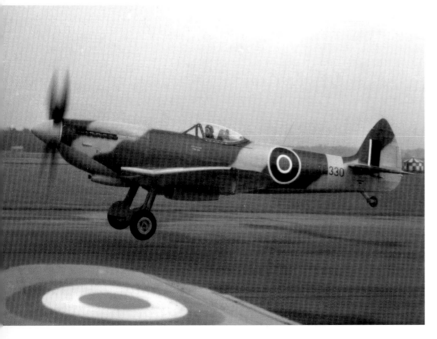

LEFT An early air-to-air image of the Historic Aircraft Flight's Spitfire XVIe, TE330, and Hurricane II, LF363, on a flight from Biggin Hill in December 1957. *(Crown Copyright/Air Historical Branch image T-462)*

CENTRE Shortly after being painted in a camouflage colour scheme, Spitfire PR XIX, PS853, of the Historic Aircraft Flight, was photographed on 11 October 1957 with Wg Cdr Peter Thompson at the controls. It was joined by a Hunter F5 (WN983/T) of 41 Squadron, flown by Flt Lt R. Irish. *(Crown Copyright/Air Historical Branch image PRB-1-13998)*

8 September 1957 by the Station Commander, Wing Commander Peter Thompson. After a satisfactory test flight, the Spitfire joined the Hurricane LF363 in the Station Flight hangar.

Officially named the Historic Aircraft Flight, the new memorial unit was formed at Biggin Hill on 11 July 1957 and later made its first flypast over Westminster Abbey on 15 September, Battle of Britain Day 1957.

In February 1958 Thompson was posted away. He had always referred to the Historic Aircraft Flight as the 'BoB Flight' and on 21 February it was officially renamed the Battle of Britain Flight.

Sadly, just two months later, one of the Spitfires (PS915) was inspected and found to be in a poor condition. It was subsequently removed from flying duties and transferred to ground display purposes to become the gate guardian – a role it carried out until 1984 when it was restored by British Aerospace at Samlesbury and returned to the BBMF in a flyable condition.

Work continued steadily and on 23 February 1958 SL574 took to the air. In the same month it was announced that Biggin Hill was to close

LEFT Spitfire LF XVIe, TE330, of the Battle of Britain Flight at Biggin Hill, photographed on 5 December 1957. This aircraft was the first Spitfire to carry out a Battle of Britain flypast for the Flight and was later presented to the USAF Academy. *(Crown Copyright/Air Historical Branch image PRB-1-14503)*

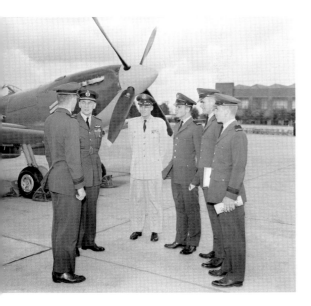

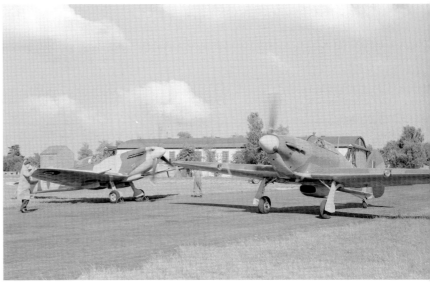

and the Flight moved to North Weald, Essex, in March 1958.

It was to be a brief stay. In May 1958 it was announced that North Weald was also to close, and thus the Flight needed to find another home. Shortly afterwards it moved to Martlesham Heath in Suffolk where it would remain for three years. It was during its time in Suffolk that the Flight lost its favoured Spitfire XVIs and, indeed, its principal event participation, due to a series of accidents and reliability problems. On 28 May, SL574 suffered significant damage in a flying incident at Martlesham and was sent away to 71 Maintenance Unit (MU) at Bicester for repair on 4 June, returning on 1 July. Then, on 10 September, TE476 was damaged in a flying accident. As a result, it was decreed that September 1959 would be the last time that the Battle of Britain Flight fighters, including the Hurricane, would participate in the flypast over London. That decision was perhaps vindicated when SL574 suffered a complete engine failure during that very sortie and the pilot, Air Vice-Marshal Harold Maguire, force-landed on the OXO cricket ground at Bromley. It was the

ABOVE LEFT Spitfire LF XVIe, TE330, was not destined to stay with the Flight for long. It was presented to the USAF Academy on 2 July 1958 in a formal presentation at RAF Odiham. This perfectly airworthy aircraft was fated to spend the rest of its life in a museum. *(Crown Copyright/Air Historical Branch image PRB-1-15295)*

ABOVE Spitfire XVIe TE476 (left) and Hurricane IIc LF363 (right) are pictured readying themselves for rehearsals for the 1959 Battle of Britain flypast. *(Crown Copyright/Air Historical Branch image PRB-1-17835)*

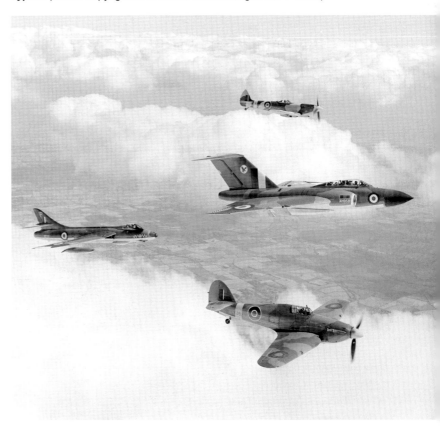

RIGHT Battle of Britain Flight Spitfire LF XVIe, TE476, and Hurricane IIc, LF363, with Hunter F6, XF511/P, of 74 Squadron, and Javelin FAW7, XH958, of 23 Squadron, rehearsing for the Battle of Britain flypast in 1959. *(Crown Copyright/Air Historical Branch image PRB-1-17839)*

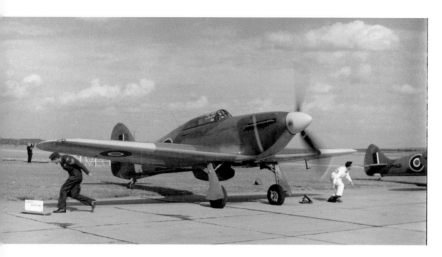

ABOVE **Hurricane IIc, LF363, of the Battle of Britain Flight, is prepared for flight during the presentation of Squadron Standards to 64 and 65 Squadrons at RAF Duxford on 6 July 1960.** *(Crown Copyright/Air Historical Branch image T-2026)*

of Hurricane LF363 and Spitfire Mk XIX PM631. It would remain this way until 1964.

Yet another setback was to befall the Flight when it was announced that Horsham St Faith was to close on 1 April 1963. The Flight upped sticks and moved to RAF Coltishall, where things began to improve significantly.

PS853 had been made serviceable again and put on charge of the Central Fighter Establishment on 31 October 1962. In April 1964 it was returned to the Flight. Then in September 1965, Vickers-Armstrong donated Mk Vb AB910 to the Flight. This aircraft came with a genuine wartime history and was delivered to Coltishall by no less a Spitfire celebrity than Jeffrey Quill.

In a letter dated 1 April 1969 it was announced that the Flight should be established on a formal basis at RAF Coltishall, with the necessary servicing personnel present on a full-time basis. It was also reported that the 'Waddington Lancaster' PA474, would be kept in flying condition at RAF Waddington until the end of 1969, when its future would be reviewed.

Having become popularly known as the Battle of Britain Memorial Flight (BBMF), the unit officially took this name on 1 June 1969.

The Flight secured a major coup when,

end for the Mk XVIs as flying aircraft with the RAF. TE476 went on the gate at Neatishead, Norfolk, in January 1960. SL574 was similarly relegated to gate guard duties at Bentley Priory in November 1961.

In November 1961, the Flight was once again forced to move; this time it went to Horsham St Faith in Norfolk (now known as Norwich airport). At the time, the Flight consisted

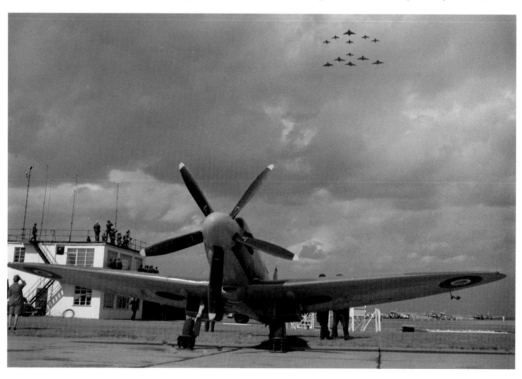

RIGHT **A mixed formation of 64 Squadron Javelins and 65 Squadron Hunters fly over Spitfire PR XIX, PM631, during the presentation of Squadron Standards at RAF Duxford.** *(Crown Copyright/Air Historical Branch image T-2033)*

after filming for the classic *Battle of Britain* was completed, it was presented with Spitfire IIa P7350 on 8 November 1968. This was – and still is – the world's oldest airworthy example of its type and a genuine combat veteran of the Battle of Britain.

ABOVE LEFT Presentation of Spitfire Vb, AB910, to the RAF by the British Aircraft Corporation (Vickers-Armstrong) at RAF Coltishall, 15 September 1965. Left to right: Sir Jeffrey Tuttle, Chairman, BAC; Jeffrey Quill, former Spitfire test pilot; Grp Capt Roger Topp, Station Commander, RAF Coltishall; Air Marshal Sir Douglas Morris, C-in-C Fighter Command. *(Crown Copyright/ Air Historical Branch image PRB-1-31531)*

Last of the Many!

Further expansion of the Flight occurred in March 1972, when Hurricane IIc PZ865 was presented to the BBMF after being refurbished by Hawker Siddeley, bringing the Flight's complement of airworthy Hurricanes to two. PZ865 had been completed at Hawker's Langley factory on 27 July 1944, the last of

more than 14,000 Hurricanes to have been built. The aircraft was named *Last of the Many!* and the name was painted on the fuselage sides, just behind the cockpit. PZ865 was rolled out in the presence of Hawker's remaining Hart, G-ABMR, bedecked in banners.

After its appearance in *Battle of Britain* in 1969,

ABOVE After the presentation ceremony former Spitfire test pilot Jeffrey Quill taxies out in AB910 for a short display. *(Crown Copyright/Air Historical Branch image PRB-1-31527)*

LEFT A press photo opportunity at Henlow in 1968: three Hurricanes and ten Spitfires (a mixture of real aircraft and replicas) are displayed ahead of their use in the 1969 film *Battle of Britain*. *(Crown Copyright/Air Historical Branch image T-8362)*

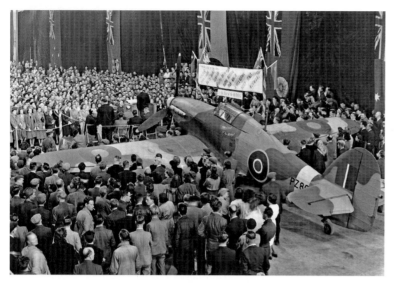

ABOVE After its appearance in the film *Battle of Britain*, PZ865 was refurbished and returned to flying condition. When Hurricane IIc, PZ865, was presented to the BBMF after being refurbished by Hawker Siddeley, it brought the Flight's complement of airworthy Hurricanes to two. *(via Peter R. March)*

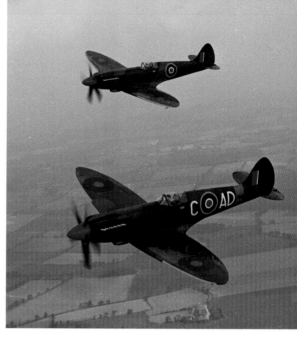

ABOVE A pair of Spitfire PR XIXs of the BBMF in 1969. Nearest the camera is PM631, painted as 'AD-C' of 11 Squadron; PS853 is un-coded. To fund the rebuild of Hurricane LF363, PS853 was sold by auction in November 1994 and is now operated by the Rolls-Royce Heritage Flight. *(Crown Copyright/ Air Historical Branch image TN-1-2678)*

PZ865 was refurbished and subsequently returned to flying condition in 1971. On 30 March 1972, PZ865 was presented to the Flight at Coltishall.

Lancaster PA474 arrives

The year 1973 saw the arrival on the Flight of a new and significant type when, on 20 November, Lancaster PA474 was officially transferred from RAF Waddington in Lincolnshire, where it had been refurbished and maintained by station personnel. The RAF's sole airworthy Lancaster bomber had been making a growing number of appearances and station resources were struggling to keep pace with the demand. It was deemed that the best option was to place the Lancaster under the care of the BBMF, which had the necessary expertise to maintain it.

RIGHT On 7 March 1954, Avro Lancaster BI, PA474/M, was transferred to the College of Aeronautics at Cranfield, where it was to be used for trials with several experimental aerofoil sections, including the Handley Page laminar flow wing. In doing so, it effectively saved an airworthy Lancaster for the nation. *(Photograph reproduced with permission from Cranfield University)*

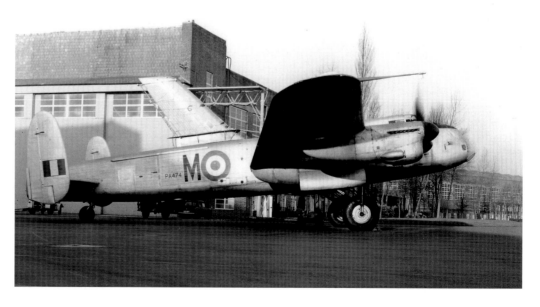

RIGHT A nostalgic view of the College of Aeronautics' varied fleet of aircraft in 1957–58, outside its main hangar at Cranfield. At the front is Short SB.4 Sherpa G-36-1, with Auster J/5F Aiglet Trainer G-AMZU to its right and Anson G-AIPC to its left. Behind is Auster J/5F Aiglet Trainer G-AMTD, Avro 19 Srs.1 G-AHIC and Dove 1 G-ALVF. To the rear is Lancaster PA474 and an unidentified Meteor. Another unidentified Anson appears on the grass in the rear of the picture. *(Photograph reproduced with permission from Cranfield University)*

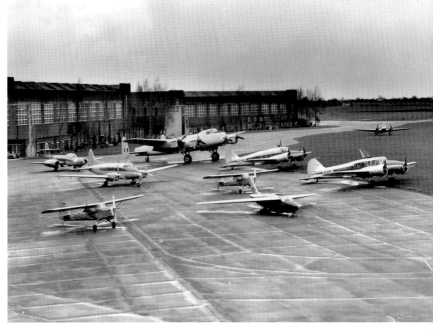

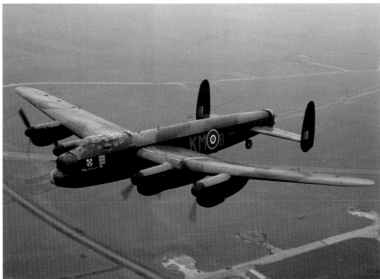

LEFT PA474, photographed during a flight from RAF Waddington on 17 May 1974. The coat of arms and 'City of Lincoln' titles had recently been applied just below the cockpit. At this time the aircraft was still missing the mid-upper turret. *(Crown Copyright/Air Historical Branch image TN-1-6922-1)*

BELOW LEFT Another lovely air-to-air view of PA474 during a later sortie, still minus her mid-upper turret, 12 April 1975. *(Crown Copyright/Air Historical Branch TN-1-7237-8)*

BELOW Little is known about this image but it is assumed to have been taken in 1986 when PA474 passed 3,000 airframe hours. At the time PA474 was in the hands of the BBMF at Coningsby and the 'Saint' logo with its spanner is thought to have been a reference to the aircraft's reliability on the Flight. By the end of 2013 the total airframe hours on PA474 had reached 5,817.5. *(Crown Copyright/Air Historical Branch image CGY-BBMF-13)*

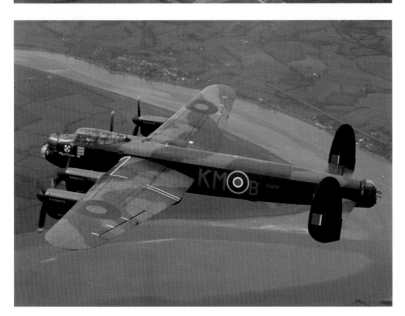

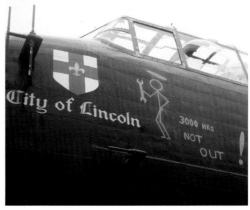

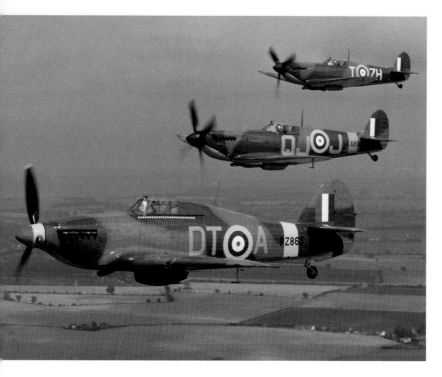

ABOVE BBMF, RAF Coltishall, 31 July 1972: Hurricane IIc, PZ865/DT-A, leads a pair of Spitfires – Vb, AB910/'QJ-J' and IIa, P7350/'ZH-T'. The code and colours of AB910 represent a 92 Squadron aircraft; P7350 represents a 266 Squadron aircraft. (Crown Copyright/Air Historical Branch image TN-1-6620-35)

BELOW The first codes applied to Spitfire PR XIX, PS853, were 'ZP-A' of 74 Squadron. It was photographed during a flight from Coltishall on 31 July 1972. In 1974 it was repainted in an overall PR blue colour scheme. (Crown Copyright/Air Historical Branch image TN-1-6620-54)

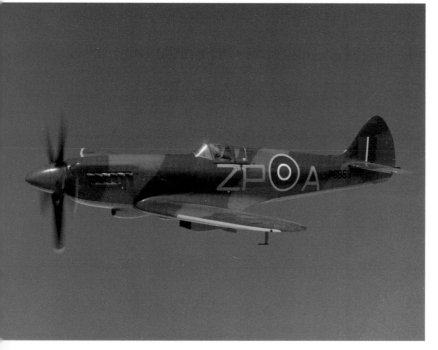

On the move again!

Less than two years later, it was announced that due to the planned introduction of the new Jaguar aircraft at the base, the BBMF would move from Coltishall to Coningsby in Lincolnshire. On 1 March 1976, the Flight's aircraft began ferrying across to their new home, the Lancaster leading a formation that included a single Hurricane and three of the Flight's Spitfires. Spitfire AB910 and Hurricane LF363 followed a few days later – along with the remains of Spitfire Mk IX MK732, which had been used at Coltishall as a source of spare parts. Thankfully, the Flight has remained at Coningsby right up to the present day.

Devon joins the Flight

For a number of years, 207 Squadron at RAF Northolt provided valuable assistance to the Flight, giving logistical support and escort facilities on occasions when the Flight was deployed away from its home base. This was particularly important when Flight aircraft had to transit Controlled Airspace (with very limited radio and avionics on board the fighters) or attend shows overseas. At first, examples of the Beagle Basset CC1 were used, but later the de Havilland Devon was employed in the role.

On 30 April 1985, authority was granted for the transfer of Devon C2/2 VP981 to the BBMF. It arrived in its former 207 Squadron grey and white colours but soon had Battle of Britain Memorial Flight titles added along the fuselage. It was later painted in classic silver and blue colours and was regularly seen at air shows across the country and, occasionally, it made forays into Europe escorting the fighters to overseas air shows.

An old friend returns

An old friend rejoined the BBMF in 1987 when Spitfire XIX PS915 was returned in airworthy condition after a major restoration by British Aerospace. PS915 made its first post-rebuild air test at Warton on 16 December 1986 and was delivered to Coningsby on 7 April 1987 when it was presented back to the Flight.

A major setback!

Sadly there was a major setback in September 1991 when LF363 suffered an engine failure

en route to Jersey and made a forced landing at RAF Wittering. It was virtually destroyed in the ensuing fire, which put it out of service for seven years. As the cost of LF363's rebuild could not be met by the public purse, it was decided to sell Spitfire XIX PS853 to raise the money necessary to restore the Hurricane. 'LF' was rebuilt and returned to the air on 29 September 1998.

A Dakota joins the Flight

Another new type joined the Flight on 20 July 1993 when Douglas Dakota III ZA947 arrived at Coningsby after transfer from the Defence Research Agency.

When ZA947 joined the Flight, the Devon's role became superfluous and the aircraft was placed in storage at Coningsby. After being put up for sale, the Devon joined the Air Atlantique Historic Classic Flight and was ferried to Coventry.

Spitfire MK356

In November 1997 there was yet another major addition when newly restored Spitfire IX MK356 arrived. Not only was the Flight getting a variant it hadn't previously operated, but MK356 also came with fine provenance – it had flown during the D-Day operations in June 1944, supporting the Allied invasion of occupied France.

Mk XVI returns to the Flight

In January 2001, the BBMF took delivery of a pair of Spitfire Mk XVIs – TB382 and TE311 – which had been placed on the Flight's strength following many years with the RAF's recruitment roadshow. They had been stored in one of Coningsby's hardened aircraft shelters since October 1999. Their Rolls-Royce Merlin engines were soon removed and one was refurbished for later use by the Flight. Both aircraft were structurally examined: TB382's skin was in poor condition, but TE311 was in remarkably good shape. As a result, TB382 was dismantled for spares and subsequently struck off charge.

TE311 was initially retained as part of a spares recovery programme, but work to restore the fuselage as a spare began in October 2001. Unfortunately, it had to be carried out at no cost to the Ministry of Defence, which resulted in the two technicians

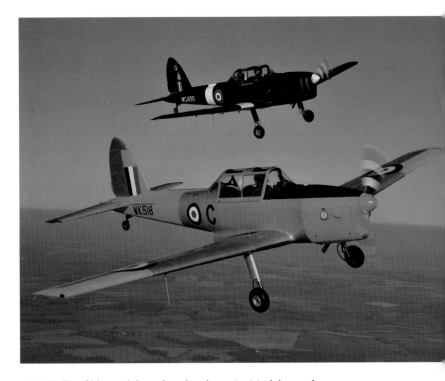

ABOVE The Chipmunk has played an important training and currency role since the type joined the BBMF. The Flight's current pair (WG486 and WK518/C), seen here on 13 December 2012, are being flown by Flt Lt Anthony Parkinson (WK518) and Wg Cdr Paul Godfrey (WG486). These are the last remaining Chipmunk aircraft in flying service within the RAF. *(Keith Wilson)*

BELOW A fairly recent addition to the Flight, Spitfire Vb MK356 arrived at Coningsby in November 1997. It wears the colours of 443 (Hornet) Squadron RCAF, which it wore on D-Day in June 1944. The aircraft featured clipped wings, which gave the fighter better low-altitude performance. It was photographed in September 2006. *(Crown Copyright/SAC Scott Lewis)*

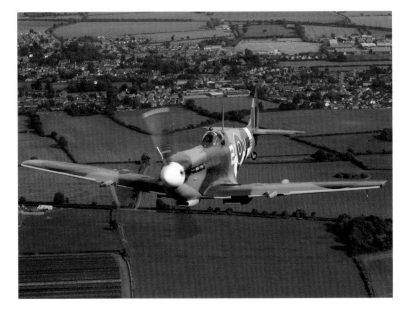

principally responsible for the project – Chief Technician Paul Blackah and Corporal Andy Bale – carrying out the work in their spare time. The project received generous help from several companies and many other BBMF engineers. Subsequently, and because of the high standard of the restoration, permission was given to complete a full restoration to flying condition. It had been a long task, taking 11 years, but the aircraft made its first flight at Coningsby on 19 October 2012, adding the important Mk XVI to the Flight's inventory for the coming years.

In demand

Records indicate that for many years after its formation the Flight conducted relatively low-key operations, typically making 50–60 appearances per season – a situation that continued into the mid-1960s. By the early 1990s, the number of appearances had trebled and demand for participation by the Flight's aircraft was continuing to grow. In 1996 individual aircraft appearances exceeded 500, and by 2003, tasking for over 700 individual aircraft appearances during each year's display season had become the norm, many of which are flypasts that are scheduled to take place en route to a display. The demand for appearances by the Flight's aircraft shows no sign of decline and indeed increases every year.

Flying hours on each airframe are carefully restricted to ensure longevity on the Flight, while a programme of major maintenance inspections (along with their subsequent remedial rebuild and replacement of critical components) ensures the airframes will operate well into the future – and way beyond what was expected of them when originally designed and manufactured!

The Lancaster can fly no more than 104 hours per display season, while the Dakota is permitted no more than 180 hours in any one year. The Spitfires are limited to 200 hours in total each season, and that is for all six airframes, not each. There is a total of 120 hours imposed on the Hurricanes, shared between the two aircraft.

Today the Battle of Britain Memorial Flight is a national institution, but the modern BBMF was created from humble beginnings. Though it paid the same mark of respect, it did so under tight budgetary constraints. It has gone from being a loose collection of obsolete types tucked away in the corners of various hangars, to a dedicated unit with its own headquarters, entrusted with caring for priceless assets of Britain's aviation heritage.

The Flight's aircraft now appear in front of an estimated total audience of 7 million people per year – a fitting and permanent reminder of the absolute sacrifice given to so many by so few.

Chronology of the BBMF

July 1957
The Historic Aircraft Flight forms at RAF Biggin Hill with one Hurricane IIb (LF363) and three Spitfire PR XIXs (PM631, PS853 and PS915).

August 1957
Three Spitfire Mk XVIs join the Flight (TE330, TE476 and SL574).

November 1957
Spitfire PS915 inspected and found to be in a poor condition. It was removed from flying duties and transferred to ground display until it was restored by British Aerospace at Samlesbury and returned to the BBMF in a flyable condition.

February 1958
Officially named the Battle of Britain Flight.

March 1958
RAF Biggin Hill closes and the Flight moves to RAF North Weald.

April 1958
Spitfire PR XIX PS853 leaves the Flight (rejoins in 1964).

May 1958
RAF North Weald closes. Flight moves to RAF Martlesham Heath.

July 1959
At a formal ceremony held at RAF Odiham on 2 July, airworthy Spitfire LF XVIe TE330 is handed over to the United States Air Force Academy.

September 1959
Two Spitfire Mk XVIs (TE476 and SL574) retired from service due to accidents and reliability problems.

November 1961
Flight moves to RAF Horsham St Faith.

April 1963
Flight moves to RAF Coltishall.

September 1965
Flight acquires Spitfire Mk Vb AB910 from Vickers-Armstrong. It arrives painted as 'QJ-J' and becomes the first aircraft of the Flight to wear unit markings.

November 1968
Flight acquires Spitfire Mk IIa P7350 on 1 November, after the aircraft had participated in the flying sequences of the film *Battle of Britain*.

April 1969
Flight established on a formal basis at RAF Coltishall, with maintenance personnel employed on a full-time basis.

June 1969
Officially renamed 'Battle of Britain Memorial Flight' on 1 June.

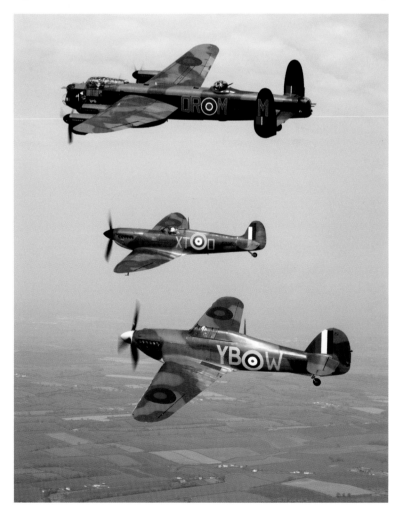

BELOW Probably the ultimate BBMF three-ship combination. Lancaster PA474 is leading Spitfire IIa, P7350, in 603 (City of Edinburgh) Squadron colours and Hurricane IIb, LF363, in 17 Squadron markings, in 2006. *(Geoffrey Lee/ Planefocus GLD060983)*

March 1972

Hurricane IIc PZ865 is presented to the BBMF after being refurbished by Hawker Siddeley, bringing the Flight's complement of airworthy Hurricanes to two.

November 1973

Flight acquires Lancaster B1 PA474 from 44 Squadron at RAF Waddington.

March 1976

Flight moves to RAF Coningsby.

April 1983

Flight acquires Chipmunk T10 WK518 (ex-RAF Manston).

April 1985

Flight acquires DH Devon VP981. Aircraft later retired in 1993 and sold in 1997.

April 1987

Spitfire PR XIX PS915 returned to the BBMF in airworthy condition after a major restoration by British Aerospace. PS915 made its first post-rebuild air test at Warton on 16 December 1986 and was delivered to Coningsby on 7 April 1987.

September 1991

Hurricane LF363 suffered an engine failure en route to Jersey and made a forced landing at RAF Wittering. It was virtually destroyed in the ensuing fire and was put out of service for seven years.

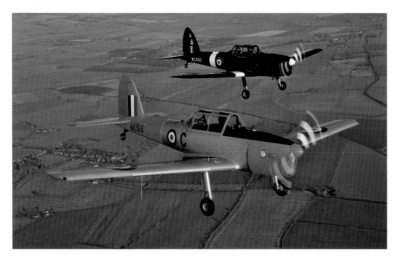

BELOW Although rarely seen at air shows, the Flight's pair of Chipmunk aircraft are an integral part of the fleet, providing important tailwheel and currency training for most of the flightcrew. Both were photographed in formation over Lincolnshire in December 2012. *(Keith Wilson)*

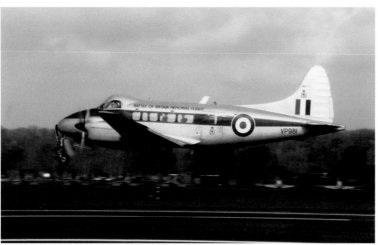

LEFT Shortly after joining the BBMF, VP981 was repainted in this attractive silver and blue colour scheme with 'Battle of Britain Memorial Flight' titles. It was photographed leaving RAF Marham in late March 1993 during celebrations for the 75th anniversary of the RAF. *(Keith Wilson)*

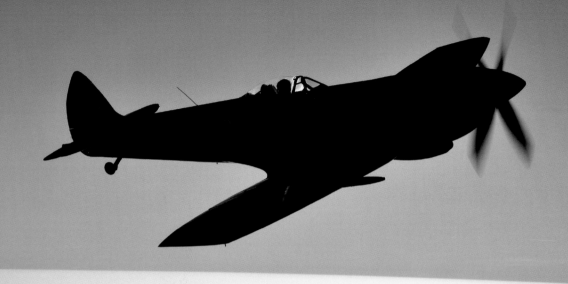

July 1993
Douglas Dakota III ZA947 arrived at Coningsby after transfer from the Defence Research Agency. When ZA947 joined the Flight, the Devon's role became superfluous and the aircraft was placed in storage at Coningsby.

June 1994
Spitfire XIX PS853 sold to defray costs of rebuild on Hurricane LF363.

June 1995
Flight acquires Chipmunk T10 WG486 (ex-RAF Gatow, Berlin Station Flight).

November 1997
Flight acquires Spitfire Mk IX MK356 after rebuild by technicians at RAF St Athan. MK356 came with fine provenance – it had flown during the D-Day operations in June 1944, supporting the Allied invasion of occupied France.

September 1998
Hurricane LF363 returns to service after rebuild.

2000
Flight granted semi-autonomous status as an independent unit.

April 2002
Two non-flying Spitfire XVIs (TE311 and TB382) allocated to the BBMF for spares support (ex-RAF Exhibition Flight). TB382 dismantled for spares and struck off charge. TE311 becomes part of a spares recovery programme.

July 2007
The BBMF celebrates its 50th anniversary of Commemorative Service. Spitfire Mk XVIe TE311 officially added to the BBMF establishment.

2012
After a 12-year restoration programme, Spitfire Mk XVIe TE311 makes its first flight at RAF Coningsby on 12 October 2012 with Squadron Leader Ian 'Smithy' Smith at the controls.

2013
70th anniversary of the Dambuster Raid is celebrated by the Flight involving Lancaster PA474 making commemorative passes over the Derwent and Ladybower Reservoirs before moving south and flying over the Eyebrook Reservoir.

2014
70th anniversary of D-Day. Dakota ZA947 is expected to be involved in a number of special celebratory events.

ABOVE It is not often that the Flight's aircraft are presented in such conditions but when the Flight's 'new' Spitfire Mk XVIe, TE311, was photographed over Lincolnshire in December 2012, the weather conditions conspired to provide this glorious photo opportunity. *(Keith Wilson)*

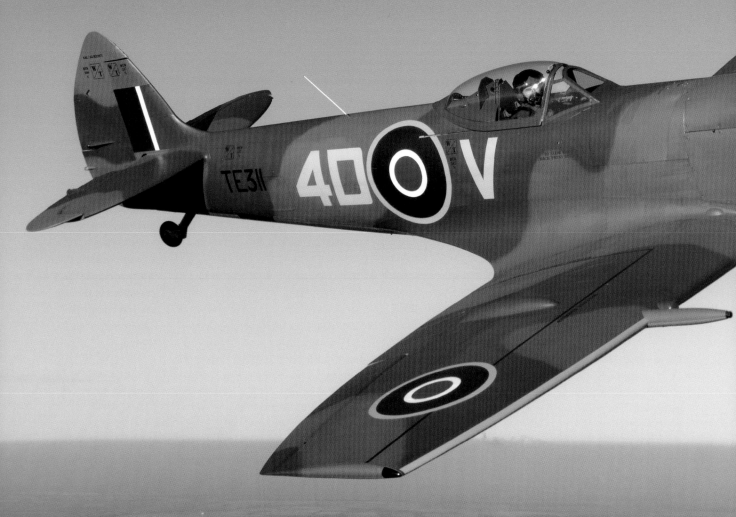

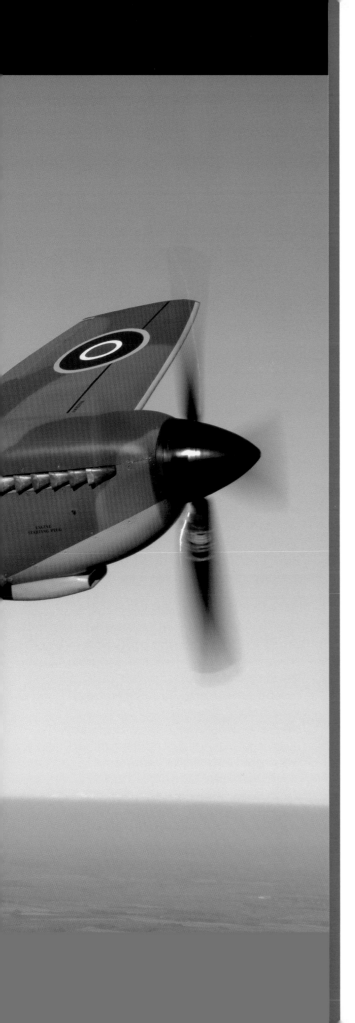

Aircraft of the Flight

When Spitfire Mk Vb AB910 was presented to the Flight by Vickers-Armstrong in September 1965, it carried the code letters QJ-J of 92 Squadron. Perhaps, a little surprisingly, it was the first aircraft on the Flight to wear unit markings.

OPPOSITE The latest aircraft to join the BBMF is Spitfire LF. XVIe, TE311, painted as 74 Squadron's '4D-V'. Its first post-restoration flight was on 19 October 2012 in the hands of Sqn Ldr Ian Smith. TE311 is pictured on a special photo-shoot over Lincolnshire on 13 December 2012 with OC BBMF Sqn Ldr Duncan Mason at the controls. *(Keith Wilson)*

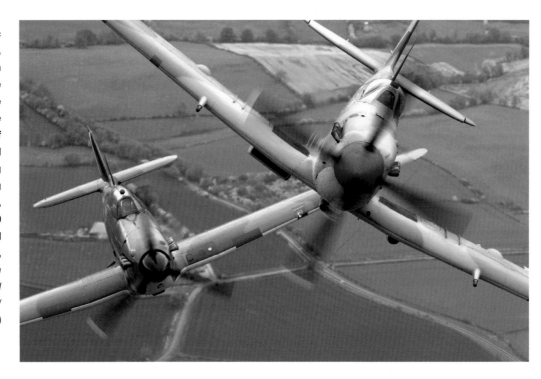

In 1968, the Flight's aircraft were used in the filming for the classic film *Battle of Britain*, directed by Guy Hamilton. Aside from aircraft used primarily for decoration and taxiing on the ground, the film used a large number of flyable historic aircraft including twelve Spitfires, two Hurricanes, two CASA 2111s (Spanish licence-built Heinkel He111H), seventeen HA-1112 Buchons (Spanish licence-built Me109) and two Spanish-built Junkers Ju52s. It proved to be a significant turning point in the worldwide warbird movement. With almost 100 aircraft used in the filming, the production company became the 35th largest air force in the world. The Flight's aircraft were used for filming during the week and at weekends they continued their display duties – often while retaining their film markings – providing photographers with an opportunity to shoot them in interesting 'operational' colour schemes.

After the filming was completed, the Flight was presented with Spitfire Mk IIa P7350, the world's oldest airworthy example of its type and a genuine combat veteran of the Battle of Britain.

On 1 April 1969, Air Marshal Sir Thomas Prickett KCB DSO DFC announced in a letter to Air Chief Marshal Sir Dennis Spotswood KCB CBE DSO DFC, the Air Officer Commanding-in-Chief, Headquarters Strike Command, that he had obtained agreement of the Air Force Board Standing Committee that the Flight should be established on a formal basis at RAF Coningsby. Initially, the Flight would consist of one Hurricane and four Spitfires, and the possibility of adding another Spitfire was under examination.

In 1975, despite opposition from certain quarters, a decision was taken to move the Flight from Coltishall to Coningsby and, perhaps more importantly, bring forward the next Air Force Board review of the BBMF that had been due in 1978. Thankfully, disbandment of the Flight was not an option, as the increased cost of substitute front-line aircraft appearing at air shows was significant. It was also recognised that disbandment would attract the widest possible public dismay. The report concluded that the BBMF represented a cheap and effective means of achieving the two principal purposes of the participation programme and was of good value for that reason alone.

With the Flight's future secure, attention turned to the aircraft markings. In summary, it was decided to leave things as they were; the various colour schemes that were in use had been influenced by their restorers, the donors or the controlling headquarters. What was clear was that changes should not be made for the sake of change alone. Aside from any other negativity, the cost of a repaint was high – £1,200 for a Spitfire and £4,000 for the

Lancaster. If a complete stripping and painting was involved, the costs rose to £4,000 and £12,000 respectively – significant sums in 1975. The conclusion was to leave things as they were and change the markings when an aircraft was repainted.

This decision meant that the Spitfires could change their representative colours every eight years, the Hurricane every six years and the Lancaster every five: all to coincide with major servicing routines. However, repainting just the codes and artwork can be accomplished at a significantly reduced sum and is undertaken to ensure that a particular aircraft is in a particular colour scheme to commemorate a particular event.

Since then, the aircraft of the Flight change their commemorative colours on a regular basis, in keeping with the Flight's policy of using its aircraft as display assets but also to commemorate various Second World War campaigns, units and, sometimes, specific individuals. So far, colour schemes have represented a variety of veterans including Group Captain Douglas Bader, Wing Commander Richard Gleed DSO DFC, Pilot Officer Eric Lock DSO DFC*, Czech fighter ace Flight Lieutenant Karel Kuttelwascher and Flight Lieutenant James 'Jimmy' Whalen DFC, as well as aircraft operating in particular conflicts or theatres.

The Lancaster has been a special case, generally representing Lancaster bombers that have flown more than 100 missions and records indicate that 36 aircraft achieved this milestone. So far, PA474 has carried the centurion markings of ED888 while it served with 103 Squadron wearing the PM-M^2 code; W4964, *Still Going Strong*; EE176, *Mickey the Moocher*; and EE139, *Phantom of the Ruhr*.

The following are details of the various colour schemes flown on the current inventory of BBMF aircraft.

SPITFIRES

Spitfire PR Mk PM631

Spitfire PR Mk XIX PM631 was built a little too late to see service in the Second World War. However, it is representative of similar high-altitude, unarmed, photographic reconnaissance Spitfires which were operational during the war. PM631 was delivered to the RAF on 6 November 1945, but was stored until May 1949 when it was issued to 203 Advanced Squadron School. After being modified for meteorological work, PM631 was flown by civilian pilots working for the Temperature and Humidity Monitoring (THUM) Flight based at Hooton Park and Woodvale. The THUM flights made ascents to 30,000ft to gather meteorological information.

Once its service career was over, PM631 was flown to Biggin Hill from Duxford by Second World War fighter ace Group Captain

BELOW PM631 is the BBMF's longest-serving aircraft and has been in continuous service with the Flight since its formation in July 1957. Shortly after joining the Flight it was painted in camouflage but without code letters, and was pressed into immediate service. *(Peter R. March)*

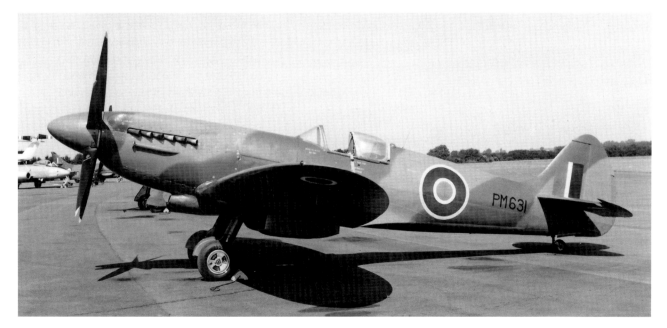

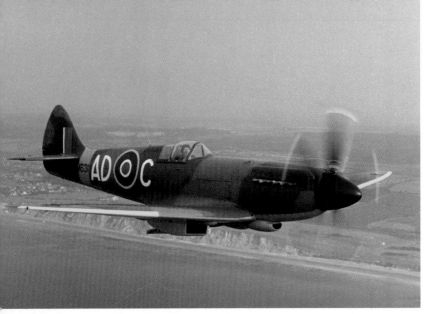

LEFT In 1967, PM631 was painted in the colours of 11 Squadron and the code AD-C added. It remained in these colours until 1983. It was photographed on a flight from RAF Coltishall on 4 July 1973. *(Crown Copyright/Air Historical Branch image TN-1-6797-13)*

CENTRE In 1990, PM631 became 'N' of 11 Squadron in South East Asia Command (SEAC) colours of 1945, with the name *Mary* added to the cowling. It was photographed in June 1990 at the Battle of Britain Day air show, Boscombe Down, and remained in these colours until 1995. *(Peter R. March)*

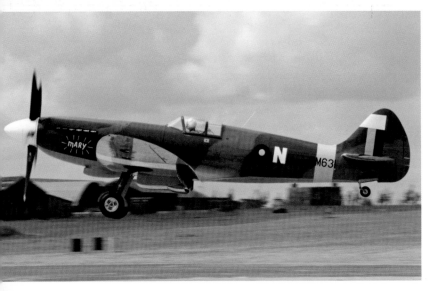

Jamie Rankin DSO* DFC*, in formation with another pair of former THUM Flight Spitfire PR Mk XIXs – PS853 and PS915 – to form the Historic Aircraft Flight in 11 July 1957. Unlike PS853 and PS915, which spent time as gate guardians after they had joined the Flight, PM631 has remained in flying condition and is the BBMF's longest-serving aircraft, with 2014 marking its 57th year of continuous service on display duties.

PM631 is painted as an early PR Mk XIX of 541 Squadron, which performed high-altitude reconnaissance missions over the European theatre from early 1944 to the end of the war. Currently, it represents an aircraft flown by Flight Lieutenant Ray Holmes in early 1945. Ray Holmes was one of the courageous pilots who flew these highly classified, long-range and dangerous, singleton operations over enemy territory, relying on the unarmed aircraft's remarkable performance to avoid being shot down. This was the final stage of the war for Ray, which had seen him fly Hurricanes in the Battle of Britain, famously ramming and bringing down a Dornier Do217 bomber close to Buckingham Palace once he had exhausted his guns.

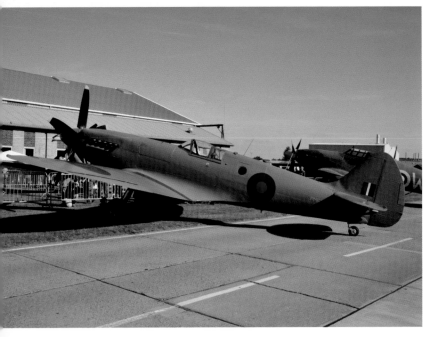

LEFT PM631 is seen here in its current colour scheme, to represent an aircraft of 541 Squadron flown by Flt Lt Ray Holmes. It was photographed while on display at the Lincolnshire Lancaster Association Day at Coningsby on 29 September 2013. *(Keith Wilson)*

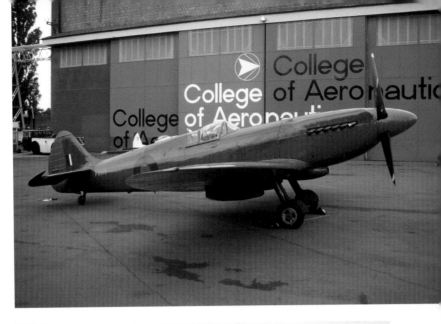

RIGHT After being modified to take a Rolls-Royce Griffon 58 engine from an Avro Shackleton, PS915 was refurbished by British Aerospace and rejoined the BBMF on 7 April 1987, painted in PR blue without any obvious squadron markings. It was photographed outside the College of Aeronautics hangar at Cranfield in June 1987. *(Keith Wilson)*

CENTRE In 1992, PS915 was painted to represent the prototype Spitfire XIV, JF319, with camouflage topsides and a prototype 'P' in a yellow circle on the fuselage. It was photographed when making an appearance at RAF St Mawgan in 1992.
(Peter R. March)

Spitfire PR Mk XIX PS915 – 'The Last!'

Like PM631, Spitfire PR Mk XIX PS915 was built too late to see active service during the Second World War, joining 541 Squadron at Benson in June 1945 before moving to the PR Development Unit to take part in tests on new cameras. Assigned to 2 Squadron at Wunsdorf in Germany, it later flew strategic reconnaissance sorties in connection with the East–West divide of Europe. It returned to the UK in 1951 and was later delivered to the THUM Flight at Woodvale in 1951. It flew with PM631 and PS853 from Duxford to Biggin Hill on 11 July 1957 and was another founding aircraft with the Historic Aircraft Flight.

Sadly, the aircraft's poor condition meant that it was relegated to gate-guard duties; serving in that capacity for nearly 30 years at West Malling, Leuchars and Brawdy. After being modified to take an ex-Shackleton Griffon 58 engine, it was refurbished to flying condition by British Aerospace and rejoined the Flight in 1987.

PS915 currently wears the colour scheme and markings of PS888, a PR Mk XIX of

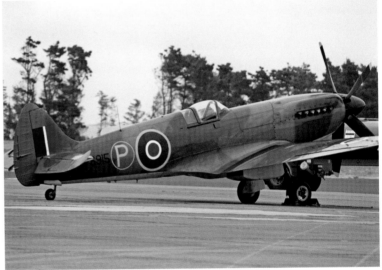

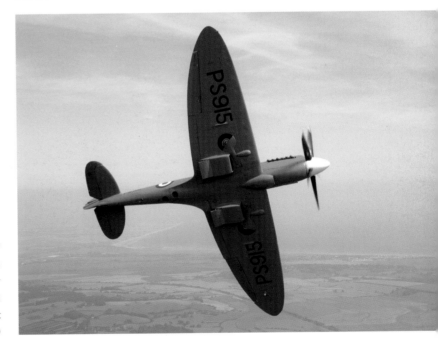

RIGHT Over the winter of 2003/04, PS915 was repainted to represent PS888, a Spitfire PR XIX of 81 Squadron based at Seletar, Singapore. PS888 carried out the last operational sortie flown by an RAF Spitfire on 1 April 1954; in recognition the groundcrew painted 'The Last!' on the port engine cowling. *(Keith Wilson)*

81 Squadron based at Seletar in Singapore during the Malaya Campaign. This aircraft conducted the last ever operational sortie by an RAF Spitfire when, on 1 April 1954, it flew a photographic mission over an area of jungle in Johore thought to contain hideouts for communist guerrillas. For the occasion, the aircraft's groundcrew painted the inscription 'The Last!' on the left engine cowling – which PS915 currently wears.

Spitfire Mk Vb AB910

Built at Castle Bromwich in 1941, Spitfire Mk Vb AB910 had a remarkable front-line operational career spanning almost four years. The aircraft was initially allocated to 222 (Natal) Squadron at North Weald on 22 August 1941 but was soon reallocated to 30 Squadron with whom it flew several convoy patrols and also escort patrols to the daylight bombing raids against the battlecruisers *Scharnhorst* and *Gneisenau* in December 1941. In June 1942, AB910 was delivered to 133 (Eagle) Squadron at Biggin Hill where the aircraft flew 29 operational missions, including 4 sorties on 19 August 1942 during the fierce aerial battles in support of the Dieppe Raid, its pilots being credited with one Dornier Do217 destroyed and one damaged. AB910 continued to fly operationally up to July 1944, serving with 242 (Canadian) and 406 and 402 (RCAF) Squadrons. With 402 Squadron, the aircraft flew numerous cover patrols over the Normandy invasion beachheads on D-Day itself – 6 June 1944 – as well as on subsequent days.

On 14 February 1945, AB910 famously flew with an unauthorised passenger. LACW Margaret Horton, a WAAF groundcrew fitter, had been sitting on the tail while the aircraft taxied out to take off (this was standard practice) without the pilot, Flight Lieutenant Neil Cox DFC*, realising she was there. The pilot took off with Margaret still on the tail. The combination of her weight on the tail and her grip on the elevator very nearly had disastrous consequences, but fortunately the pilot was able to regain control and one large circuit later he landed with a very frightened WAAF still wrapped around the tail.

AB910 was purchased by Group Captain Alan Wheeler for air racing and was placed on the civil aircraft register as G-AISU. After a heavy landing during the King's Cup Air Race in 1953, it was returned to Vickers-Armstrong where it was refurbished and subsequently flown by Jeffrey Quill until being donated to the Flight in 1965.

While with the Flight, AB910 has seen a variety of interesting colour schemes, some of which the aircraft wore while on wartime duties. The most interesting has probably been the desert camouflage scheme of Spitfire Mk Vb

BELOW When Spitfire Vb AB910 was presented to the Flight by Vickers-Armstrong in September 1965, it carried the code letters 'QJ-J' of 92 Squadron. It was the first aircraft of the Flight to wear unit markings. *(Crown Copyright/Air Historical Branch image T-8098)*

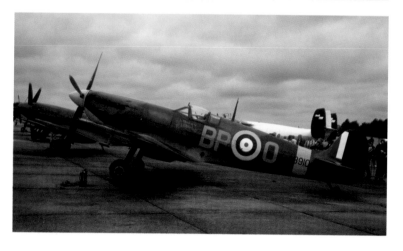

LEFT In 1986, after a major service at the College of Aeronautics, Cranfield, AB910 appeared in 457 Squadron colours as 'BP-O'. It was inscribed with the words 'In memory of R.J. Mitchell'. It was photographed at the Spitfire's 50th anniversary celebrations at Duxford in 1988. *(Keith Wilson)*

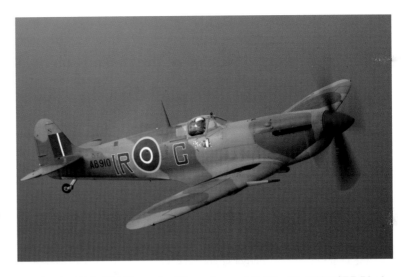

RIGHT The unusual desert colour scheme applied to AB910 includes the initials of the wartime ace Wg Cdr Ian Gleed – 'IR-G' – which replaced the squadron codes, and a Figaro the Cat cartoon appeared below the cockpit on the starboard side. (Crown Copyright/Air Historical Branch)

AB502 along with the inscription and artwork of Figaro the Cat – representing the personal aircraft of Wing Commander Richard Gleed DSO DFC when he led 244 Wing in Tunisia in 1943.

In 2011, AB910 once again took on the colours of 133 (Eagle) Squadron with the code MD-E; colours it wore while serving with the squadron in 1942.

At the end of the 2012 display season, AB910 was flown to ARCo at Duxford on 7 October to undergo a scheduled major maintenance plus and the aircraft is due to emerge towards the end of the 2014 season in a new colour scheme representing a Mk Vb BM327 flown by Flight Lieutenant Tony Cooper of 64 Squadron in 1944.

BM327 was taken on charge by the RAF in March 1942 and was operated by 72, 92 and 66 Squadrons before arriving with 64 Squadron at Deanland on 22 May 1944. An entry in Tony Cooper's logbook for that day records that he took over a new personal aircraft – a clipped-wing Spitfire Mk Vb coded SH-F – which he named after his newborn son Peter John, who had been born on 5 May 1944. The name on the left side of the Spitfire under the port quarter-light was 'Peter John 1'. He completed a flight and cannon test on 22 May. The following day he took part in escort duties with 24 Mitchell aircraft bombing the aerodrome at St Malo. On 24 May he was again engaged in escorting a raid involving 24 Mitchell aircraft – this time against targets at

BELOW In 2007, AB910 acquired the colours of Spitfire Vb EN951/'RF-D' of Sqn Ldr Jan Zumbach when he flew with 303 (Ko ciuszko) Squadron in 1942. It was photographed at Goodwood in September 2008. (Peter R. March)

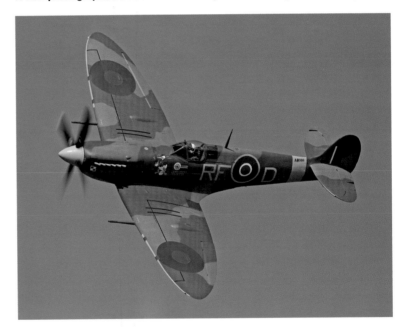

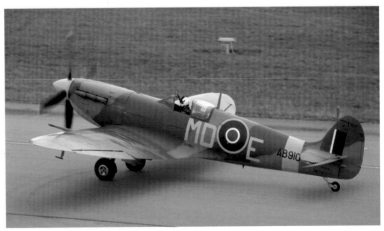

RIGHT From 2011, AB910 flew as 'MD-E' of 133 (Eagle) Squadron when it was serving with the squadron in 1942. In October 2012, AB910 was flown to ARCo, Duxford, where the aircraft is undergoing a major maintenance plus. It is scheduled to emerge in new colours, hopefully in late 2014. (Keith Wilson)

Lille-Vendeville – and his logbook noted 'medium flack – no losses'.

Cooper had said that clipped-wing Spitfires were not suitable for operations in and out of the short runways at the temporary airfield at Deanland, especially at night, and all the 64 Squadron Spitfires were refitted with full-span wingtips.

Flight Lieutenant Cooper's logbook records that he flew BM327 twice on D-Day (6 June 1944) when he flew fighter cover over both *Utah* and *Omaha* beaches. For the first trip, his logbook recalls: 'Patrolling at 05:20 hours. Navy shelling coast defences – first landing made at 06:20 hours. Nearly shot down by Thunderbolt, a Spitfire in front actually was. Another Spit hit by naval shell and blew up.' Against his second trip, his logbook notes: 'Hun bomber attacked invasion fleet – tremendous return fire from ships – the bomber destroyed.'

On the following day (D-Day+1, 7 June 1944) he flew three sorties over the D-Day beaches at *Utah* and *Omaha*, where once again he provided fighter cover. For the first of those sorties, his logbook notes: 'Beach heads established – another airborne Division (gliders) dropped in successfully.' By the second sortie, 'Landings continuing – Naval units bombed inland targets (Nelson, Respite etc.)'. His third sortie was at night and lasted 2 hours and 35 minutes. The logbook recalls: 'Very bad visibility – no attacks – sent 40 miles out to sea on return owing to reciprocal homing vectors. Very shaky experience – brought in eventually with rockets.'

The colour scheme on AB910 will be standard camouflage for the D-Day period, with D-Day/invasion stripes similar to images of other 64 Squadron aircraft.

Spitfire Mk IIa P7350

P7350 is the oldest airworthy Spitfire in the world and the only Spitfire still flying today to have fought in the Battle of Britain. It is believed to be the 14th aircraft of 11,989 built at the Castle Bromwich 'shadow' factory near Birmingham, and entered service in August 1940. It flew with 266 Squadron and 603 (City of Edinburgh) Auxiliary Air Force Squadron. While serving with the latter at Hornchurch, on or around 25 October 1940 it was involved in combat with Messerschmitt Bf109s and force landed. It was soon repaired and flew again on 15 November, just three weeks after the crash landing. Interestingly, repaired bullet holes can still be seen on its port wing. The aircraft subsequently served operationally with 616 and 64 Squadrons. After April 1942, P7350 was relegated to support duties.

Having survived the war, P7350 was sold for scrap in 1948 to Messrs John Dale Ltd for the princely sum of £25. Fortunately, the historical significance of the aircraft was recognised and it was generously donated to the RAF Museum at Colerne. P7350 was restored to flying condition in 1968 so it could appear in many of the flying scenes in the epic film *Battle of Britain*. After filming was completed, the aircraft was generously presented to the BBMF.

Since then, P7350 has sported a variety of colour schemes and codes, all dedicated to the brave individuals who flew during the Battle of Britain, and especially to those who lost their lives doing so.

In 2012, P7350 appeared as EB-G of 41 Squadron to represent a Spitfire Mk Ia, N3162, flown by Battle of Britain ace Pilot Officer

BELOW P7350 was presented to the Flight in November 1968 after appearing in the *Battle of Britain* film. Its first identity was as 266 (Rhodesia) Squadron's 'ZH-T' that had fought during the Battle of Britain. It was photographed at the Biggin Hill Air Fair in May 1972 where it was displaying with Hurricane IIb LF363/ DT-A. (Keith Wilson)

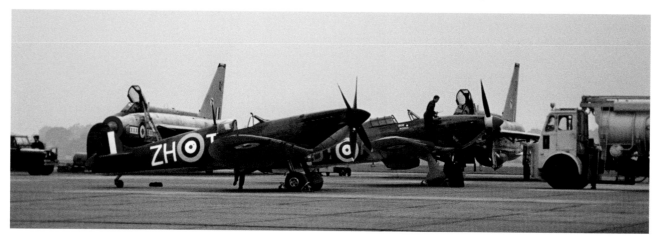

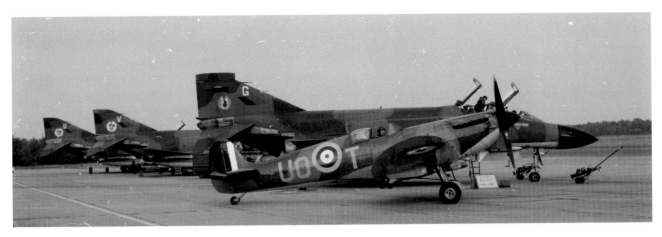

ABOVE Late in 1972, P7350 was painted as 'UO-T', the original 266 Squadron code that it wore in September 1940. It was pictured at Wildenrath on 11 September 1977 with a line of 19 and 92 Squadron Phantom FGR2s including XV484/G and XV489/V behind.
(Crown Copyright/Air Historical Branch image TN-1-7748-24)

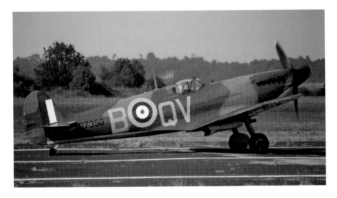

ABOVE In late 1977, P7350 adopted the markings of 19 Squadron's 'QV-B' to represent a Spitfire IIa that operated from September 1940 to October 1941. It was photographed in 1981. *(Peter R. March)*

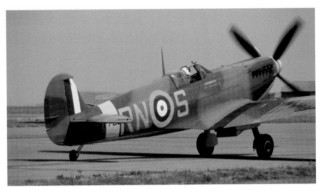

ABOVE P7350 was repainted in 1994 as 'RN-S' of 72 (Basutoland) Squadron to represent Spitfire P7832. Named *Enniskillen*, it also carried the title 'Belfast Telegraph Spitfire Fund' in recognition of the aircraft's donor. It was photographed at Wroughton in June 1994. *(Peter R. March)*

BELOW At the time of writing P7350 flies as 'EB-G' of 41 Squadron, representing a Spitfire Ia (N3162) flown by Plt Off Eric Lock on 5 September 1940, when he achieved four confirmed kills and one probable in a single day. It was photographed at Coningsby on 29 September 2013. *(Keith Wilson)*

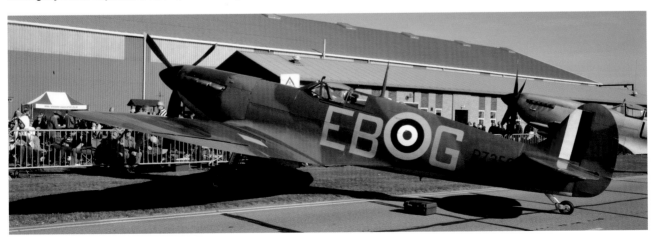

Eric Lock DSO DFC*. On 5 September 1940, Lock achieved four confirmed kills and one probable kill in a single day. By the end of his first week in the busy and dangerous south-east sector, Lock had become a double ace, shooting down ten enemy aircraft. By 20 September 1940, his tally had increased to 15 kills, making him a triple ace – and all in just 16 days of fighting. Lock was awarded the Distinguished Flying Cross on 1 October 1940, and three weeks later, he was awarded a Bar to his DFC.

Modern research credits Eric Lock with 21 kills during the period of the Battle of Britain, plus eight probable kills. This makes him the highest-scoring RAF pilot of the battle by some margin. His final total score, which is officially recognised, was 26½ enemy aircraft destroyed. Sadly, Eric Lock was killed on 3 August 1941 on a fighter sweep over northern France when he apparently spotted some German troops and vehicles on a road near the Pas-de-Calais. He signalled an attack to his wingman and peeled off to strafe the enemy on the ground. He was never seen again. It is most likely that he was brought down by ground fire in a heavily defended area. His aircraft, Spitfire Mk Vb W3257, and his body, have never been found.

V-S Spitfire Mk LFIXe MK356

Spitfire LFIXe MK356 was built at Castle Bromwich in early 1944. In February 1944 it was allocated to B Flight of 443 (Fighter) Squadron of the Royal Canadian Air Force, which had been formed at RAF Digby, Lincolnshire, the previous month. Just seven days after delivery, in March the squadron moved to Hampshire in preparation for the

imminent invasion of France. Operational sorties began in April and continued up to and beyond D-Day in June, with fighter sweeps and bomber escort missions over northern France.

The Spitfire was flown by a number of squadron pilots, but was the primary mount of Flying Officer G.F. Ockenden, who flew the aircraft for around 40 of its total flying hours of probably less than 100. Exact information on the aircraft's activities is not known as some of the squadron's records were lost in France. It is believed that it suffered two belly landings prior to the one that ended its wartime flying career, and was damaged by enemy action on three occasions. It is known that Flying Officer Ockenden claimed a half kill while flying the aircraft against an Me109 on 7 June 1944.

On 14 June 1944, the aircraft took off at 08.00hrs with Flying Officer T.G. Munro at the controls. Unfortunately, a wheel fell off on take-off, but the pilot elected to continue with the mission over France. On his return to Ford in Hampshire – the squadron's base at the time – at 10.25 a belly landing was made. The aircraft was declared Category A, meaning that it should have been repairable on station, but as the squadron moved to a forward base in France the next day, MK356 was assigned to 83 Ground Support Unit at Redhill.

At the end of the war, the maintenance serial 5690M was allocated and the airframe was used in an instructional role at RAF Halton until 1951. It was painted as M5690 and moved to gate-guard duties at RAF Hawkinge for ten years, before moving to Locking in 1962 where it was placed on a pole. It was prepared for a ground role in the film *Battle of Britain*, and after the completion of filming it was put on display in the museum at RAF St Athan.

During the late 1980s, a survey team from RAF Abingdon was tasked with finding a potentially airworthy Spitfire Mark IX and MK356 was chosen. The main spars were badly corroded and replaced with those acquired from SL574 – a Mk XVI with clipped wings of a low-flying variant. In January 1992, the team at St Athan set about the restoration programme, which culminated in MK356's first flight for 53 years on 7 November 1997.

The aircraft was delivered to the BBMF shortly afterwards, painted as 2I-V of 443

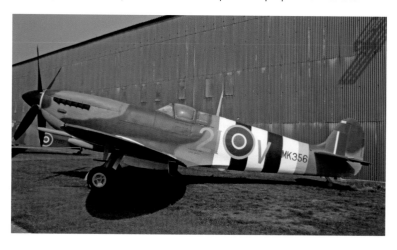

(Fighter) Squadron, Royal Canadian Air Force, along with D-Day invasion stripes to the undersides of its wings and fuselage in recognition of the aircraft's military career.

Over the winter of 2007/08, MK356 underwent a major maintenance and was repainted to represent UF-Q, a 610 (County of London) Squadron aircraft, MJ250, flown by Flight Lieutenant Derek Ibbotson DFC*. It has had its more normal rounded wingtips added and is painted in a silver colour scheme used during late 1944 when the squadron carried out fighter-bomber missions over the Balkans from the bases of Perugia, Loreto and Fano in southern Italy. MJ250 was slightly unusual in that it featured this natural, polished metal, all-silver finish, rather than the normal Desert Air Force sand and brown camouflage scheme worn by most of the squadron's other Spitfires.

At the end of the 2013 season, MK356 was flown to Humberside to undergo a complete repaint at the hands of Clive Denney and his team from Vintage Fabrics. Just a few weeks later, MK356 was collected by OC BBMF Squadron Leader 'Dunc' Mason and flown back to Coningsby. For the next few years MK356 will fly in the colours of a Spitfire Mk IXc with the codes 5J-K of 126 (Persian Gulf) Squadron, to represent aircraft ML214 flown by Squadron Leader Johnny Plagis from July to December 1944.

Wing Commander John Agorastos Plagis DSO DFC*, was a Southern Rhodesian flying ace most noted for his part in the Defence of Malta during 1942. The son of Greek immigrants, he was the war's top-scoring Southern Rhodesian ace, and the highest-scoring ace of Greek origin, with 16 confirmed aerial victories, including 11 over Malta. He held a number of commands towards the end of the war and finished it as one of Southern Rhodesia's most decorated servicemen, having won the Distinguished Service Order and other medals.

Initially turned down by Rhodesian recruiters as he was legally a foreign national, Plagis was accepted by the RAF – officially as a Greek – after Greece joined the Allies in late 1940. Following spells with 65 Squadron and 266 (Rhodesia) Squadron, he flew to Malta in March 1942 as part of Operation Spotter and joined No 249 (Gold Coast) Squadron.

Flying Spitfire Mk Vs, Plagis was part

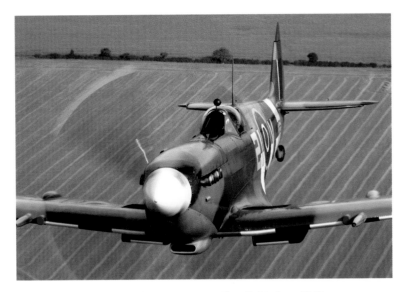

ABOVE MK356 made its first post-restoration flight since 1944 on 7 November 1997 and was delivered to the BBMF at Coningsby a few days later. This dramatic head-on image was shot on a sortie during the Lincolnshire Lancaster Association Members' Day on 26 September 2006. *(Crown Copyright/SAC Scott Lewis)*

of the multinational group of Allied pilots who successfully defended the strategically important island against numerically superior enemy forces over the next few months. Flying with 185 Squadron from early June, he was withdrawn to England in early July where he operated as an instructor for around a year.

BELOW In 2008, MK356 was repainted in this unusual silver paint used during late 1944 when 601 (County of London) Squadron carried out fighter-bomber missions over the Balkans from bases in southern Italy. It is painted to represent MJ250, the aircraft of Flt Lt Desmond 'Ibby' Ibbotson DFC*. It was photographed at Coningsby on 29 September 2013. *(Keith Wilson)*

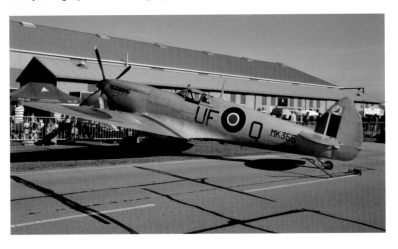

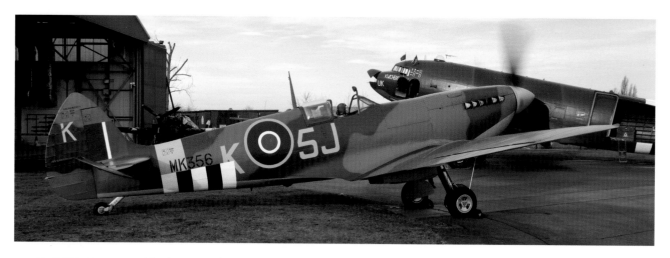

ABOVE In October 2013 MK356 was repainted by Clive Denney of Vintage Fabrics. It emerged as ML214/'5J-K', a Spitfire IXc of 126 (Persian Gulf) Squadron flown by its CO, Sqn Ldr Johnny Plagis, in July 1944. MK356 is seen here at Coningsby on 8 December 2013.
(Keith Wilson)

Plagis returned to action in September 1943 as CO of 64 Squadron, flying Spitfire Mk Vc aircraft over northern France.

He took command of 126 (Persian Gulf) Squadron in June 1944, and led many attacks on German positions during the invasion of France and the campaign that followed. Plagis was shot down over Arnhem during Operation Market Garden but, thankfully, was only lightly wounded. After converting to flying Mustang IIIs, he later commanded a wing based at RAF Bentwaters. Plagis completed the war with the rank of squadron leader. He remained with the RAF after the war, commanding 266 (Rhodesia) Squadron during the occupation of Germany.

The citation for the Distinguished Flying Cross published in the *London Gazette* on 1 May 1942, read: 'Since the beginning of March 1942, this officer has destroyed four and probably destroyed a further three hostile aircraft. With complete indifference to odds against him, he pressed home his attacks with skill and courage. In one day alone, he destroyed two enemy fighters and one bomber. He has set an outstanding example.'

He was later awarded a bar to the DFC and the *London Gazette* of 3 July 1942 reported: 'This officer has displayed exceptional skill and gallantry in combat. He has destroyed at least ten enemy aircraft, two of which he destroyed in one engagement. Undeterred by superior numbers of attacking aircraft, he presses home his attacks with great determination.'

In October 1944, while serving with 64 Squadron, Acting Squadron Leader Plagis was awarded the Distinguished Flying Order. The *London Gazette* of 31 October 1944 reported: 'Since being awarded the Distinguished Flying Cross this officer has participated in very many sorties during which much damage has been inflicted on the enemy. Shipping, radio stations, oil storage tanks, power plants and other installations have been amongst the targets attacked. On one occasion, he led a small formation of aircraft against a much superior force of enemy fighters. In the engagement five enemy aircraft were shot down, two of them by Sqn Ldr Plagis. This officer is a brave and resourceful leader whose example has proved a rare source of inspiration. He has destroyed sixteen hostile aircraft.'

Plagis retired from the RAF as a wing commander in 1948 and returned to Southern Rhodesia, where he was honoured for his wartime contributions by having a street in Salisbury's northern Alexandra Park neighbourhood named after him; he promptly received full citizenship. He set up home at 1 John Plagis Avenue, opened a bottle store bearing his name, and was a director of a number of companies, including Central African Airways in the 1960s. Plagis died in 1974.

V-S Spitfire Mk XVIe TE311

Spitfire Mk LFXVIE TE311 is a low-back, bubble-canopy Mk XVI with 'clipped' wingtips. It was built at Castle Bromwich in 1945 and allocated to the Empire Central Flying School Handling Squadron at Hullavington on 5 October 1945. It served there until placed in storage in February 1946. On 31 May 1951, it was transferred to the 1689 (Ferry Pilot Training) Squadron at Aston Down, Gloucestershire.

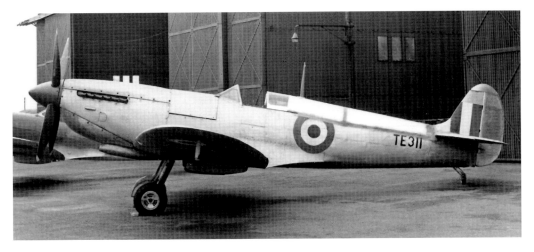

LEFT TE311 was modified at Henlow for taxiing scenes in the *Battle of Britain* film with a 'high-back' rear fuselage and painted into camouflage to represent an early mark Spitfire. When filming was completed, TE311 reverted to its LFXVIe configuration and was displayed on the gate at RAF Benson.
(Peter R. March)

In July 1952, it was moved to Flying Training Command and later allocated to the Ferry Training Unit at Benson in April 1953. That September, it was returned to storage before spending January to February 1954 with No 2 Civilian Anti-Aircraft Co-operation Unit at Langham, Norfolk.

In August 1955, TE311 was placed on gate-guard duties at Tangmere and remained there until 1967, when it was loaned to Spitfire Productions Ltd for use in the film *Battle of Britain*. For filming, the Mk XVI was restored to a taxiable condition and fitted with a modified rear fuselage to represent a much earlier Spitfire Mk 1.

After filming, TE311 was returned to Mk XVI configuration and given back to the RAF to be prepared for gate-guard duties at Benson. It was soon moved to Abingdon where it joined the RAF Exhibition Flight. It subsequently made numerous appearances as a travelling exhibit as part of the RAF's roadshow and recruitment programme.

Along with fellow roadshow Mk XVI exhibit TB382, both aircraft were stored in one of Coningsby's hardened aircraft shelters in October 1999, before being moved into the BBMF hangar in January 2001. Both aircraft were inspected; the skin of TB382 was found to be in very poor condition and the aircraft was dismantled for spares before being struck off charge. TE311 was in much better condition and was retained as a spares recovery programme, but permission was gained to restore the fuselage as a spare. This programme had to be carried out at no expense to the taxpayer so Chief Technician Paul Blackah and Corporal Andy Bale set about the work in their own time, with generous assistance provided by other members of the BBMF. Such was the quality of the restoration that it was later decided to complete a full restoration to flying condition.

After painstaking work, TE311 made its first flight at Coningsby on 19 October 2012, with Squadron Leader Ian 'Smithy' Smith at the controls.

The aircraft is painted in grey/green camouflage to represent Spitfire Mk XVI TB675, a 74 Squadron aircraft, with the code 4D-V, the aircraft flown by Squadron Leader Tony Reeves DFC, the commanding officer of 74 Squadron in 1945.

With its flight test programme now completed, TE311 became a welcome addition to the Flight's strength and appeared at numerous air shows in 2013. Having had three Mk XVIs on strength back in the formative days of the Flight in 1957 – only to see all of them

BELOW TE311 photographed while on gate-guard duties at RAF Benson in July 1971. *(Peter R. March)*

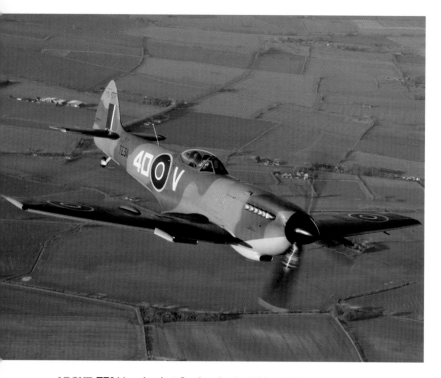

ABOVE TE311 arrived at Coningsby in 1999 and joined the Flight in January 2001. Such was the quality of its rebuild that permission was granted for restoration to full flying condition, with its first flight on 19 October 2012. TE311 is pictured over Lincolnshire on 13 December 2013 flown by Sqn Ldr Duncan Mason. *(Keith Wilson)*

BELOW LF363 was the last airworthy Hurricane in RAF service and became the founding member of the Historic Aircraft Flight in June 1957. It was present at Biggin Hill on 11 July during the ceremony to mark the formation of the Flight. It is seen here with the three ex-THUM Spitfire PR. XIXs. *(Crown Copyright/Air Historical Branch PRB-1-13571)*

subsequently 'lost' for one reason or another – it is even more fitting to see a Mk XVI back on strength at Coningsby.

HURRICANES

Hawker Hurricane IIb LF363

LF363 first flew in January 1944 and is believed to be the very last Hurricane to enter service with the RAF. In 1957, after a major refit at Hawkers, LF363 became one of the founding aircraft of the Historic Aircraft Flight formed at Biggin Hill that year. LF363 took part in the film *Battle of Britain* and from 1969 to 1972 operated in 242 Squadron colours but without a specific code. In 1973 things changed, and LF had the code LE-D added to its 242 Squadron colours, representing the aircraft flown by Group Captain Douglas Bader. Since then, LF has flown in a variety of colours, as well as having almost seven years away from the Flight after its unfortunate accident at Wittering in September 1991.

In 2006, following a major maintenance with ARCo at Duxford over the winter of 2005/06, LF was painted to represent a Hurricane Mk I, P3878 YB-W; the personal aircraft of Flying Officer Harold 'Birdy' Bird-Wilson, a Battle of Britain ace who flew with 17 Squadron.

During the Battle of Britain, 17 Squadron operated from both Tangmere and Debden. Bird-Wilson had previously been involved in a pre-war flying accident in which he was badly burned, becoming one of the earliest aircrew 'guinea pigs' of the famous pioneering plastic surgeon, Sir Archibald McIndoe. After his recovery, Birdy rejoined 17 Squadron in April 1940 and fought continuously through the Battle of France and the Battle of Britain, achieving six confirmed kills, sharing in the destruction of several others and being awarded the DFC. His luck ran out on 24 September 1940, when he became Adolf Galland's 40th victim and had to bale out of a flaming YB-W over the Channel.

Bird-Wilson survived the war and retired as an air vice-marshal, having been awarded the CBE, DSO, DFC and Bar, and the AFC and Bar.

Having last had a major maintenance back in 2008, LF363 was taken into the hangar at Coningsby at the end of the 2013 season to commence a major maintenance plus. These

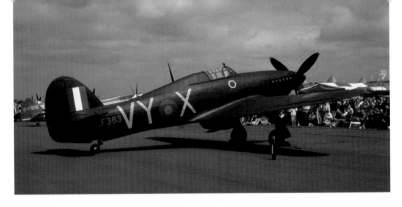

RIGHT LF363 was painted in an all-over black scheme with the 85 Squadron code 'VY-X' applied. This was a night fighter scheme for 85 Squadron aircraft while at Debden during the Battle of Britain. It wore these colours for the 1983–86 seasons and was photographed at Duxford in 1984. *(Keith Wilson)*

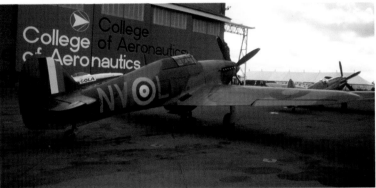

RIGHT In 1987, the 79 Squadron code 'NV-L' was applied. No 79 Squadron was active during the Battle of Britain, based at both Biggin Hill and Hawkinge. LF363 was photographed outside the College of Aeronautics hangar at Cranfield in June 1987. *(Keith Wilson)*

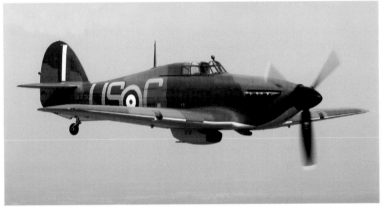

RIGHT LF363 was repainted in 56 Squadron colours as 'US-C' in 1998, colours it carried for seven years. At the time of the photograph (September 2005), 56 Squadron were operating Tornado F3 aircraft at Coningsby. *(via Peter R. March)*

BELOW In October 2005, LF363 went to ARCo at Duxford for a repaint and maintenance. It emerged in March 2006 as 'YB-W', representing a 17 Squadron Hurricane I (P3878) flown by Flg Off Harold 'Birdy' Bird-Wilson. LF363 is seen here near the south-east coast in August 2012. *(Keith Wilson)*

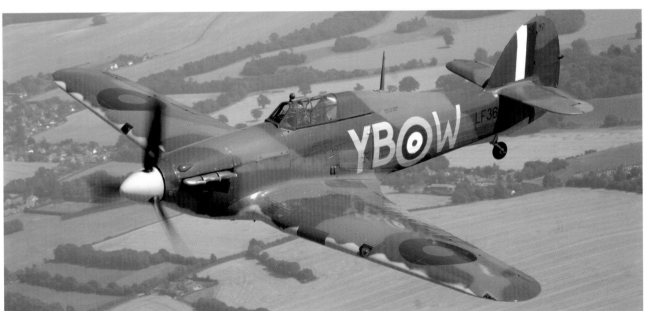

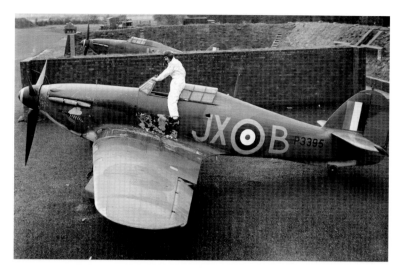

ABOVE After major maintenance at Coningsby in 2013–14, LF363 re-emerged in the colours of Hurricane I (P3395/'JX-B') of 1 Squadron, flown in November 1940 by Flt Lt Arthur Victor 'Taffy' Clowes. This picture shows Clowes climbing into his Hurricane (P3395) in a revetment at Wittering in late October 1940. *(Crown Copyright/Air Historical Branch image CH-17331)*

By March 2014, the aircraft had been re-covered by Vintage Fabrics at Coningsby and, after completion of the work, the aircraft was moved to the paint shop for a repaint. In early April it emerged in the colours of a Hurricane Mk I, P3395, coded JX-B of 1 Squadron, flown by Flight Lieutenant Arthur Victor 'Taffy' Clowes DFC DFM in November 1940.

Clowes had originally joined the RAF as an aircraft apprentice in 1929. Later, he successfully applied as a non-commissioned pilot and after training he joined 1 Squadron at Tangmere in late 1939. During the Battle of Britain he claimed ten enemy kills and one probable kill.

He was commissioned in September 1940 and went on to lead 1 Squadron's first offensive mission of 1941 with two other pilots. He later commanded three other squadrons – 79, 601 and 94 – for the remainder of the war.

P3395 was best known for the wasp emblem painted on the nose of the aircraft during the Battle of Britain, with Clowes adding a new stripe to the body for each enemy aircraft he shot down. His final score was at least 12.

Hawker Hurricane Mk IIc PZ865 – 'Last of the Many!'

PZ865 was the last Hurricane ever built and rolled off the production line at Langley, Buckinghamshire, in the summer of 1944. It carried the inscription 'Last of the Many!' on both sides of its fuselage. Shortly afterwards, the aircraft was purchased from the Air Ministry by Hawkers and temporarily placed in storage before being employed as a company communications and test aircraft. In 1950, wearing the civil registration G-AMAU, it was entered into the King's Cup Air Race by HRH Princess Margaret. Flown by Group Captain Peter Townsend, it finished in second place.

During the 1960s, PZ865 was returned to its

have normally been conducted at third-party facilities, but the bold decision was taken to complete the work on LF363 in-house. The BBMF engineers got to work on LF363 and quickly removed all the fuselage and control surface fabric to allow the inspections to be made. A 'new' zero-houred engine has been installed as the previous one was time-expired.

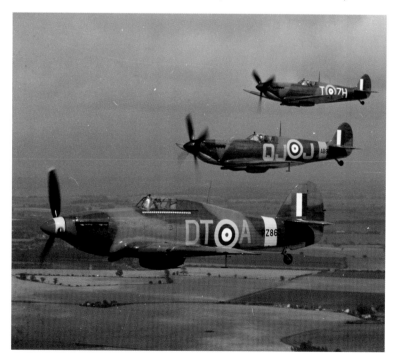

LEFT When PZ865 joined the Flight in March 1972, it initially operated without squadron codes. It was subsequently repainted as V6864/'DT-A' of 257 (Burma) Squadron, the personal aircraft of Sqn Ldr 'Bob' Stanford-Tuck. PZ865 was photographed in July 1972 with Spitfire Vb AB910/'QJ-J' and Spitfire IIa P7350/'ZH-T'. *(Crown Copyright/Air Historical Branch image TN-1-6620-35)*

RIGHT From 1982 to 1988, PZ865 reverted to its post-war colours, with 'The Last of the Many!' inscribed on both sides of its fuselage. It was photographed at Alconbury in 1984. *(Keith Wilson)*

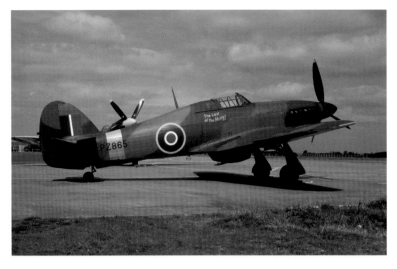

wartime camouflage and used by Hawkers as a communications aircraft as well as a chase plane in the early P1127 trials. It appeared in the film *Battle of Britain* and also made a number of airshow appearances in the hands of the famous fighter pilot and test pilot Bill Bedford. After a complete overhaul by Hawkers, PZ865 was presented to the BBMF at Coltishall in March 1972.

Following a major maintenance over the winter of 2004/05, PZ865 emerged in the colours representing Hurricane IIc BE581 *Night Reaper*, as flown by Czech fighter ace Flight Lieutenant Karel Kuttelwascher with 1(F) Squadron during night intruder operations from Tangmere in 1942. It remained in these

RIGHT In 1998, following a major service, PZ865 emerged in SEAC colours as 'Q' to represent an aircraft of 5 Squadron. On 17 September 2013, when this photograph was taken, 5 Squadron were resident at Coningsby with Typhoon aircraft. *(Crown Copyright/Air Historical Branch image/Cpl Gary Morgan)*

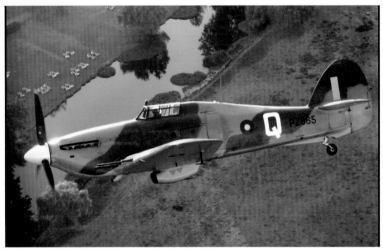

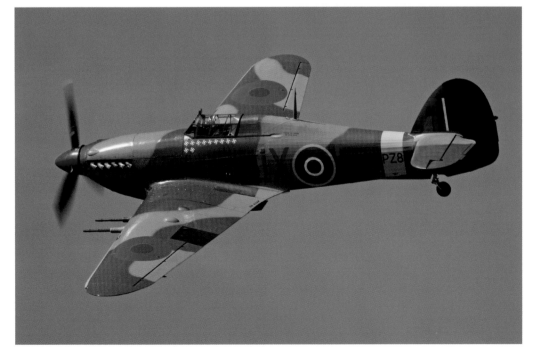

LEFT Following a major winter servicing in 2005, PZ865 was repainted to represent Hurricane IIc, BE581 *Night Reaper*, as flown by the Czech fighter ace Flt Lt Karel Kuttelwascher during night intruder operations from Tangmere in 1942 with number 1(F) Squadron. PZ865 is seen here at Goodwood in September 2008. *(Peter R. March)*

ABOVE At the end of 2010, PZ865 was flown to ARCo at Duxford for a major maintenance. Engineering issues delayed its reappearance for the 2011 season. It finally re-emerged in March 2013 wearing the SEAC colours of Hurricane IIc, HW840/'EG-S', of 34 Squadron.
(Keith Wilson)

colours until the end of the 2010 display season when the aircraft was due another major maintenance and was flown to ARCo at Duxford in November 2010, although work did not commence until the new year.

For the 2013 season, the aircraft emerged from the ARCo hangars in South East Asia Command colours to represent Hurricane IIc HW840 of 34 Squadron, which wore the code EG-S and was the personal aircraft of its young Canadian pilot, Flight Lieutenant James 'Jimmy' Whalen DFC during the ferocious battle for Kohima in 1944.

Whalen joined the RCAF in June 1940, but was destined to fly as a Canadian with RAF units throughout his war. He flew Spitfires with 129 Squadron and while flying a Spitfire Mk Vb during fighter sweeps over Europe in 1941, he shot down three Messerschmitt Bf109s and damaged another. In February 1942, Whalen was posted to 30 Squadron, which was embarking its Hurricane IIbs on the aircraft carrier HMS *Indomitable*, to move them from North Africa to Ceylon. On 6 March 1942, the squadron flew them off the aircraft carrier into Ratmalana, just outside Colombo. On 5 April, a Japanese naval strike force attacked Ceylon with 125 carrier-based aircraft. In the ensuing desperate aerial conflicts, Whalen destroyed three Japanese Naval Val bombers. This made him an ace, with three German and three Japanese kills.

In December 1942, Whalen was transferred to 17 Squadron in India and in August 1943 to 34 Squadron, which was operating Hurricane IIcs in South East Asia Command (SEAC) colours. At the time of the Battle of Kohima, he was a flight commander on the unit. Whalen's personal aircraft with the squadron was HW840, and it was equipped with four 20mm cannons and could carry a 250lb bomb under each wing.

On 18 April 1944, during the Battle of Kohima, 34 Squadron Hurricanes continually attacked the significantly larger Japanese invading forces. One particular bunker was proving especially obstinate and while the squadron had attacked it repeatedly, its best efforts had been repulsed by murderous anti-aircraft fire. Whalen had a plan for knocking it out and was granted 'just one more shot' by his squadron CO. He took off from Dergeon and led six of the squadron's Hurri-bombers towards the target. Despite heavy ground fire, he dropped his bombs from 50ft directly on to the bunker. Unfortunately, Whalen had been hit and his aircraft was seen to roll inverted and crash into the dense jungle. He was killed just five days before his 24th birthday.

LANCASTER

Lancaster centurions

According to various sources, there have been 36 Lancasters that famously recorded 100 operations or more during their wartime careers. All were unceremoniously

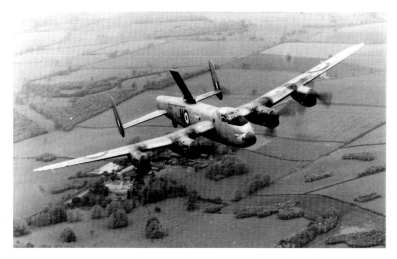

LEFT Lancaster PA474 was transferred to the College of Aeronautics at Cranfield in March 1954, where it is seen on test with an experimental aerofoil section above its fuselage. As a consequence an airworthy Lancaster was saved for the nation. *(Photograph reproduced with permission from Cranfield University)*

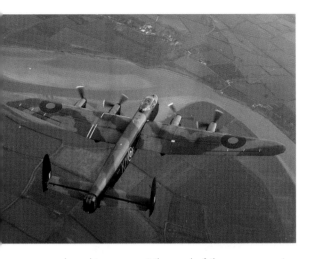

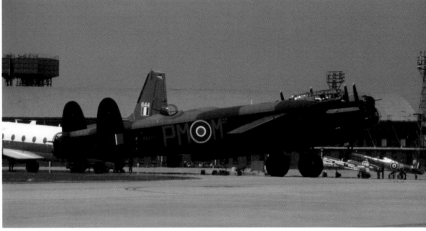

reduced to scrap at the end of the war except for *Q-Queenie/S for Sugar*, which flew 137 operations and was the gate guard at RAF Scampton from 1959 until 1972, when it was placed on permanent display at the RAF Museum, Hendon.

Since its acquisition in November 1973, the BBMF has painted PA474 to represent centurion Lancasters on four occasions. The first scheme was in 1988 when it was painted to represent ED888 while it served with 103 Squadron wearing the PM-M^2 code. During its service life with 103 and 576 Squadrons, ED888 completed 140 missions – more than any other Lancaster.

Next, after servicing at St Athan over the winter of 1993/94, PA474 flew as 9 Squadron's W4964 with the code WS-J and the distinctive Johnnie Walker nose art and *Still Going Strong* titling. W4964 also completed more than 100 wartime operations.

Following another scheduled maintenance at

ABOVE LEFT In 1964 PA474 was ferried to Henlow for storage before joining the new RAF Museum. However, the CO of 44 (Rhodesia) Squadron asked to have the aircraft transferred into its care at Waddington where it was repainted as Sqn Ldr John Nettleton VC's 'KM-B'. It was photographed on 12 April 1975. *(Crown Copyright/Air Historical Branch image TN-1-7237-48)*

ABOVE PA474 underwent a major servicing at West Country Air Services at Exeter. When the aircraft returned to Coningsby in March 1988 it wore the markings of ED888/'PM-M^2' of 103 Squadron. During its time with 103 and 576 Squadrons, ED888 completed 140 missions. PA474 is shown here at an Armed Forces Day at Mildenhall. *(Keith Wilson)*

St Athan over the winter of 1999/2000, PA474 returned to Coningsby painted as *Mickey the Moocher*, representing a 61 Squadron Lancaster III, EE176, with the code letters QR-M. Records differ, but EE176 is thought to have flown between 115 and 128 operations. The Disney cartoon character Mickey Mouse was painted on to the port forward fuselage of the aircraft.

LEFT In 2000, after another scheduled maintenance at St Athan, PA474 returned to Coningsby painted as *Mickey the Moocher*, representing a 61 Squadron Lancaster III, EE176, with the code letters 'QR-M'. This photograph was taken in May 2004. *(Crown Copyright/Air Historical Branch image BBMF-072)*

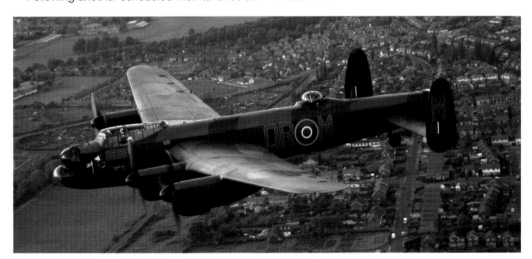

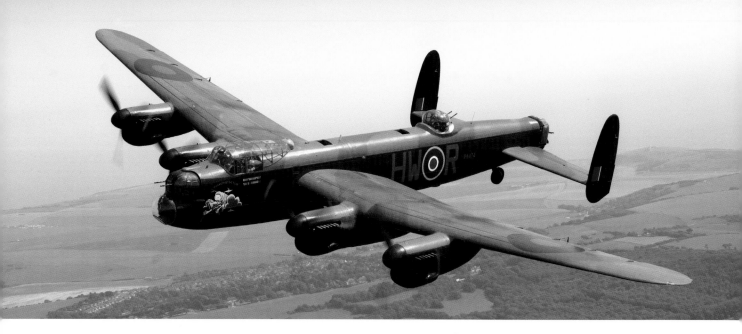

ABOVE During the winter of 2006/07, PA474 underwent a major maintenance with Air Atlantique where it was repainted as Lancaster III, EE139, *Phantom of the Ruhr*, which flew with 100 and 550 Squadrons. PA474 displayed the 100 Squadron code 'HW-R' on the port side and that of 550 Squadron ('BQ-B') to starboard. It was photographed in August 2012. *(Keith Wilson)*

Finally, in 2007, PA474 was painted to represent Lancaster III, EE139, *Phantom of the Ruhr*, which operated with both 100 and 550 Squadrons. On the port side of the aircraft it carries the 100 Squadron code HW-R, with which the aircraft flew 30 operations. The starboard side of PA474 carries the 550 Squadron code BQ-B. The *Phantom of the Ruhr* artwork was not applied to the port side

– instead it retains its 'City of Lincoln' wording and coat of arms. After being transferred from 100 to 550 Squadron, EE139 flew a further 91 operations, ending with a career total of 121.

The famous 617 Squadron was formed at RAF Scampton on 23 March 1943 and 2013 saw its 70th anniversary. In September 2012, PA474 was repainted at Eastern Airways, Humberside, to represent a Lancaster B1, DV385, of 617 Squadron, with the code KC-A applied. DV385 was delivered to 617 Squadron at Coningsby in November 1943. It was later fitted with bulged bomb-bay doors to accommodate the 12,000lb Tallboy bomb. It dropped a total of 15 Tallboys as well as 5 12,000lb HC blast bombs. The nose art of PA474 is now *Thumper Mk III* and features the cartoon rabbit from the 1942 Walt Disney animated feature film *Bambi* holding a foaming pint of beer. It is similar to that carried on DV385 during its time with 617 Squadron. While DV385 did not finish with a career total of 100 missions, the aircraft did fly 50 operations, of which 37 were known to be successful.

PA474 now carries 35 yellow bomb symbols on the port side forward fuselage, just below the cockpit. The bomb symbols include one marked with a 'D' denoting its involvement

LEFT In August 2012, PA474 was repainted by Clive Denney of Vintage Fabrics. It emerged as Lancaster BI, DV385, *Thumper Mk III*, of 617 Squadron, which was later modified to carry the 12,000lb Tallboy bomb. PA474 was photographed displaying at the BBC Children in Need Air Show at Little Gransden, 25 August 2013. *(Oliver Wilson)*

in Operation Taxable, the spoof D-Day chaff mission on 5/6 June 1944. There is another with a swastika denoting a kill against a German fighter. On 7 November 1944, DV385 was delivered to Coningsby for modification, which included the fitting of long-range fuel tanks to increase the capacity to 2,406 gallons, and the removal of its mid-upper turret to reduce the weight of the aircraft. On 29 October and 12 November 1944, DV385 took part in the two long-range raids against the battleship *Tirpitz* in Tromsø Fjord. Flying Officer John Castagnola and his crew claimed a direct hit against the ship on the second raid.

The mid-upper turret was then refitted for its remaining operations, one of which was flown in March 1945. With the cessation of hostilities, the aircraft was cut up for scrap.

DAKOTA

Douglas Dakota III ZA947

Dakota ZA947 was built as a C-47A Skytrain, 42-24338, at Long Beach, California, and delivered to the USAAF on 7 September 1943. Just a week later it was transferred to the Royal Canadian Air Force (RCAF) as 661. It served mainly in Canada, but in 1965 was used by the RCAF in Europe and was an occasional visitor to the UK. It was declared surplus to requirements in 1969.

The Royal Aircraft Establishment (RAE) then purchased the aircraft, which was allocated the British military serial number KG661 (probably on the assumption that as it had carried the RCAF serial 661, it was the same aircraft). Initially, it was repainted in an RAF Transport Command style white and grey colour scheme, but later received the RAE's classic red, white and blue 'raspberry ripple' paintwork. It was used by the RAE at West Freugh in Scotland where it flew a variety of tasks and trials, including dropping test sonobuoys off the Scottish coast.

For some time there was a doubt about the aircraft's allotted serial number and it transpired that KG661 was a Dakota III that had crashed on 13 December 1944. In 1979, the aircraft was allocated the new serial number ZA947. In 1992, the Defence Research Agency – the successor to the RAE – declared the Dakota surplus to requirements and offered it for sale.

ZA947 was adopted by RAF Strike Command and transferred to the BBMF in March 1993. Initially, it was delivered to Coningsby in the raspberry ripple colour scheme but was soon overhauled by Air Atlantique at Coventry and then repainted at RAF Marham to represent KG374, a 271 Squadron aircraft with the code YS-DM. This was the aircraft of Flight Lieutenant David Lord VC DFC. Lord was posthumously awarded the VC for his actions

BELOW While operating with the Royal Aircraft Establishment, ZA947 was painted in the RAE's traditional red, white and blue 'raspberry ripple' colours. It was a welcome exhibit at the RIAT at Fairford in July 1985, carrying special stickers to its fuselage, wings and tail in celebration of the Dakota's 50 years in service.
(Keith Wilson)

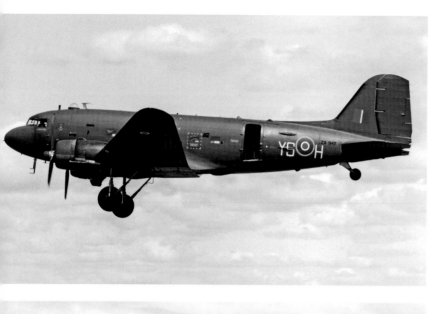

on 19 September 1944 in Operation Market Garden, the airborne assault on Arnhem.

At the end of the 1997 season, ZA947 went back to Air Atlantique for a winter service. It emerged wearing new colours, this time given the markings of YS-H of 77 Squadron, to represent an aircraft that participated in the Berlin Airlift of 1948/49. To celebrate the 50th anniversary of the Berlin Airlift, ZA947 made two trips to Berlin and another to Hamburg.

At the beginning of 2003, ZA947 was moved to Sprayavia at Norwich airport for a major repaint. Firstly, all the old paint was removed – some 14 layers being found in places – before a thorough inspection of the surfaces

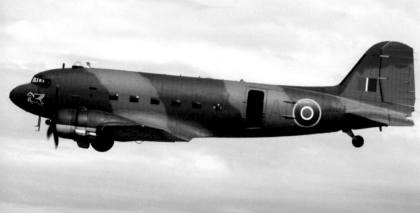

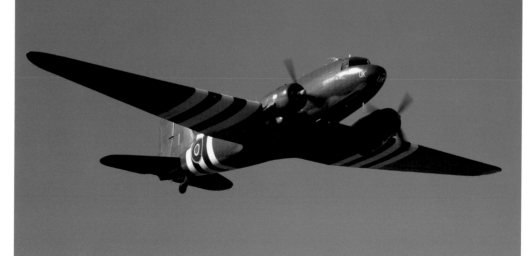

was carried out to examine for corrosion. Thankfully, ZA947 was in good condition and the aircraft was resprayed before returning to Coningsby on 17 February 2003. It was now painted in dark green/dark earth camouflage topsides and 'sky' undersides, along with the markings of 267 Squadron to represent an aircraft serving in Italy during 1944. Red codes AI appeared on the fuselage sides along with the squadron's prominent Pegasus emblems on both sides of the forward fuselage. No 267 (Pegasus) Squadron flew in the transport, trooping and resupply roles in the Middle East and Mediterranean theatres during 1943 and 1944. In 1994, authentic para seats had been fitted to ZA947, returning the cabin to its original wartime specification in time for the D-Day 50th anniversary para-drop made over Ranville on 5 June 1994.

In 2011, ZA947 was once again repainted. Now it represents Dakota FZ692 of 233 Squadron, from around the D-Day period in 1944. This aircraft, named *Kwicherbichen* by the crew, was involved in para-dropping operations on the eve of D-Day and subsequently in resupply and casualty evacuation missions into and out of forward airfields in the combat areas. The female nurses who escorted the casualties on these flights became known as 'the Flying Nightingales'. By the end of 1944, 1,092

stretcher cases and 467 sitting wounded had been evacuated to England by the 233 Squadron Dakotas. ZA947 remained in these colours for the 2014 display season.

CHIPMUNK

De Havilland Canada DHC1 Chipmunk WK518

The Flight's brace of de Havilland Canada Chipmunk T10s are the very last of the classic trainer in service within the RAF. WK518 had been delivered to the RAF in January 1952, going to the RAF College (RAFC) at Cranwell. Later in its career, WK518 served with the University Air Squadrons for Liverpool, Manchester, Cambridge, Hull, Leeds and London, as well as the Station Flight at Cottesmore and 1 Air Experience Flight (AEF) at Manston. From here the aircraft was delivered to the Flight in April 1983, still wearing the then standard red and white training colours.

It was then repainted back into RAF silver and blue colours and operated in this scheme for a number of years before both of the Flight's Chipmunks were repainted in the RAF all-over black training colour scheme in 2000, with the code K added to the tail of WK518.

In 2012, WK518 was again repainted, this time into its former Hull University Air Squadron silver and orange Day-Glo colours with the

LEFT The two Chipmunks operated by the BBMF are the last of the type in RAF service; they are also the least seen of the Flight's aircraft. They are used all year round primarily for the conversion and continuation training of BBMF pilots on tailwheel aircraft.
(Keith Wilson)

code letter C on the tail. It currently retains these colours.

De Havilland Canada DHC1 Chipmunk WG486

WG486 was also delivered to the RAF in January 1952 and has had a varied career to date. It served with 5 Basic Flying Training School, 9 Refresher Flying School and 2 Flying Training School, before being used by the army with 651 and 657 Squadrons. It later went on to serve with the Royal Air Force College Cranwell, Initial Training School at South Cerney and Church Fenton, Bristol University Air Squadron and 3 Air Experience Flight.

WG486 was engaged on operational service in 1958 with 114 Squadron in Nicosia, Cyprus, during Operation Thwart, where the Chipmunks were used to carry out anti-terrorist operations from December 1958 to March 1959. Their tasks included observation and liaison, flying with army officers in the rear seat.

In 1987, WG486 moved to Germany to operate as part of the Gatow Station Flight in Berlin, which was then surrounded by Soviet Bloc territory. From the 1950s, Chipmunks were used to carry out air coverage of the 20-mile radius of territory around Berlin, where there were large concentrations of Soviet and East German forces. Operating at low level and with hand-held cameras, the Chipmunk crews often returned to base with valuable images of the Warsaw Pact forces' equipment and troop movements. Occasionally, hostile action would occur – on at least one occasion a Chipmunk returned to Gatow with a bullet hole in the airframe.

When the Berlin Wall came down, Gatow closed. The aircraft spent a year at Laarbruch before being delivered to the Flight in 1995, still wearing the all-grey colour scheme used at Gatow. WG486 remained in these colours until both of the Flight's Chipmunks were repainted in the RAF all-over black training colour scheme in 2000, with the identification letter G added to the tail of WG486. At the time of going to press, this was the colour scheme being worn by WG486.

BELOW In June 1995 the Flight gained a second Chipmunk. T10, WG486, had previously served in an 'operational' role during the Cold War at RAF Gatow, Berlin. Seen here wearing the all-over black RAF training scheme, she was photographed over Lincolnshire on 13 December 2012, flown by Wg Cdr Paul Godfrey. *(Keith Wilson)*

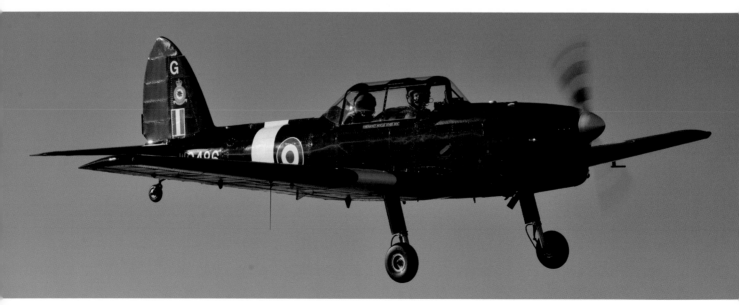

Aircraft no longer current with the BBMF

V-S Spitfire PR Mk XIX PS853

1957 Officially joined the Historic Aircraft Flight on 11 July 1957. Shortly afterwards it was repainted in green/grey camouflage.

1958–64 In April 1958, it was announced that the Flight was to lose PS853 to RAF West Raynham, to be struck off charge. In the event, it ended up as the station gate guard on 1 May 1958. It later moved to the Central Fighter Establishment in April 1962 and was made airworthy before returning to the Flight in April 1964.

1972 Repainted as ZP-A of 72 Squadron.

1973–9 Returned to its photo-reconnaissance all-over blue colours without code letters.

1980–89 PS853 was grounded as the Griffon 61 engine had reached the end of its life. It was later fitted with a Griffon 58 (adapted from an Avro Shackleton installation).

1989–90 Took to the air again in July 1989 repainted in the all-over blue photo-reconnaissance colours representing a 16 Squadron aircraft of the 2nd Tactical Air Force.

1991–94 Identification letter C added to the fuselage, along with black and white stripes to the undersides of the wings and fuselage.

1995 Aircraft was sold at auction at Sotheby's and raised £410,000. The deal fell through and PS853 was then sold to Euan English who moved the aircraft to North Weald on 17 February 1995. Sadly, English was killed in an aircraft accident shortly afterwards. PS853 was purchased by Rolls-Royce and is currently operated by its Heritage Flight.

V-S Spitfire Mk XVI TE330

1957–58 TE330 acquired by the Flight after use at the 1957 Royal Tournament. After being made airworthy, it carried out the Flight's first Battle of Britain flypast over London on 15 September 1957.

1958 TE330 was presented to the United States Air Force Academy during a ceremony at RAF Odiham on 2 July 1958. It later transferred to the USAF Museum at Dayton, Ohio. Following a series of subsequent moves, the aircraft was being restored to flying condition in New Zealand, but was then acquired by the China Aviation Museum, Datangshan, and is now exhibited in the museum marked as HT-B.

V-S Spitfire Mk XVI TE476

1957–59 Following a landing accident at Martlesham Heath on 10 September 1959, TE476 was retired from the Flight and placed on the gate at Neatishead in January 1960.

1968 It was modified to appear as a Spitfire Mk 1 and used in a non-flying capacity during the filming of *Battle of Britain*.

1969 When filming was complete, the aircraft was restored to its original low-back Mk XVI status and was placed on gate-guard duties at RAF Northolt. TE476 now forms part of the Kermit Weeks' Fantasy of Flight collection at Polk City, Florida. It was made airworthy for several years and named *Winston Churchill*.

V-S Spitfire Mk XVI SL574

1957–59 SL574 was made airworthy and operated with the Flight until it crash-landed on to the OXO cricket ground on 20 September 1959, following its Battle of Britain flypast over London. After being repaired, it was transferred to gate-guard duties at HQ Fighter Command, Bentley Priory, in November 1961. In 1987, SL574 was sent to St Athan for preparation for display at the San Diego Air and Space Museum.

V-S Spitfire Mk XVIe TB382

1999–2001 Arrived at Coningsby and stored in a hardened aircraft shelter.

2001–02 Joined the Flight in January 2001 and was retained as a spares recovery programme, but the skin was found to be in poor condition and it was dismantled for spares and struck off charge.

De Havilland Devon C1 VP981

1985–96 Arrived at Coningsby in April 1985, painted in standard grey and white colours. Shortly after arriving, 'Battle of Britain Memorial Flight' titles were added to the upper fuselage. It was later painted in a striking metallic silver and blue colour scheme.

1997 After the arrival of Dakota ZA947, VP981 was withdrawn from service and stored at Coningsby.

1998 Aircraft sold to Air Atlantique at Coventry and registered as G-DHDV.

De Havilland Canada Chipmunk T10 WP855

1975–83 Joined the Flight in 1975, painted in the standard RAF red and white training colours. When WK518 arrived at Coningsby in April 1983, WP855 was transferred to No 1 Air Experience Flight (AEF) at Manston.

Chapter Three

The people

When the Historic Aircraft Flight came into being at RAF Biggin Hill in July 1957 it possessed three Spitfire PR XIXs and a single Hurricane IIb LF363. What it didn't have was people! No commanding officer; no engineers, as all maintenance had to be completed voluntarily; and no budget. What it did have was loads of enthusiasm and dedication to see the Flight succeed.

OPPOSITE The Battle of Britain Memorial Flight's team of engineers for 2013, photographed at Coningsby just before the start of the Lincolnshire Lancaster Association Day on 29 September 2013. *(Crown Copyright/Sergeant Peter George MA ABIPP)*

The initial driving force to create the Flight had been provided by RAF Biggin Hill's then Station Commander, Wing Commander Peter Thompson. He had seen the need for a Historic Aircraft Flight to maintain and operate the last remaining piston-engine fighters from the Battle of Britain era so they could be flown over London during the annual commemorative flypasts. To get the fledgling Flight off the ground, he needed the considerable help of Squadron Leader E.H. Sowden, then the OC Engineering at Biggin Hill. Sowden, along with a small but significant number of engineers, volunteered to get the aircraft into the air and keep them airworthy.

Today, things have changed. The BBMF is a formal unit within Number 1 Group of the RAF, with a permanent headquarters at RAF Coningsby. It has a full-time commanding officer and a small but dedicated and highly skilled team of engineers. That said, the budget is very limited when compared with, say, the Red Arrows – particularly when one considers the sheer number of displays and fly-bys undertaken every season by the Flight's small fleet of aircraft and volunteer aircrew.

For the 2014 season, the Flight has a permanent staff of just 30 engineers, providing a ratio of 2.5 engineers to each aircraft. That may appear high, but compares particularly well with a Tornado Squadron that used to operate with a 10:1 ratio, as well as the current Typhoon units where the ratio is more usually around 11.5:1.

Aside from the BBMF's ultra-experienced Operations Officer, Flight Lieutenant Anthony 'Parky' Parkinson MBE, the OC BBMF is the only other full-time and dedicated member of the aircrew serving on the Flight. All other pilots, navigators, air engineers and air loadmasters volunteer their services, effectively giving up three weekends out of every four from May through to September in order to fly and display the iconic aircraft. Currently, the flightcrew come from five stations – Brize Norton, Coningsby, Cranwell, Marham and Waddington – and are currently flying an interesting variety of aircraft including the Typhoon, Tornado, Hercules, King Air, Sentinel, Tristar, Tutor and Voyager in their primary role.

Officer Commanding BBMF/fighter leader

The current OC BBMF is Squadron Leader Duncan 'Dunc' Mason who assumed command of the Flight in October 2012. As OC BBMF, 'Dunc' is responsible for overseeing all the operations, administration and engineering functions as well as the overall management and planning of the display programme. 'Dunc' joined the BBMF for the 2008 display season and then served with the Flight for three years as OC Designate from 2009 through to September 2012, while the Flight was under the command of Squadron Leader Ian Smith. Interestingly, both men had served in the Red Arrows, as had Anthony Parkinson, although not at the same time

'Dunc' joined the Royal Air Force in 1991 and after flying training completed tours on 3(F) Squadron at Laarbruch on the Harrier GR7 and 19(F) Squadron at Valley as a flying and weapons instructor on the Hawk T1. In 2002, 'Dunc' was selected to join the Red Arrows, where he flew as Red 3 (2003), Red 5 (2004) and Red 9 (2005). He was then posted back to the Harrier as a flight commander on 1(F) Squadron and later to 800 Naval Air Squadron, both based at Cottesmore. He undertook operations in the Balkans and Afghanistan while serving with the Harrier.

OC BBMF designate

The system of succession for the post of OC BBMF, which is expected to continue into the future, ensures that each new 'boss' gains the necessary experience before taking command of the Flight for a three-year tour.

Squadron Leader Andy 'Milli' Millikin was OC Requirements Capture at the Typhoon Missions Support Centre at RAF Coningsby when he saw the transfer signal for the post of OC BBMF Designate advertised. At the time, Millikin was just 38 years old and considering leaving the RAF; incredibly he had already reached pensionable age. In order to apply for the post, he requested an extension to his service period so he could attend the interviews and undertake the associated flight tests. He recalled, 'It was a bit like doing X-Factor.' Initially, the post is a

four-year volunteer posting with the Flight as a secondary RAF duty, followed by the three-year tenure that the post offers. 'Milli' was offered the post and gladly accepted it.

Currently, he is in a non-flying post at Coningsby but continues to fly the Typhoon across the Coningsby squadrons on both front-line squadrons as well as the OCU, as they are relatively short of people. 'Milli' just loves flying. He is a regular volunteer for the QRAs (Quick Readiness Alerts) when two Typhoon jets are on constant standby to deal with any possible problem or incursion.

Interestingly, 'Milli' is a third-generation aviator, his grandfather, father and brother all having been RAF pilots. His father, Paul Millikin, is remembered as the Vulcan display pilot.

Milli started flying at just 16 at the Marham Gliding Club. He then flew Chipmunk aircraft with the Combined Cadet Force (CCF) at RAF Newton and was awarded a flying scholarship. He completed this at Cambridge airport on Cessna 152 aircraft. He went to Southampton University and while here joined the Southampton University Air Squadron (UAS) in 1992 where he flew the Bulldog aircraft.

He joined the RAF in 1995 and completed his basic flying training at Barkstone Heath on the Slingsby Firefly. Next stop was the Tucano at RAF Linton-on-Ouse before going to RAF Valley on the Hawk T1 to complete his flying training. Once completed, a spell on the Jaguar OCU at RAF Lossiemouth was followed by his first posting – to fly the Jaguar on 6 Squadron at RAF Coltishall. While here he flew on operations over Iraq to protect the Kurds from Saddam Hussein. Next stop was the qualified weapons instructor course at 16 Squadron, which he completed in 2003 before joining 54 Squadron as a qualified instructor (QI). While on the Jaguar Force, 'Milli' accrued more than 1,200 hours on type and flew on exercises in America, Oman, Denmark, France, Gibraltar, Cyprus, Norway and Canada.

In 2005, he joined the Typhoon Force with a posting to 17(R) Squadron where he was involved in the operational development of the aircraft, specialising in its capability as strike platform. In 2008, he was promoted and became a flight commander on 29(R) Squadron – the Typhoon OCU. Here he became a qualified pilot instructor, teaching both RAF and

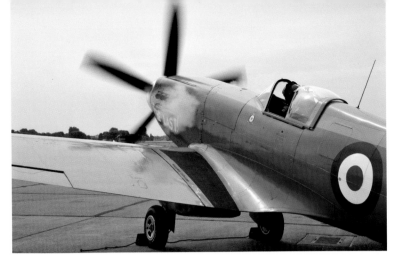

Saudi pilots to fly the Typhoon. He also ran the first Typhoon qualified weapons instructor course. Because of his considerable strike experience he was detached to 11 Squadron in the summer of 2011 flying the Typhoon on operations over Libya.

The highlight of his career to date has been intercepting a couple of Russian Bears on a QRA in April 2011 and his three-month deployment to Italy where he operated over Libya and saw real action.

ABOVE Sqn Ldr Andy Millikin fires up the Griffon engine on Spitfire PR XIX, PS915, before departing Coningsby on 24 July for a series of flypasts. *(Keith Wilson)*

Bomber leader

For the 2013 season, the role of bomber leader was filled by Squadron Leader 'Russ' Russell – one of the Flight's navigators.

Russell had joined the RAF on a university cadetship in 1977 and entered Cranwell in 1980. Following navigator training at Finningley, he was posted to 360 Squadron at Wyton on the Canberra for two years before moving on to the Phantom Force where he served on 29 and 56 Squadrons, both at Wattisham.

Next it was back to Finningley as an instructor initially on the venerable Jet Provost but later on the Hawk T1 undertaking nav training as well as ground school. On promotion to squadron leader, 'Russ' took over the Bulldog and Tucano Squadron (BATS), which he commanded for two years.

A ground tour as the JMC (joint maritime course) exercise planner followed, before converting to the Tornado F3 in 1998. He did tours on XI Squadron for two years at Leeming followed by five years on 5 Squadron at Coningsby. These were followed by a detachment as OC 1435 Flight in the Falkland Islands.

In 2004 he qualified as a low-level navigation instructor on 55(R) Squadron flying the

ABOVE When PA474 completed its display at the Lincolnshire Lancaster Association Day at Coningsby on 29 September 2013, it was a bittersweet moment for Sqn Ldr 'Russ' Russell (second from left) who had made his last flight in the Lancaster. After 36 years in the RAF (7 on the Flight) Russ was about to retire. *(Oliver Wilson)*

BELOW All of the BBMF fighter and bomber crews gathered around the Lancaster for a farewell picture with Sqn Ldr Russ Russell and Wg Cdr Paul Godfrey at the end of the display at Coningsby on 29 September 2013. *(Keith Wilson)*

Dominie, teaching low-level navigation using radar to find the targets. In 2007, he moved to the CFS Exam Wing where he taught and tested instructors on all aspects of rear-seat navigation. Finally, in 2011, he moved to the Air Warfare Centre at Cranwell as part of the AE (Air Electronics) Warfare Training Team.

By the autumn of 2013 he had accumulated well over 4,500 hours as a navigator during his RAF career. In his own words, 'a reasonable pedigree'!

Russ remembers writing his letter to the OC Operations at Coningsby to apply for one of the volunteer navigator posts with the BBMF. He was soon accepted and in 2007 joined the Flight. He trained to navigate both the Dakota and Lancaster and served for four years before leaving the Flight in 2010. 'I had a great time,' he said, adding: 'it was a real privilege to serve with the BBMF but I felt it only fair that someone else should get a chance to do what I had.'

Within five months of leaving, he was asked to return; he rejoined the Flight during the middle of the 2011 season. In 2012, he was called upon to undertake the role of navigation leader and for the 2013 season stepped up into the role of bomber leader. He remembers the 2013 season well. 'It was a busy time and with maintenance issues on both the Dakota and Lancaster we were late. Obtaining the PDA was a close-run thing.' As for the working-up process, 'that is complex to say the least! Engineering and pilot work-up is a balancing act; throw in the British weather and it has the potential to become difficult.'

All the fighter pilots on the Flight are based at Coningsby. For the volunteer bomber crews, they are based all over the UK, so getting a complete crew to Coningsby to complete a flight test, say, takes some serious organising. The BBMF navigators are based at Marham, Brize Norton and Cranwell. If the weather decides not to cooperate, the trip is rolled over to the next available day. Is the crew still free then? It can become a logistical nightmare!

Russ believes that 'once the aircraft [Dakota or Lancaster] is flying, the better it behaves'. During the 2013 season, the Lancaster flew 104 hours. Russ recalls, 'The weather was good and the aircraft very reliable. The engineers did a great job!' According to Russ 'there is great camaraderie within the bomber crews and although there is some banter with the fighter pilots, we get on really well'.

When Russ stepped out of the Lancaster on to the ramp at Coningsby during the Lincolnshire Lancaster Association Day on 29 September 2013, it was for the very last time. Meeting him at the bottom of the steps was OC BBMF Squadron Leader 'Dunc' Mason with a customary bottle of champagne. All his colleagues soon joined in the congratulations before photographs were taken to record the event.

Since then, Russ has left the Royal Air Force. In mid-October 2013 he joined the Cobham Group as a line EWO (electronics warfare officer) in Falcon 20 aircraft. All of his extensive Phantom and Tornado F3 back-seat experience

is being put to very good use in training the next generation of RAF pilots and EWOs. After 36 years in the RAF, Russ has had a great time. 'I did 5,500 hours in the RAF and I finished with a flight in the Lancaster. It couldn't be better!'

Bomber leader 2014

At the end of the 2013 season, when 'Russ' Russell left the Flight, OC BBMF 'Dunc' Mason approached Flight Lieutenant Tim Dunlop and asked him who he thought should take on the role. 'I gave all of the other names and was asked why I shouldn't do it. I was given the task of bomber leader for 2014 and I see it as a great honour.'

Flight Lieutenant Tim 'Twigs' Dunlop had always wanted to join the RAF. He was working as a compressor design engineer with Rolls-Royce when he applied in April 1997. After graduation from Cranwell, he did his elementary flying training at Barkston Heath on the Firefly and moved straight to multi-engine training with 45(R) Squadron on the Jetstream. Tim was awarded his wings at the end of the Jetstream course in April 2000. He did a short hold on the Dominie while keeping up his flying as a second pilot.

Next stop was the Hercules OCU at Lyneham, where he trained on the Hercules K model. He then completed 18 months with 30 Squadron, flying the Hercules on airline-style cargo hauling all around the world. While on 30 Squadron, he converted to the newer J model of the Hercules.

He was transferred to 70 Squadron, another unit operating the new J model, but here they specialised in tactical work – low-level insertion, stores-dropping as well as para-dropping. While here he deployed to Iraq and the Democratic Republic of Congo as well as Afghanistan where he met his wife-to-be – an RAF intelligence officer.

In 2004, Tim was awarded his captaincy and completed the Captains OCU, followed shortly by the tactical work-up as captain. In this role he completed tours in Afghanistan and the Falklands, but also travelled globally.

At the end of 2006, he became a QFI (qualified flying instructor) at Cranwell and spent 12 months on the Grob Tutor, completing the CFS course along with the Elementary QFI course. With his instructor tickets in hand, he was transferred to 45(R) Squadron in 2007 to instruct multi-engine pilots on the King Air.

'I had always yearned to fly the Lancaster,' Tim explained. 'One of my instructors at 45(R) was a Lancaster pilot with the Flight and my boss on Grob Tutors at Cranwell was none other than Squadron Leader Ian Smith, who

went on to become OC BBMF from 2010 to 2012. It was "Smithy" who suggested I should apply to join the Flight, which I did in 2008.'

Tim was accepted and joined the Flight in 2009, initially as a Dakota captain and then as a Lancaster co-pilot halfway through the season. 'I remember my first PDA really well, completed under the then bomber leader, Squadron Leader Stu Reid'. Tim continued with the Flight in 2010 and during the 2011 season was worked up to be a Lancaster captain by the then Bomber Leader Flight Lieutenant Ernie Taylor, which he achieved by the end of the season.

For the PDA at the beginning of the 2012 season Tim was a captain on the Lancaster. 'I was very nervous,' he recalls. 'The AOC 1 Group, AVM Stu Atha, was in the control tower watching my every move. Your heart is always in your mouth when landing the Lancaster.' During the 2013 season he completed 50 hours on the Lancaster and qualified as an 'Experienced' Lancaster captain. Towards the end of 2013, he became an instructor on the Dakota (after having been checked by a multi-engine examiner from the CFS) and at the end of the year he also became an instructor on the Lancaster.

With the BBMF role being purely voluntary, Tim continued instructing with 45(R) Squadron, achieving a variety of training qualifications. In 2013, he joined the Standards Unit. This is where instructors are taught how to instruct as well as 'standardised' on the level of training expected from them. This role, in turn, is regularly examined by the CFS to ensure that everything remains in order.

Tim's appointment as bomber leader for 2014 was announced at the end of the 2013 season. As one season ends, the next one is just beginning and Tim was straight into the planning stage for 2014 and reviewing all standard operating procedures (SOPs), as well as seeing what could be learned from the 2013 season. He also had to plan and write up the work-up programme for the following season. The team is only permitted a maximum of 40 hours per season for training and working-up on the Dakota and just 7 hours on the Lancaster. During this very limited time, all the pilots and other trades must complete their training and currency before achieving their PDA qualification from the AOC. For the past few years this role has been undertaken by AOC 1 Group, Air Vice-Marshal Stu Atha, but for 2014 it was undertaken by Gary Waterfall – a former member of the Red Arrows.

As bomber leader, Tim Dunlop is expected to work and coordinate the roles of the trade leaders. For the 2014 season, the trade leaders on the BBMF bomber team are:

Bomber leader	Flight Lieutenant Tim 'Twigs' Dunlop
Navigator leader	Squadron Leader Tony 'Sluf' Beresford
Flight engineer leader	MACR Archie Moffat
Air loadmaster leader	Flight Sergeant Paul Simmons

Tim has to ensure that each member of the team has appropriate time for their work-up, but he also recognises that it is imperative to 'maximise what little time we have on the aircraft; but we don't want two skills being taught at the same time'. The first aircraft to get its initial flight test was the Dakota ZA947, which was flown during the first week of March. Tim Dunlop was pilot on the flight, with 'Sluf' Beresford in the right-hand seat as navigator and MACR Craig Bampton at the back as the air loadmaster. At the end of the flight, Tim declared 'the aircraft was suitable for the season having had all engineering requirements met'. After the initial flight test there is a short time for Tim and 'Sluf' to complete some currency work on the Dakota. In addition, 'Sluf' is also receiving some extra training from an old Hercules navigator, so he will become a nav expert on para-dropping with the Dakota. He will then be able to screen and teach other navigators the additional skills required for CARP (calculated air release point). During 2014 the 70th anniversary of D-Day and the landings at Arnhem are to be commemorated, with the BBMF Dakota being in great demand to appear and participate in celebratory parachute drops.

On 17 March 2014, a ground training day on the Dakota had been organised. All Dakota flightcrew were expected to attend, along with a new Dakota pilot. After this, everyone had to qualify on type. To achieve this, they got one trip involving some circuits and simulated emergencies. Once this had been completed,

Tim Dunlop and Roger Nicholls worked up the new pilot as a Dakota captain. The first trip involved circuits and some upper air work, including stalling the aircraft. The second trip involved asymmetric flying on just one engine, the second engine powered back to idle to simulate the emergency before the third flight, which was the new captain's first solo on type.

Next item on the schedule was the display work-ups for all the crew. For the new Dakota captain, he got the opportunity to perform up to six display practices on just one trip while Tim Dunlop and Roger Nicholls 'critiqued' the performances from the Coningsby control tower while also being in radio contact with the Dakota. 'Sluf' Beresford worked up the navigators (there is one new navigator for 2014); while Paul Simmons worked up the loadmasters (with two new loadmasters on the team for 2014).

It was hoped that the Lancaster would be available to flight test at the beginning of April and this proved to be the case as Tim Dunlop was accompanied by Roger Nicholls (co-pilot) on the flight deck, along with 'Sluf' Beresford (navigator) and Martin Blythe (flight engineer). Once the flight test had been successfully completed and the aircraft declared 'suitable', the training and work-up on the Lancaster began. With only 7 flight hours available for the flight test and work-up in order to protect the annual hours on the Lancaster, it all has to be carefully planned and executed.

For the 2014 season, Flight Lieutenant Loz Rushmere needed to be worked up as a Lancaster captain, and both Seb Davey and Leon Creese needed co-pilot re-currency checks. Once this was completed, Tim Dunlop, Roger Nicholls and Loz Rushmere all worked up their Lancaster display sequence which, incidentally, is much the same as that for 2013. The PDA examination for the 2014 season was scheduled for 24 April, not giving much time for the bomber crews to achieve their objectives. Tim Dunlop concluded: 'With perfect weather, the aircraft behaving and the engineers getting everything done, nothing can possibly go wrong – can it?'

The year 2014 is the last season on the Flight for Flight Lieutenant Loz Rushmere, so a new Lancaster captain is required for future seasons. Both Seb Davey and Leon Creese must be in pole position to take on the task.

How long does Tim Dunlop plan to stay on the Flight? 'Maybe another two to three years as bomber leader. To ensure the longevity of the Flight it is important that others are able to join and fly the aircraft, so the length of time one stays with the Flight is a careful balancing act.'

In addition to Flight Lieutenant Tim 'Twigs' Dunlop, the other bomber pilots for the 2014 display season are Flight Lieutenant Roger Nicholls, Flight Lieutenant Loz Rushmere, Flight Lieutenant Leon Creese and Flight Lieutenant Seb Davey.

ABOVE The BBMF bomber pilots for the 2014 season. From left to right: Flt Lt Seb Davey, Flt Lt Loz Rushmere, Flt Lt Roger Nicholls, Flt Lt Tim Dunlop and Flt Lt Leon Creese. *(Crown Copyright/ Corporal Paul Robertshaw)*

Navigator leader 2014

The navigator leader for 2014 is Squadron Leader Tony 'Sluf' Beresford. Tony joined the RAF in 1987, directly from school. Following navigator training, he was posted to the Tornado F3 where he completed tours with 43 Squadron, 56 Squadron, 21 Gruppo (Italian Air Force) and 25 Squadron, which included operational tours Gulf War 1, Operation Southern Watch and the Falklands.

LEFT The navigation leader for 2014 is Sqn Ldr Tony 'Sluf' Beresford. *(Crown Copyright/Corporal Paul Robertshaw)*

In 2001 he was posted to the Navigator Training Unit (NTU) on 100 Squadron as a fast jet instructor. During this tour he was promoted to squadron leader and took over command of the NTU. In 2005 Tony was posted to NATO's deployable Combined Air Operations Centre at Ramstein Air Force Base in Germany. Following this ground tour he returned to the UK as OC Maritime and Fast Jet Training for Weapons Systems Officers on the Dominie aircraft based at RAF Cranwell. He is currently employed as OC Rear Crew Examiner on the Central Flying School.

In addition to Squadron Leader Beresford, the other navigators on the Flight for the 2014 display season are Flight Lieutenant Ady Hargreaves, Flight Lieutenant 'Big Jim' Furness and Flight Lieutenant Rich Gibby.

Flight engineer leader 2014

Leader of the small team of flight engineers for the 2014 display season is MACR Archie Moffat. Archie joined the RAF in 1986

and after air engineer training was the last air engineer to be trained on the Shackleton AEW Mk 2. He served eight years with 8 Squadron and accumulated 1,200 hours on the venerable type.

In 1991, Archie was posted to RAF Lyneham on the Hercules fleet. He served a total of 20 years in transport support roles with 70 Squadron, 47 Squadron (SF) along with the Operational Evaluation Unit, amassing a total of 4,000 hours on type. Posted to RAF Brize Norton in 2011, he is now operating on the RAF TriStar aircraft with 216 Squadron in the air transport role. To date, Archie has flown around 5,900 hours in RAF service.

Archie joined the BBMF in 2012 and 2014 will be his third year with the Flight. In addition to Archie Moffat, the other flight engineers on the Flight for the 2014 display season are MACR Gavin 'Gav' Ovenden, Flight Sergeant Martin Blythe, Flight Sergeant Mark Fellowes and Sergeant Jon Crisp.

Air loadmaster leader 2014

Flight Sergeant Paul Simmons is in his third season as leader of the air loadmasters. Paul joined the RAF in 1990, and after training he was posted to 230 Squadron at RAF Aldergrove on the Puma Mk 1. In 1994 he transferred to 18 Squadron at RAF Laarbruch on the Chinook Mk 2, the last helicopter squadron to be based in Germany. Having served on both 18 and 27 Squadrons at RAF Odiham, he completed tours in the Falkland Islands, Bosnia and Kosovo. In 2000 he became a qualified helicopter crewman instructor (QHCI) on the Chinook Operational Conversion Flight (OCF), before becoming the crewman instructor. In 2004 he was posted to 216 Squadron at RAF Brize Norton operating the TriStar, before moving to become head of fixed-wing flying training at 55(R) Squadron at RAF Cranwell, instructing weapon system operators on the Dominie.

This is Paul's fifth season with BBMF. In addition to Paul Simmons, the other air loadmasters on the Flight for the 2014 display season are Squadron Leader Pete Appleby, MACR Craig Bampton, MACR Brian Handforth and MACR Dino Hempleman.

Station Commander

It has become a tradition that both the station commander and the OC Operations Wing 'volunteer' to fly the fighter aircraft on the Flight during the duration of their stay at the base. In 2012, when Group Captain 'Sammy' Sampson was promoted and moved on, he was succeeded as station commander at Coningsby by Group Captain 'Johnny' Stringer.

Stringer joined the RAF in September 1990, having been sponsored by the service through both sixth form and university. After initial officer training and flying training, he was posted to the Jaguar Force from 1993 to 2003, serving as a squadron pilot, qualified weapons instructor and flight commander/squadron XO (executive officer). A number of staff tours followed within the Ministry of Defence before he returned to flying duties. From September 2007 to October 2009, Johnny commanded 29 Squadron, the Typhoon Operational Conversion Unit located at Coningsby. Promoted on posting, Stringer served another series of staff tours where he was actively involved in Operations Herrick and Ellamy where his responsibilities included air and aviation, targeting, ISR, joint fires, ROE, influence/IO, cyber, geo, and the TLAM and Storm Shadow cruise missile planning/support agencies. His deployed operational experience includes Operation Deny Flight over the former Yugoslavia from 1994 to 1998 and Operation Resolute (North) over the Iraqi northern no-fly zone from 1999 to 2002.

The 2014 season is Johnny's second with the Flight.

OC Operations Wing

Wing Commander Justin 'Hells' Helliwell took command of Operations Wing, RAF Coningsby, in June 2013. He succeeded Wing Commander Paul 'Godders' Godfrey, although 'Godders' continued to fly with the BBMF until the end of the 2013 display season.

Initially, Justin got the flying bug while attending Liverpool University. Here he flew the Bulldog with the Liverpool University Air Squadron. He entered the RAF as a university cadet, joining full-time on graduation in 1992. After completing training on the Tucano and Hawk, he was posted to 5(AC) Squadron on the Tornado F3 at RAF Coningsby

in 1998. While with 5(AC) he served on operations over Iraq and also on homeland defence of the UK and Falkland Islands.

In 2002, 'Hells' graduated as a qualified weapons instructor and was posted to the Operational Test & Evaluation Squadron where he helped introduce the Advanced Medium-Range Air to Air Missile (AMRAAM), firing the first in-service missile in 2004. He transferred to 17(R) Squadron testing the Typhoon in 2005 before being selected to serve on exchange in Las Vegas with the United States Air Force's largest fighter squadron, the 422nd Test and Evaluation Squadron. While in the US he served as an assistant director of operations and flew all blocks of the F-16 while also participating in the test of A-10, F-15 and F-22.

Upon his return to the UK, he undertook a ground tour at MoD Abbey Wood, being promoted mid-tour to wing commander. After completing a Typhoon conversion with 29(R) Squadron, he took command of Operations Wing in June 2013.

The 2014 display season is his first with the Flight.

ABOVE The BBMF air loadmasters for 2014. From left to right: MACR Dino Hempleman, Flight Sergeant Paul Simmons and Sqn Ldr Pete Appleby. (Crown Copyright/Sergeant Peter George MA ABIPP)

LEFT Wg Cdr Paul Godfrey sits on the wing of Spitfire P7350, having just been presented with a bottle of champagne by Sqn Ldr Duncan Mason. (Keith Wilson)

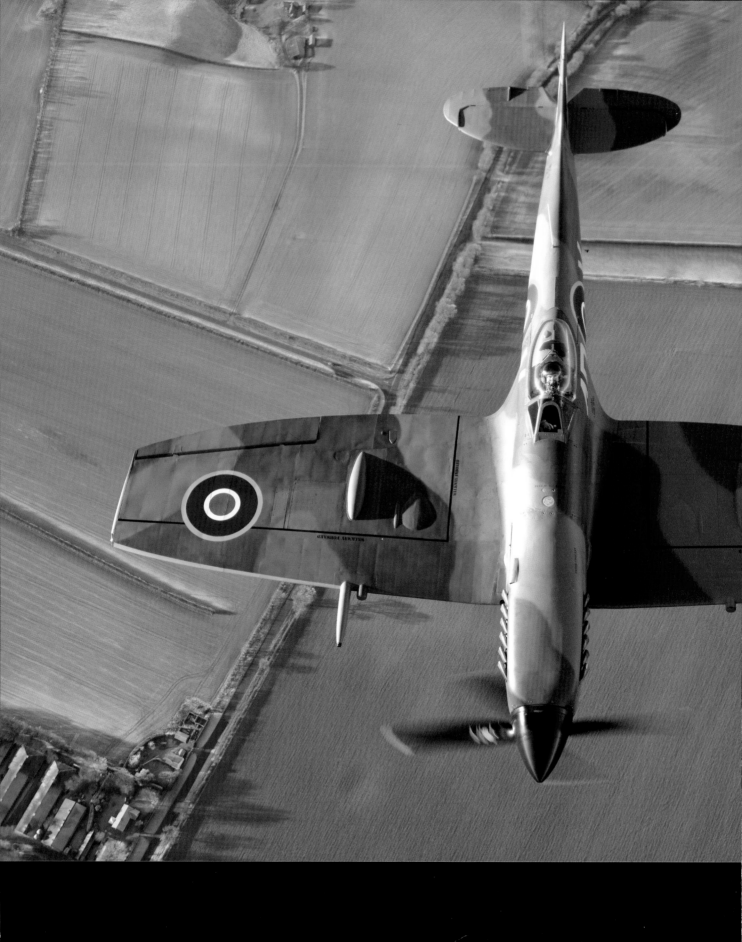

Chapter Four

The programme

If you were to ask people to describe their experience of the Battle of Britain Memorial Flight, they would probably describe the wonderful sound 'those engines' make. There is, after all, something very special about the sound of a Rolls-Royce Merlin engine. When the Lancaster flies, there are four in formation and the sound is special. Add a Spitfire and a Hurricane to the formation and you have a six-piece orchestra – then the sound is quite spectacular!

OPPOSITE A very welcome new addition to the BBMF for the 2013 display season was Spitfire XVIe, TE311. After a twelve-year restoration with the Flight, led by Chief Technician Paul Blackah and Corporal Andy Bale, TE311 made its first flight at Coningsby on 19 October 2012. It was flown for a special photographic sortie over Lincolnshire on 13 December 2013. *(Keith Wilson)*

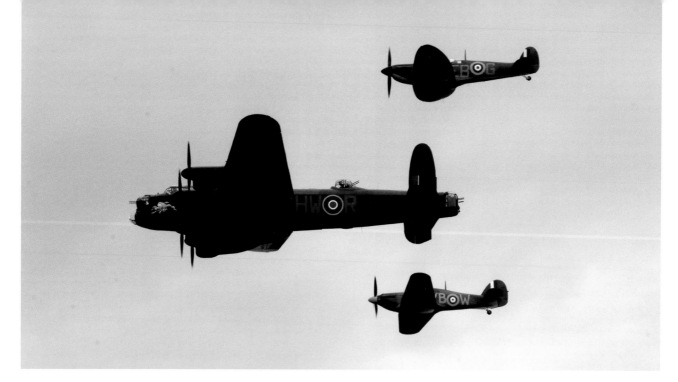

ABOVE The BBMF signature three-ship formation of Lancaster, Spitfire and Hurricane performing the opening sequence at the Public Display Authority (PDA) inspection at Coningsby on 24 April 2012 in front of AOC 1 Group, Air Vice-Marshal Stuart Atha. *(Keith Wilson)*

RIGHT Occasionally, the three-ship formation is reduced to a two-ship formation. Serviceability issues with the Hurricane, as well as the very high demand for Spitfire displays elsewhere in the country, meant that at the Farnborough Air Show on 14 July 2012, the Lancaster was accompanied by just a single Spitfire – LF IXe, MK356/'UF-Q' – flown by Sqn Ldr Andy 'Milli' Millikin. *(Keith Wilson)*

The BBMF represents something very special. It is nostalgic. A living memory. A constant reminder of the debt of gratitude we owe to so many who paid the ultimate sacrifice.

People who watch the BBMF are not all aviation enthusiasts. Many have not even been to an air show. They may get confused between a Spitfire and a Hurricane, but most people will recognise the Lancaster when it flies over – invariably stopping what they are doing and gazing skyward, while the hairs on the back of their necks stand on end. The BBMF has that kind of effect on people.

During the course of a display season, most enthusiasts will get to see the hallmark Lancaster, Hurricane and Spitfire display that commences with a perfect three-ship formation entry from crowd rear, before making one or two formation passes along the crowd line. The three aircraft then separate and hold to the rear of the audience, while an individual aircraft or pair entertains the audience. The Lancaster has its own special display routine (more later), which includes passes with undercarriage down as well as another with the huge bomb-bay doors open.

Fighter displays

On occasion the fighters perform individually along centre stage, with each aircraft being flown to its best effect. At other times, the Spitfire and Hurricane may perform together, sometimes

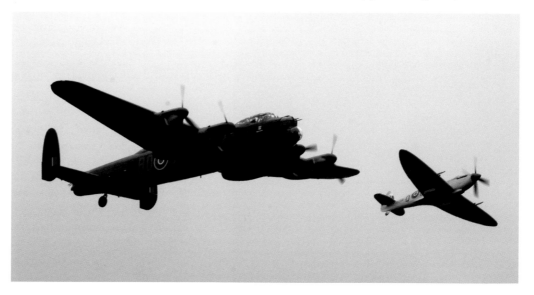

RIGHT The Lancaster has a better range than both the Hurricane and Spitfire. As a consequence, the aircraft depart at different times, often making a series of flypasts en route to a display location, and then join up for the traditional three-ship Lancaster, Hurricane and Spitfire routine. Hurricane IIb, LF363, and Spitfire PR XIX, PS915, were photographed over Kent in August 2012. *(Keith Wilson)*

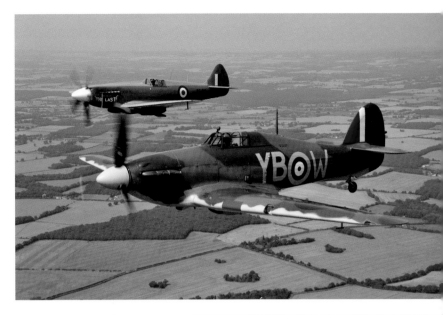

BELOW Another relatively new routine is the 'Synchro Pair', usually performed by a Hurricane and Spitfire but occasionally by a pair of Spitfires. At the Flying Legends show at Duxford in July 2013 it was the turn of recently painted Hurricane IIc (PZ865) and Spitfire XVIe (TE311) to entertain the large crowd. *(Keith Wilson)*

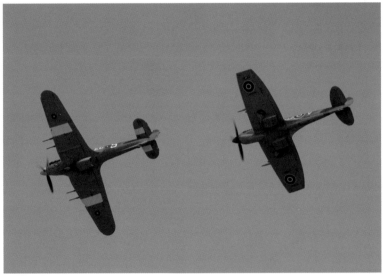

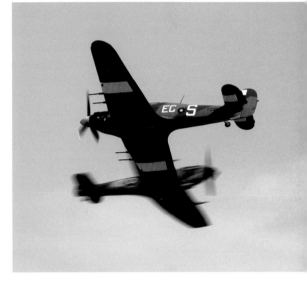

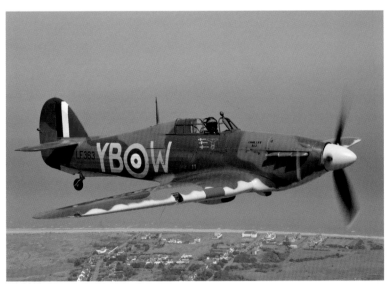

ABOVE In addition to the 'Tail Chases' (see above opposite) the 'Synchro Pair' routine also features a series of opposition manoeuvres, much like those the Red Arrows or other jet display teams use to good effect. Once again, it provides the photographers in the audience with great photo opportunities although you have to be sharp to press the shutter at the correct moment! *(Keith Wilson)*

LEFT Hurricane IIb, LF363, can hold claim to be the longest continuously serving aircraft in the Flight. It was photographed over the Kent coast in August 2012 with the then OC BBMF, Sqn Ldr Ian Smith at the controls. *(Keith Wilson)*

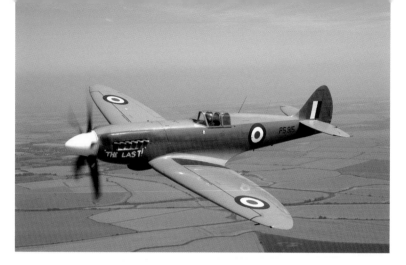

ABOVE Photographed on the same day (see page 65) was Spitfire PR XIX, PS915, with the current (2014) OC BBMF, Sqn Ldr Duncan Mason at the controls. PS915 flies in a colour scheme representing PS888, an 81 Squadron aircraft based at Seletar, Singapore. PS888 carried out the last operational sortie flown by an RAF Spitfire on 1 April 1954. *(Keith Wilson)*

photo opportunities, as well as the sound of two Rolls-Royce Merlin engines in tandem. During the 'Synchro Pair', the two fighter aircraft perform a series of opposition manoeuvres, including some crossovers, similar to the Red Arrows and other jet formation display teams.

For the 2013 season, a new routine was introduced in which the Hurricane performed a series of formation fly-bys with the Lancaster to emphasise its escort fighter duties, and allowing the Spitfire to take centre stage and fly an aerobatic routine.

Bomber displays

Generally, the Lancaster leads the formation before separating and holding to the rear of the crowd, allowing the fighters to do their stuff. With the fighter routines complete, the Lancaster takes centre stage with a series of solo passes (see display diagram below), showing off its cavernous bomb bay and undercarriage retraction sequence. Many of these manoeuvres are completed with the

displaying a 'Tail Chase' routine or the excellent 'Synchro Pair'. The 'Tail Chase' is exactly what it says – the Hurricane and Spitfire, or a pair of Spitfires, following each other around the sky, one behind the other. It provides the spectators with some great formation flying and excellent

BELOW Lancaster display profile.

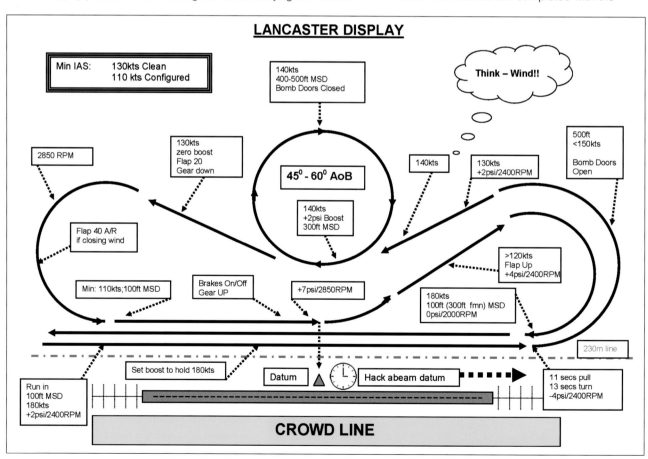

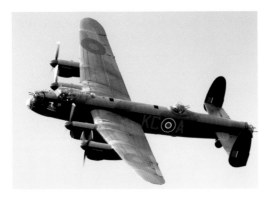

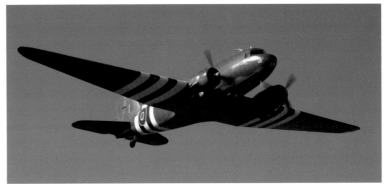

bomber in front of the crowd, while completing a series of 360° turns and remaining in view of the audience throughout. Once these have been completed, the three aircraft rejoin and close with a couple more formation passes before moving off to their next display.

Very occasionally, if the Lancaster is not available for serviceability reasons, the Dakota takes its place in the three-ship routine. However, as the Dakota is considerably slower than the fighters, it is rare for the three aircraft to be seen in transit together. Generally, the fighters and the Dakota would make their own way to a location before joining up to display.

The Dakota has become a major display item in its own right and in 2014 – with the 70th anniversary of D-Day and Arnhem being celebrated – ZA947 is in great demand. Its display routine is very similar to that of the Lancaster (see display diagram on p. 66), performing a series of passes and 360° turns right in front of the audience.

Thankfully, the Lancaster's excellent reliability record ensures that the Dakota, Hurricane and Spitfire display is rarely seen.

The Lancaster display routine

S quadron Leader Stuart Reid joined the BBMF in 1999 and was bomber leader with the Flight from 2001 until his retirement in 2010. Stuart has flown around 430 hours on the Lancaster and 290 in the Dakota. Stuart Reid explains what it feels like to fly the BBMF Lancaster display routine:

Having taken careful note of the wind and its anticipated effect on the display and with the preceding fighter clearing the display arena,

ABOVE LEFT At the BBC Children in Need Airshow at Little Gransden in August 2013, Lancaster PA474 put on a spirited display, making the most of the dual-axis crowd line to display the aircraft beautifully. *(Oliver Wilson)*

ABOVE June 2014 marked the 70th anniversary of D-Day. The BBMF Dakota, resplendent in its D-Day stripes, was in great demand at air shows and events across Europe. *(Oliver Wilson)*

the Lancaster completes the arrival pass at around 180 knots IAS (indicated airspeed, as displayed on the airspeed indicator) and the optimum height for the display. The optimum height is usually, but not necessarily, as low as the minimum authorised height, as the aim is to present the spectators with the best views and, above all, sound of the aircraft – you've heard of 'The Three Tenors', well we present 'The Four Merlins'! At all stages of the display, the pilot is not only flying the current manoeuvre, but anticipating and planning the next.

The stopwatch is started as the aircraft passes abeam the display datum. At this stage it is imperative to maintain the wings in

BELOW The Lancaster had also appeared at the Little Gransden show in August 2012. It made one of its passes along the crowd line with the bomb-bay doors open. *(Oliver Wilson)*

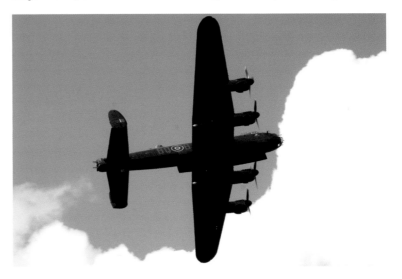

level attitude while tracking towards a visual reference point on the horizon or maintaining a heading. After 9 seconds have elapsed, the pilot raises the nose, maintaining wings level, so that the aircraft achieves a vector away from the ground. At 11 seconds, the pilot calls for 'minus four' (inches boost) and commences a climbing turn away from the crowd line in a gentle wing-over, through around 225° to slow the aircraft in readiness for the display, achieve the minimum authorised altitude to manoeuvre safely and vector back towards the datum.

As the speed reduces below 150 knots IAS the pilot calls 'bomb doors open' and the navigator operates the bomb door lever at the rear left side of the pilot's seat – the pilot will observe the 'Bomb Doors (Not Closed)' light illuminate on the lower left side of his instrument panel. The Lancaster is now inbound to the datum with the IAS reducing to around 135 knots and the bomb doors open. As the speed reduces to a round 140 knots, the pilot calls for either 'zero' or 'plus 2' (inches boost) to maintain the speed above 130 knots.

Approaching the display line from the front right, the pilot commences a level turn away from the crowd line to expose the underside of the aircraft, and the open bomb bay, to the crowd as the aircraft passes abeam the datum. As the datum is passed, the aircraft enters a 360° turn away from the crowd and the pilot calls for either 'plus 2' or 'plus 4' (inches boost) to enable a gentle climb to commence, while maintaining the turn and aiming to be on the opposite side of the 'circle' on a reciprocal heading when passing abeam the datum. The climb is commenced to minimise the alarming visual illusion of the aircraft losing height in the level turn as it would appear to the crowd if flown level. On achieving the reciprocal heading abeam the datum the pilot calls 'bomb doors closed' and either 'zero' or 'minus 2' (inches boost) while maintaining the turn and commencing a gentle descent as the aircraft turns back towards the display line to pass abeam the datum again.

While maintaining the turn, the pilot adjusts the rate of descent to be in a level turn away from the crowd abeam the datum and while passing through a heading parallel to the display line. As the aircraft levels, the pilot calls for 'zero boost' to maintain speed. Passing abeam the datum,

the pilot continues the turn away for a further 45° before rolling out and calling 'below 150, flaps 20'. The co-pilot moves the flap selector valve to the down position until the flaps have travelled through 20°, before returning the selector to the neutral position. With the flaps set at 20°, the pilot calls 'below 150, gear down', and the flight engineer selects the undercarriage lever to the down position. The pilot confirms that he has two 'reds' on his undercarriage position indicator and both the navigator and flight engineer confirm visually that the undercarriage is lowering.

As the gear travels, the pilot commences a gentle descending turn back towards the datum for the 'gear down pass'. The gear takes approximately 20 seconds to lower, after which time the pilot confirms he has 'two greens' on his undercarriage position indicator and calls for '2,850rpm'. The co-pilot adjusts the rpm levers to increase the engines from 2,400rpm to 2,850rpm. The descending turn is continued to establish the aircraft on a heading parallel to the display line and inbound to the datum at the minimum authorised height. If necessary, the pilot may call for 'flap 40', to compensate for wind.

At this stage, the fighters, which have been holding 'crowd rear', turn to chase the Lancaster along the display line to effect a join into close formation when the Lancaster has 'cleaned up' and is accelerating away from the crowd line.

Approaching the datum with the flaps at 20° (or 40°) and the undercarriage down, the pilot operates the control column wheel-brake lever and applies the wheel brakes for 1 second before calling 'gear up'. The flight engineer unlatches the undercarriage lever locking bolt, selects the lever to the up position and the pilot confirms that the two greens on his undercarriage position indicator change to two reds. At the datum, the pilot calls for 'plus 7' (inches boost) and, with the co-pilot advancing the throttles to increase engine power, commences a climbing turn away from the crowd line. In my opinion this is the best part of the display. The four Merlins are on 'full song', and I defy any aviation enthusiast not to be moved by the sight and sound of the Lancaster climbing away at full power – soul-stirring stuff!

With the power set at 7 inches boost and 2,850rpm, the pilot may call for 'flaps 20' if the aircraft is configured at 40°, which the co-pilot

selects. As the speed increases through 120 knots, the pilot calls for 'flaps up', at which point the co-pilot operates the flap selector valve to retract the flaps. Because the flaps retract quite quickly (in around 2 seconds), the pilot has to be ready for a significant pitch trim change as the flaps move. As soon as the flaps indicate up, the pilot calls for 'plus 4 (inches boost), 24 (2,400rpm)' and, with the aircraft accelerating, awaits both undercarriage 'reds' to go out. The co-pilot, who is working quite hard at this stage, first reduces the throttles to their approximate setting, before reducing the engine rpms to their approximate setting and then refines both the throttle and rpm settings with the power under control. It must be appreciated that, although the engines each have separate throttle and rpm controls, movement of one will affect the setting of the other, necessitating readjustment of each following a power change.

With the aircraft now accelerating away from the crowd line in the 'clean' configuration, the pilot awaits the 'clear turn' call from the fighters that are closing to join in close formation as the Lancaster turns back towards the crowd line for the final pass. The call is made to advise the Lancaster pilot that he may initiate the turn at his discretion; it is not a command for the Lancaster to turn.

With the speed increasing through 150 knots, the Lancaster pilot calls for 'plus 2' (inches boost) and the co-pilot adjusts the throttle settings to reduce the rate of acceleration. At this stage the Lancaster navigator will often transmit a speed call to enable the fighters to assess and adjust their rate of closure and effect a safe and expedient join in close formation. As the aircraft roll out of the final turn, the speed can increase rapidly, prompting the pilot to call 'zero boost' to keep the speed under control.

With the three aircraft in close formation, the Lancaster pilot positions the formation for the final run-through down the display line at around 180 knots, before clearing the display venue. Once clear of the venue, the fighters will be given clearance to break formation and, once clear of each other, all aircraft adjust power and speed for the cruise, followed by the 'post-display checks'.

Apart from power settings and speeds, the Dakota display is otherwise almost identical to the Lancaster display in terms of the manoeuvre sequence, as shown in the display diagrams.

BELOW Dakota **display profile.**

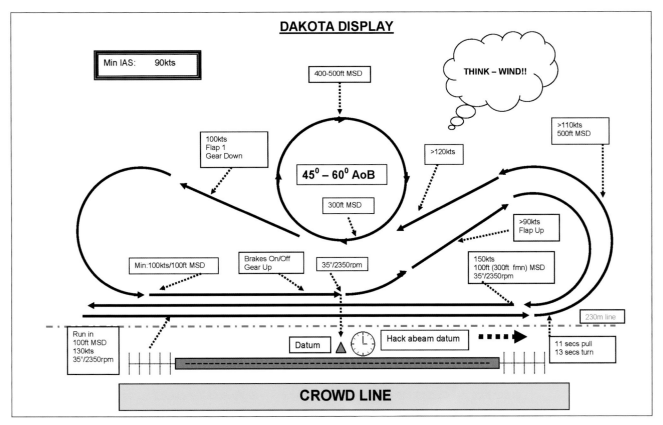

Poppy drop

Poppy drops are a unique aerial spectacle undertaken by the Battle of Britain Memorial Flight Lancaster to commemorate major wartime and related events, such as the unveiling of the Bomber Command Memorial in London's Green Park on 28 June 2012. Invariably, poppy drops receive widespread media coverage and, although they appear simple in context, they are not quite as straightforward as is often perceived. Here, Stuart Reid explains the poppy drop process:

It is important to appreciate that it is not just a matter of turning up at the venue, opening the bomb doors and hoping for the best – a poppy-drop requires careful planning, coordination and execution if it is to be a success. The poppies dropped are the red paper petals used on the Royal British Legion commemorative poppies and the same as those dropped from the ceiling during the annual Festival of Remembrance at the Royal Albert Hall, London.

The first concept to understand is that there are two types of poppy-drop – the 'over the top drop' and the 'on top drop' – and it is both the nature and location of the commemorative event that will dictate the most appropriate type of drop to undertake.

'Over the top drop'

In an 'over the top drop', the poppies are discharged from the Lancaster bomb bay as the aircraft passes directly over the venue, thereby giving a most impressive visual spectacle of the poppies trailing from the aircraft as it passes. The aim is to present onlookers with a flypast by the Lancaster which releases the poppies over the venue in a symbolic red plume in the sky. Depending on the wind strength, the poppies linger for a few minutes over the venue before scattering and drifting away as they fall to earth, though not necessarily directly onto the venue area. After release from the Lancaster, the poppies are often carried a great distance by the wind and take many minutes to descend to the surface.

'On top drop'

For an 'on top drop', the aim is to have the poppies fall directly onto the venue after release from the Lancaster. The aircraft will not necessarily fly over the venue, as it is positioned to release the poppies upwind of the drop zone, so that they drift down and onto the venue after the aircraft has passed. An 'on top drop' is a far more difficult exercise to complete successfully, with many more factors to be borne in mind during the planning phase. It is, nonetheless, a very poignant sight.

Planning considerations

As with all BBMF flying activity, timing is crucial and the Flight's crews pride themselves on their meticulous timekeeping skills. It is not easy to ensure that a formation of prized artefacts of the nation's aviation heritage arrive over a venue to the second and perform their often sombre, though well-publicised, duty in their characteristically unhurried manner.

It all starts back at the planning stage, often many weeks before the event – but the one major factor that it is not possible to take account of until the day is the wind. The wind can play havoc with the sortie timing, but by following some basic procedures, much of its effect can be mitigated.

The initial planning of the sortie is completed assuming 'still air' conditions to get a feel for the route and the overall sortie duration. On the day of the sortie, the forecast wind is factored into

the route plan to estimate how it will affect the timing en route to the venue and, consequently, whether it is necessary to either bring forward or delay the take-off time. However, that is only part of the story. Invariably, the wind is never quite as forecast, so it helps to do one of two things: first, incorporate a timing 'hold' which can be lengthened or shortened to cater for wind variability; or second, factorise the headwind (by 150%) and tailwind (by 50%) components along the route to give a wider margin for error. In other words, assume a headwind will be stronger than forecast and a tailwind less than forecast.

The other factors to take into account are that the speed limit for opening the Lancaster bomb doors is 150 knots, so during the final phase of the run to the venue, there is no catch-up capability if you are running slightly late. Also, it takes approximately 7 seconds for the entire contents of the bomb bay to discharge over the venue, so it is imperative that the drop is initiated at the correct point to avoid dropping the bulk of the poppies either well short of or well beyond the venue. For an 'on top drop', the bomb doors are opened a considerable distance from the venue, often with an offset line-up as is explained in the following text.

Execution of the poppy drop

With the planning complete and all variables factored in, the sortie gets under way. The one area where there is massive scope for a calamity is during engine start. In the normal pre-engine start configuration, the bomb doors are open and are closed after starting the number three engine to confirm integrity of the number three engine hydraulic pump. It would be very easy, through what is known as a 'cognitive failure', for the navigator to instinctively operate the bomb door lever after starting the number three engine with the ensuing embarrassment of depositing a million poppies onto the aircraft dispersal during the start sequence. Consequently, for poppy-drop sorties, the bomb doors are closed before engine start and the bomb door lever is wire-locked in the closed position to prevent inadvertent operation during the engine start procedures. The wire is not difficult to break and

is usually removed as the aircraft approaches the venue. For the more technically minded, the integrity of the number three hydraulic pump is checked by cycling the trailing edge flaps after starting the number three engine and ensuring that hydraulic pressure recovers. All other start, taxi and take-off procedures are unchanged.

Once airborne, routing to the venue is flown in accordance with normal procedures. Once you are approaching the initial point (IP) from which the run to, and over, the venue is commenced, the workload builds. The navigator carefully monitors the timing to ensure that the datum time is maintained and that the aircraft will be below 150 knots when approaching the venue. With a maximum airspeed of 150 knots for operation of the bomb doors, it is particularly important to make due allowance for a headwind on the final run to the venue. The co-pilot monitors the IAS (indicated airspeed), making small power adjustments to refine the correct speed control. If there is any doubt, it is preferable to be slightly early.

If flying a formation of aircraft with the Lancaster in the lead, power changes can make station keeping for the fighters more difficult, resulting in a 'concertina' effect in the formation when viewed from the ground. To make things easier for the fighter pilots, any necessary adjustments to the formation speed is carried out by lowering the nose of the Lancaster very slightly to increase speed and raising the nose to reduce speed. The effect on altitude control is minimal and virtually imperceptible from the ground, but the formation looks neater and the fighters less likely to be out of position. The only other consideration is that the fighters, especially the Spitfire Mk.XIXs, are quite uncomfortable with airspeeds below 150 knots. It is, therefore, a fine balancing act to ensure that the formation will arrive at the venue on time, at an airspeed of (just) less than 150 knots and without provoking airborne 'comment' from the fighter pilots!

Once established on the final run to the venue on the flypast track, the Lancaster pilot has several things to do. The first is to visually acquire and track towards the venue datum, which is not as simple as it sounds. With any

crosswind component on track, the pilot will be forced to fly a heading that points to one side of the venue to ensure that the aircraft actually tracks directly towards it. If the pilot does not fly the correct heading, the aircraft will deviate from the inbound track which results in what is called a 'curve of pursuit' onto the venue during the latter stages of the run-in. This looks awful from the ground and will have a drastic effect on the poppy plume as it is released, so is something to be avoided wherever possible.

Fortunately, such is the nature of the commemorative events at which poppies are dropped, that the venue is likely to be a well-known landmark; but the datum itself can sometimes be difficult to pinpoint visually. Once the datum has been sighted, the pilot must maintain an accurate track towards it and then, almost immediately, identify a visual feature well beyond the datum to enable the accurate inbound track to be maintained as the Lancaster's nose starts to obscure the datum. Typically, and depending on aircraft altitude, the nose obscures the datum some 2 to 3 miles out, so the visual reference beyond the venue is critical to accurate tracking over the datum.

Before the datum is obscured, the pilot must identify another visual feature to the side of the datum to aid his determination of when to open the bomb doors and then to commence any subsequent turn when clear of the venue. Her Majesty would not appreciate the BBMF Lancaster, or formation, approaching from any direction other than the correct one or being seen to turn onto the outbound track too early!

Approaching the venue datum, the pilot calls for the navigator to 'stand by' with the bomb door lever and, if not already removed, the bomb door lever wire lock is disconnected. Continually assessing the alignment and distance to go, using the two visual references, and with smooth, progressive control inputs to assist the fighters in close formation, the pilot call for the bomb doors to be opened using the TLAR (that looks about right) sighting method. From personal experience, this is about when the datum 'passes' through the line of the rudder pedals.

The drop

As the pilot calls for the bomb doors to be opened, it is imperative that straight and level flight over the venue is maintained to avoid the stream of poppies forming an unsightly curve as they leave the bomb bay – the trail must be absolutely straight for the best visual impact. As the bomb doors open, the poppies start to trail from the bomb bay, with the main discharge occurring 1–2 seconds after the bomb doors were selected to open. The poppy plume forms in the wake of the aircraft and the crew are aware of a rushing sound as the poppies brush against the underside of the rear fuselage as they clear the bomb bay. After 3–4 seconds the bulk of the poppies have left the bomb bay and for the next few seconds, the remaining poppies fall as the trailed plume dissipates behind the aircraft.

Ideally, the Lancaster maintains in straight and level flight for a minimum of 10 seconds after the bomb bay door lever is activated to ensure the plume looks perfectly straight and to ensure the venue datum is passed before turning. After the drop, as the turn-away manoeuvre from the venue is commenced, the bomb doors are closed. The 'bomb door open' light goes out; then the aircraft accelerates to normal cruise speed to either return to base or continue to the next venue.

A poppy drop is always an event to stir the soul, particularly for the Lancaster crew, and the spectacle of the plume being released and then falling to earth is always an emotive sight.

External checks for the Spitfire and Hurricane aircraft

Spitfire

Instructions taken from the Flight Reference Cards for the Spitfire Mk IIa (P7350) and Mk Vb (AB910), Issue 4, dated March 2012 – reference AP101B-7101-14. (Other marks of Spitfire will vary.)

Carry out a systematic inspection of the aircraft for obvious signs of damage, leaks, loose panels or fairings. At the same time make the following specific checks:

LEFT After ensuring that the aircraft is in a suitable position for starting and taxiing, and no obvious fuel oil or coolant leaks are apparent, climb up on to the port wing and check the operations of the hood, then check inside the cockpit and remove the control locks before ensuring the ignition switches are set to 'off'. *(Keith Wilson)*

ABOVE Move to the port mainplane and ensure that all panels are closed and secure, the flap is up and the mechanical indicator flush and the aileron both have full and free movement before checking that the wingtip navigation light is not damaged. *(Keith Wilson)*

BELOW Examine the tyre for cuts, wear and creep. Note the white mark on the tyre, which should line up with the similar white mark on the hub – if it doesn't, it suggests the tyre is creeping on the wheel hub and needs attention. *(Keith Wilson)*

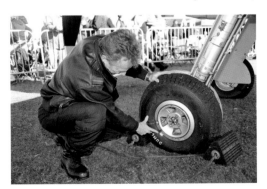

Port Mainplane

Flap	Up. Mechanical indicator flush
Aileron	Full/free movement, check split pin. Leave neutral
Nav light	Secure. Condition
Pitot mast	Secure. Condition
Pressure head	Cover removed. Condition
Oil cooler	Intake and matrix unobstructed
Landing gear:	
Wheel well	General condition
D door	Secure. Undamaged
Oleo	Condition. Extension
Brake pipe	Secure. Check for leaks and chafing. Ensure clear of wheel and ground
Tyre	Cuts, creep and wear. Correct inflation. Valve free
Engine air intake	Unobstructed. No excess fuel
Engine cowling fasteners	Secure
Port exhaust stubs	Secure. No undrilled cracks
Propeller blades	Undamaged
Starboard exhaust stubs	Secure. No undrilled cracks
Engine cowling fasteners	Secure

Starboard Mainplane

Starboard landing gear	As for port landing gear
Coolant radiator	Intake and matrix unobstructed. Fuel vent pipe undamaged
Nav light	Secure. Condition
Aileron	Neutral. Full/free movement. Check split pin
Flap	Up. Mechanical indicator flush

Tail Unit

Elevators	Full and free movement. Condition of tabs
Rudder	Full and free movement. Condition of tabs
Tailwheel tyre	Cuts, creep and wear. Correct inflation. Valve free

Port Fuselage

Baggage pannier panel	Secure
Radio mast	Secure. Condition

ABOVE Next, tap the three exhaust pipes. They should all sound a nice 'ting'. Any dull or tinny note should be investigated. *(Keith Wilson)*

LEFT A check on the leading edges of the propeller is required, looking for any stone chips or damage that might degrade its performance. *(Keith Wilson)*

LEFT After repeating the upper and lower mainplane checks on the port wing, the inspection moves to the tailfin. Here, check the elevators for full up and down movement before checking the rudder for full left and right movement. *(Keith Wilson)*

RIGHT The tailwheel assembly and tyre are inspected for cuts, excessive wear and creep. Also visually check the level of inflation. *(Keith Wilson)*

RIGHT Examine the elevators for full and free movement and check the trim tab and connections. *(Keith Wilson)*

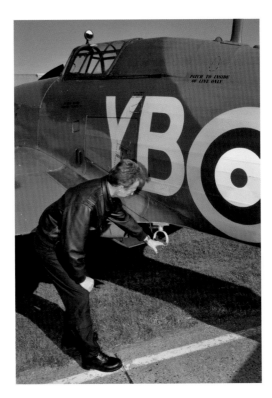

Hurricane

Instructions taken from the Flight Reference Cards for the Hurricane Mk IIc (PZ865 and LF363), Issue 3, dated March 2012 – reference AP101B-7300-14.

Carry out a systematic inspection of the aircraft for obvious signs of damage, leaks, loose panels or fairings. At the same time make the following specific checks:

Port Mainplane

Flap	Up
Aileron	Full/free movement. Leave neutral
Nav light	Secure. Condition
Pitot mast	Secure. Condition
Pressure head	Cover removed. Condition
Landing gear:	
Wheel well	General condition
D door	Secure. Undamaged
Oleo	Condition. Extension
Brake pipe	Secure. Check for leaks and chafing. Ensure clear of wheel and ground
Tyre	Cuts, creep and wear. Correction inflation, valve free
Oil tank filler cap	Secure
Radiator	Intake and matrix unobstructed
Engine cowling fasteners	Secure
Port exhaust stubs	Secure. No undrilled cracks
Propeller blades	Undamaged
Carburettor air intake	Unobstructed. No excess fuel or oil
Starboard exhaust stubs	Secure. No undrilled cracks

Starboard Mainplane

Starboard cockpit access	Clear
Panel	Secure
Starboard landing gear	As for port landing gear
Landing light	Condition
Nav light	Secure. Condition
Aileron	Full/free movement. Leave neutral
Flap	Up

Starboard Fuselage

Baggage locker panel	Secure
Radio mast	Secure. Condition

Tail Unit

Elevators	Full and free movement. Condition of tabs
Rudder	Full and free movement. Condition of tab
Tailwheel tyre	Cuts, creep and wear. Correct inflation and valve free

Port Fuselage

Retractable step	Check operation

LEFT Check that the flap is up and examine the aileron for full and free movement. Also visually inspect the pitot mast. (Keith Wilson)

RIGHT While passing the wingtip check that the navigation light is secure and in good condition before checking the landing light for any sign of damage. *(Keith Wilson)*

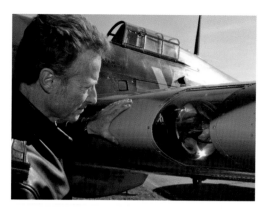

RIGHT Moving to the underside of the wing, examine the landing gear, oleo and brake pipe before checking for cuts and condition, as well as signs of creep. *(Keith Wilson)*

RIGHT Moving to the centre of the fuselage, make a good visual inspection of the radiator to ensure the matrix and intake are unobstructed. By looking straight into the intake you should be able to see that all the fins are clean and clear of any objects or damage. *(Keith Wilson)*

BELOW Moving towards the tailplane, check the starboard elevators for full and free movement, and then examine the rudder for full right and left movement. Next examine the rudder trim tab before moving to the starboard tailplane. *(Keith Wilson)*

ABOVE While at the underside of the fuselage examine the wheel wells, especially the undercarriage catches that retain the gear in the 'up' position. *(Keith Wilson)*

FAR RIGHT With the external checks completed, return to the cockpit and examine the undercarriage and flap selector lever located on the starboard side of the cockpit. The red guard stops selection of the undercarriage to 'up' while on the ground. *(Keith Wilson)*

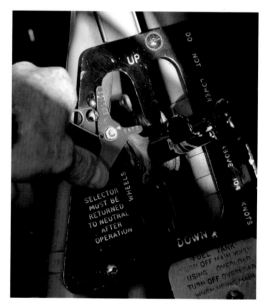

External checks for the Lancaster and Dakota aircraft

It is customary for all flightcrew to carry out a sequence of external checks around their aircraft before flight. It is a final safety check to ensure that nothing is out of place and that the aircraft may be declared safe for flight by the flightcrew. The importance of the inspections cannot be overstated and, as a precursor to completing a full 'walk-round', the following items are noted as the flightcrew approach their aircraft:

A The chocks are positioned correctly.
B Other than rainwater, there are no pools of fluid under the aircraft.
C No fluid is observed dripping from the aircraft other than is permissible from drainage apertures or tubes.
D Fire extinguishing equipment is placed correctly.
E All servicing equipment, other than that needed for engine start, is removed from the proximity of the aircraft.
F There are no hazards to affect the aircraft moving under its own power.
G The position and orientation of the aircraft is safe for engine start and taxi.
H The aircraft is configured as stated in the maintenance documentation.

Having declared the aircraft to be safe to start and taxi as the crew approached it, the initial internal checks are completed before the full pre-flight exterior inspection gets under way. These checks are not exhaustive and are completed, typically, in a matter of minutes.

Lancaster

The checks are usually completed by both pilots; by setting them out in the following text, they appear to take longer to complete than they do in reality. Starting from the main entrance door, one pilot moves clockwise around the airframe to meet the other who proceeds in an anti-clockwise direction.

The checks are described as if moving anti-clockwise around the entire aircraft starting at the main door.

1 Examine the right fuselage side surface forwards from the main entrance door to the wing root, upward to the mid-upper turret structure and downward to include the right bomb-door exterior towards the trailing edge of the right wing. Check the antenna on the lower right side is secure.

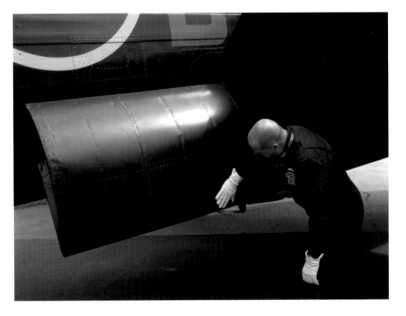

LEFT After leaving the cockpit via the main door, walk forward along the fuselage and remove the guard on the pitot static sensor. *(Keith Wilson)*

BELOW Next, walk along and inspect the outer skins of the bomb-bay doors for any sign of damage. *(Keith Wilson)*

ABOVE At the rear of the wing, examine the interior and exterior structure of the large flap mechanism. *(Keith Wilson)*

2 Inspect the right wing, trailing edge, trailing edge (split type) flaps and flap actuators. The flap actuating struts should all be inclined at the same angle as each other; the strut angle is a function of flap setting but they should all be the same.

3 Examine the under surface of the wing, paying particular attention to the trailing edge flap surface and right aileron. Be aware that, in warm temperatures, fuel may be dripping from the No. 3 fuel tank vents due to expansion in the tank.

4 Examine the right wingtip, underside of the right wingtip area and check the integrity of the navigation light housing.

5 Inspect the leading edge and forward underside of the outboard right wing section.

6 Inspect the right outboard (No. 4) engine cowling; examine the exhaust stubs (which are prone to cracking), carburettor air intakes, radiator intake and propeller. The lower propeller blade should not have any evidence of hub 'play' when pushed fore and aft. The position of the radiator shutter is noted – all the engine radiator shutters should be in the same position. The radiator shutter is a small ramp-like panel on the base of the engine cowl, aft of the radiator intake that operates under pneumatic pressure to regulate airflow through the radiator housing.

7 Inspect the right wing leading edge and underside between the right engines.

8 Repeat the checks performed at item 6 for the right inboard (No. 3) engine.

9 Examine the left main undercarriage assembly, paying particular attention to the condition of the tyre, brake hoses, gear struts and retraction mechanism. Remove the undercarriage locks if still fitted and ensure stowed.

10 Examine inside the wheel bay, engine fire extinguisher connections and engine oil tank area.

RIGHT While walking along the leading edge of the wing, thoroughly examine each engine and propeller in turn. The lower propeller blade should not have any evidence of hub 'play' when pushed fore and aft. *(Keith Wilson)*

FAR RIGHT Examine the undercarriage and pay particular attention to the condition of the wheel hub, tyre, brakes and retraction mechanism. *(Keith Wilson)*

11 Inspect the wing leading edge and underside of the wing inboard of the right inboard engine, the fuselage side under the right inboard wing section and the forward exterior of the right bomb door.

12 Examine the forward right side of the fuselage, the right side of the nose turret and the bomb aimer's Perspex cupola.

13 Inspect the bomb-bay interior and bomb door hydraulic actuators.

14 Examine the right and left forward fuselage area, nose turret and pitot tube.

15 Inspect the left side of the forward fuselage, forward left bomb-door exterior, including the rotating beacon and VHF aerial, and the left inboard wing section leading edge and underside.

16 Inspect the left main wheel and undercarriage assembly (see item 9).

17 Inspect the left wheel bay (see item 10).

18 Inspect the left inboard (No. 2) engine nacelle (see item 6).

19 Examine the left wing leading edge and underside between the left engines.

20 Examine the left outboard (No. 1) engine nacelle (see item 6).

21 Inspect the outboard left wing leading edge and underside ensuring that the landing lights are retracted and flush with

the wing, wingtip, navigation light and left aileron.

22 Examine the left wing trailing edge, trailing edge flaps and flap actuators. The trailing edge flaps should be in the same position as those on the right wing.

23 Inspect the left side mid-fuselage area rearwards from the left wing trailing edge to the tailplane, upwards to the mid-upper turret structure and downwards to include the exterior of the left bomb door.

24 Examine the left side of the tailwheel assembly, paying particular attention to strut extension and the condition of the tailwheel tyre.

ABOVE Remove the red ground undercarriage safety lock and stow it in its location inside the rear of the fuselage. *(Keith Wilson)*

FAR LEFT Make a thorough inspection of the interior of the bomb bay, paying particular interest to the hydraulic actuators. *(Keith Wilson)*

LEFT Inspect the left vertical stabiliser, rudder, rudder tab and mass balances on the tail of the Lancaster. Repeat the examination on both port and starboard tailfins. *(Keith Wilson)*

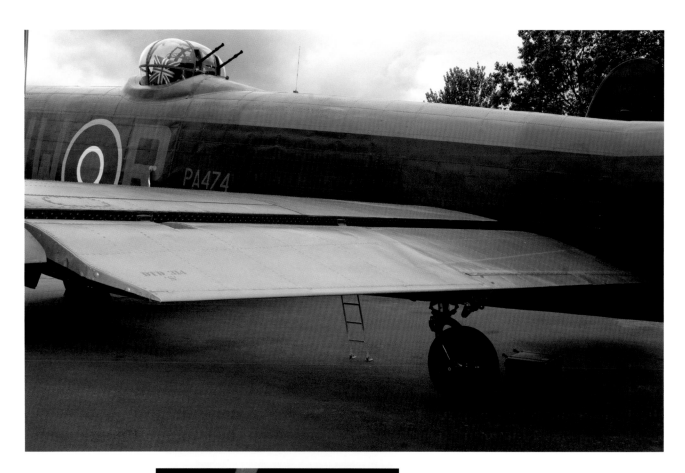

25 Inspect the left horizontal and vertical stabiliser leading edges, rudder, rudder tab and mass balances – check in particular for damage caused by prop-wash debris.

26 Examine the upper surface of the left tailplane, elevator, hinges and tab. Move the elevator control surface gently to the fully up position, and then fully down, listening for the sound of debris moving inside the elevator control.

27 Examine the lower surface of the left tailplane, elevator, hinges, tab and linkages.

28 Inspect the rear fuselage and tail turret, checking in particular for prop-wash debris damage.

29 Examine the right horizontal stabiliser and flight controls (see items 25 and 26).

30 Examine the right rudder, rudder tab, balances and right vertical and horizontal stabiliser leading edges.

31 Inspect the right rear fuselage forward from the tail turret to the main access door.

32 Finally, examine the right side of the tailwheel assembly, anti-shimmy unit and tailwheel.

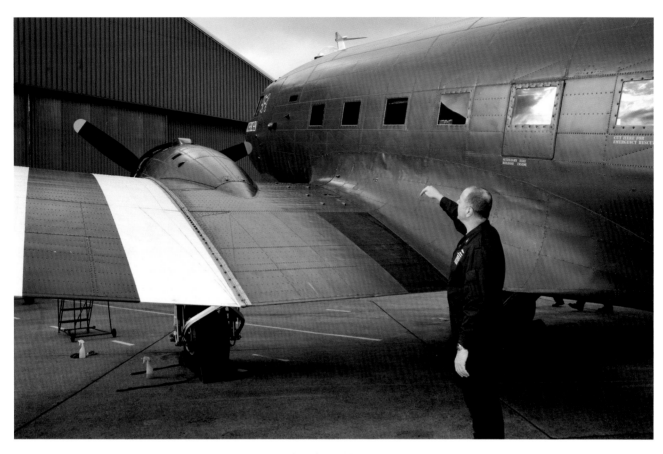

Dakota

The Dakota pre-flight external checks are completed by the pilot. Before commencing the checks, the pilot confirms with the navigator on the flight deck that the hydraulic pressure is above 500psi. Starting from the main entrance door, the pilot moves clockwise around the airframe as follows:

1 Examine the left fuselage side surface forwards from the main entrance door to the wing root, checking the left side cabin windows and ensuring the left emergency window exit is flush with the fuselage side.
2 Ensure that both left fuel tank caps are in place.
3 Inspect the left wing trailing edge and upper surface, and that the aileron control lock is removed and stowed.
4 Examine the under surface of the left wing and left aileron, paying particular attention to the fabric surfaces and attachment nuts.
5 Examine the left wingtip, navigation light,

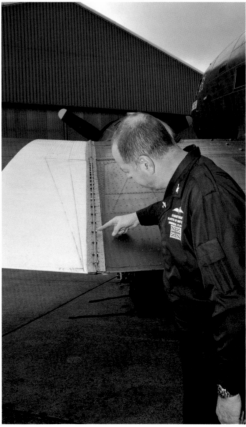

ABOVE After exiting the aircraft by the fuselage door, turn to the right and start by examining the upper surfaces of the wing area. *(Keith Wilson)*

LEFT Pay particular attention to the line of fixings at the wing join. *(Keith Wilson)*

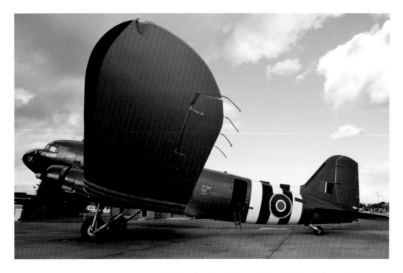

ABOVE **Walk along the rear of the port wing and inspect the flaps; continue with an examination of the aileron to ensure full and free movement. At the wingtip, check the condition of the navigation light.** *(Keith Wilson)*

left wing leading edge to the left engine cowling and left landing light.

6 Inspect the left (No 1) engine cowling, cowl flaps, exhaust manifold, exhaust duct cabin air heat exchanger. Check that the cylinder head cooling air inlet behind the propeller hub is clear of obstructions. There should be no 'play' in the propeller hub when the lower prop blade is pushed fore and aft. If necessary, the engine should be 'turned' by hand to purge the lower cylinders of any fluid accumulations.

7 Examine the left main undercarriage assembly, paying particular attention to the condition of the tyre, brake hoses, gear struts and retraction mechanism. Remove the undercarriage lock.

8 Examine the wheel-bay interior, engine fire extinguisher connections and engine oil tank area.

9 Inspect the left wing leading edge and underside inboard of the left engine and under the fuselage, paying particular attention to the aerials and fuel tank drains.

10 Inspect the forward fuselage and that the crew service door is closed and secure.

11 Confirm with a crew member on the flight deck that the pitot heaters have been set to 'on' and with a covered hand, check for warmth in the pitot/static heads. After the check confirm that the pitot heaters are set to 'off'.

12 Inspect the aircraft nose and right forward fuselage.

13 Inspect the wing leading edge and underside of the right wing inboard of the right (No 2) engine (see item 9).

14 Examine the right engine (see item 6).

15 Inspect the right landing gear assembly and wheel-bay interior (see items 7 and 8).

16 Inspect the upper and lower surfaces of the right wing, right aileron, trailing edge flaps and fuel tank filler caps (see items 2, 3, 4 and 5).

17 Examine the fuselage side aft of the right wing to the horizontal stabiliser, including the fixed portion of the vertical stabiliser (see item 1).

18 Examine the left side of the tailwheel assembly, paying particular attention to

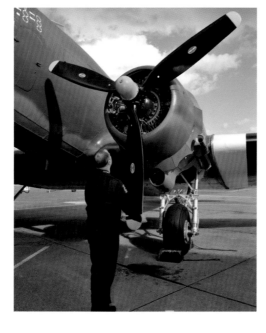

RIGHT **After examining the condition of the wing leading edge, inspect the port propeller. There should be no 'play' in the propeller hub when the lower prop blade is pushed fore and aft. If necessary, the engine should be 'turned' by hand to purge the lower cylinders of any fluid accumulations.** *(Keith Wilson)*

BELOW **Move towards the nose of the aircraft and visually inspect the fuselage undersides and cockpit glass. Ensure all inspection hatches are correctly closed.** *(Keith Wilson)*

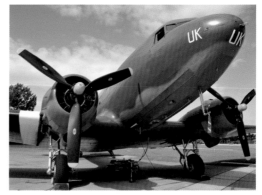

FAR LEFT Closely examine the main wheel and tyre, looking particularly for any sign of cuts, damage or wear. Thoroughly examine the condition of the brake and hoses, paying special attention to any sign of brake fluid leaking. *(Keith Wilson)*

LEFT Remove the undercarriage lock. Examine the wheel-bay interior, engine fire extinguisher connections and engine oil tank area. *(Keith Wilson)*

strut extension, strut alignment and the condition of the tailwheel tyre. The tailwheel alignment is checked because, regardless of the position of the tailwheel lock on the flight deck centre pedestal, the tailwheel lock will not engage in the strut unless it is aligned with the fuselage centreline.

19 Inspect the right horizontal stabiliser leading edge, upper and lower surfaces, checking in particular for damage caused by prop-wash debris. Ensure the elevator control lock is removed and stowed. Move the elevator control surface gently to the fully up position, and then fully down, checking the surfaces for prop-wash debris damage and listening for the sound of debris moving inside the elevator control. Check the integrity of the elevator tabs and linkages.

20 Inspect the rudder surfaces, tabs and linkages, ensure the rudder control lock is removed and move the rudder from side to side. Be aware that surface winds may cause the rudder to deflect without warning and render it difficult to move by hand.

21 Inspect the left horizontal stabiliser and elevator (see item 19).

22 Inspect the left rear fuselage forward from the horizontal stabiliser to the main access door.

23 Finally, examine the left side of the tailwheel assembly.

LEFT Carefully examine the tailwheel, paying attention for any signs of wear, damage or creep. *(Keith Wilson)*

LEFT Move to the rudder. Check for any signs of damage and after removing the gust lock, check for full and free movement. Also check the rudder trim tab for correct function and any signs of damage. *(Keith Wilson)*

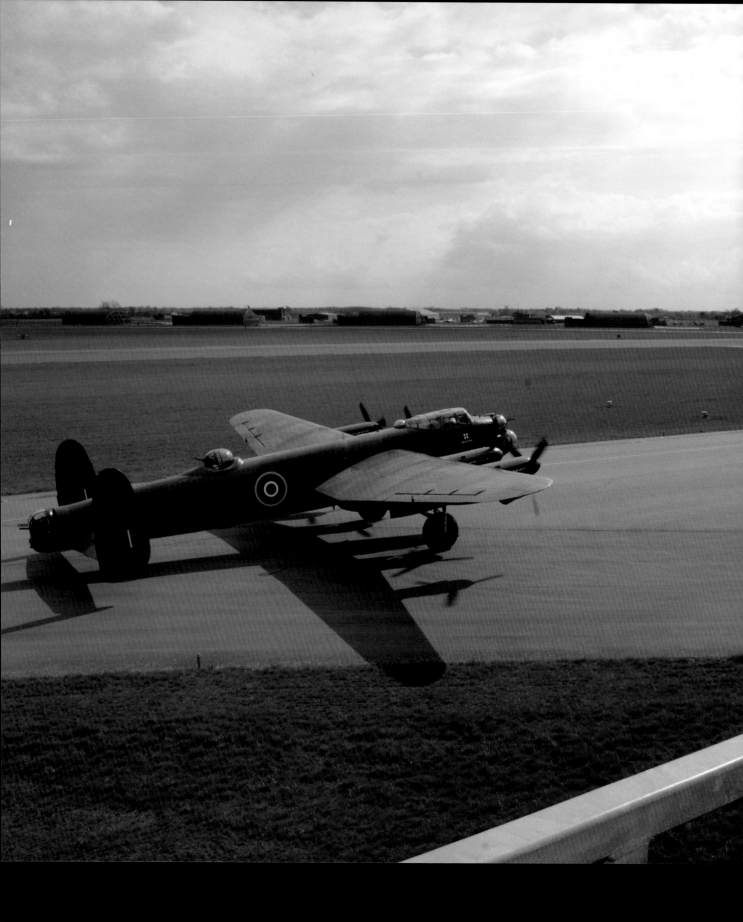

Chapter Five

Working up

The Lincolnshire Lancaster Association Day at Coningsby – usually held on the last Sunday in September – marks the end of the display season for the Battle of Britain Memorial Flight. In 2013, the event was held on 29 September and while it was the last display of the season, it was also the day on which the Flight said farewell to a number of key members of the team.

OPPOSITE The Public Display Authority (PDA) is issued following an inspection by the AOC 1 Group. In 2012 the role was undertaken by Air Vice-Marshal Stuart Atha (station commander of RAF Coningsby in 2007–08). As part of his duties he had volunteered to fly with the BBMF and consequently he knew what to look for! *(Keith Wilson)*

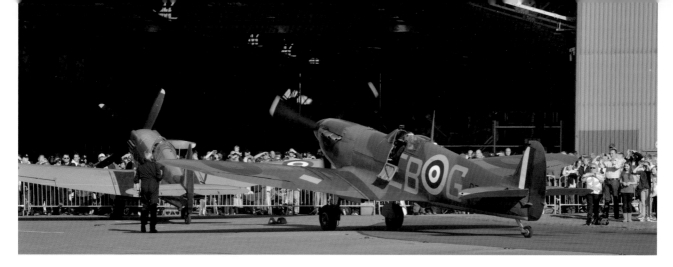

ABOVE Following the three-ship display, and at the end of his very last flight in a BBMF Spitfire, Wg Cdr Paul Godfrey landed and taxied towards the waiting crowd, as well as members of the groundcrew and his family. *(Oliver Wilson)*

From the flightcrew, these included the bomber leader, Squadron Leader 'Russ' Russell, fighter pilot Wing Commander Paul 'Godders' Godfrey (OC Operations Wing, RAF Coningsby) and air loadmaster MACR Andy Whelan. The engineering team said farewell to Flight Sergeant Dick Chaffey, who retired from the RAF and returned to civvy street, along with SAC Jay Billington (promoted and posted to RAF Marham), SAC(T) Dale 'Teapot' Wheildon (promoted and posted to 29 Squadron at RAF Coningsby) and SAC(T) Chris Cochrane (promoted and posted to RAF Cosford).

The penultimate aircraft to return to the ramp at the end of the display was Spitfire P7350/EB-G, flown for the very last time by Wing Commander Paul 'Godders' Godfrey. A small group of family and friends had gathered

to welcome him back. Shortly after landing and exiting the cockpit, he was met by OC BBMF Squadron Leader 'Dunc' Mason, who presented him with the customary bottle of champagne to mark the occasion.

The very last aircraft to return to the ramp was Lancaster PA474, with the 2014 bomber leader, Squadron Leader 'Russ' Russell on board. After six years on the team, where he had served as both navigation leader and bomber leader, it was Russell's very last flight with the RAF – although a trip in the Lancaster is not a bad way to end an illustrious career! Once again, when the door was opened and the crew started to depart the Lancaster, Squadron Leader 'Dunc' Mason was on hand to provide the customary bottle of champagne and to organise the farewell photographs.

Next day, it was business as usual for the Flight. A clean-up operation commenced at Coningsby and any sign of the previous day's event was soon gone, allowing the Flight to concentrate on the all-important winter engineering activities and pilot training. Strangely, the morning of Monday 30 September 2013 represented the *first* day of the new 2014 season and plans were already

BELOW The last aircraft to land and taxi back to the BBMF ramp at Coningsby on 29 September 2013 was the Lancaster. It was bomber leader, Sqn Ldr 'Russ' Russell's very last flight in the Lancaster. Shortly afterwards Russ retired from the RAF after a career spanning 36 years, including 7 with the BBMF. The Lancaster trip was not a bad way to end it!
(Keith Wilson)

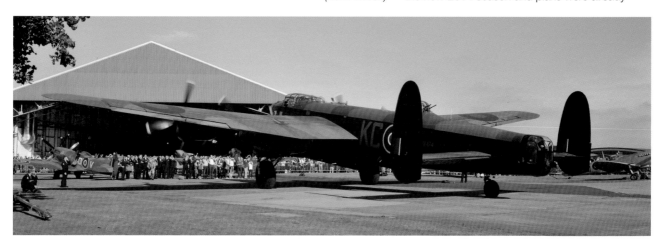

afoot for all the changes on the horizon – the initial objective being the award of the Flight's Public Display Authority (PDA) in April 2014 to enable the team to undertake all of its commitments for the forthcoming display season.

The first stage in the working-up process is looking back on the previous season by getting everyone together for an end-of-season wash-up meeting. It involves all the key sections: operations, PR, administration, as well as engineering. OC BBMF presents two flying case studies so that everyone can learn lessons from them. This is a no-holds-barred meeting where everyone, regardless of rank, has an input.

With this process completed, the Flight can look forward and consider the training and selection of new and current fighter pilots. Unfortunately, the bomber (Lancaster and Dakota) flying training could not start until the aircraft completed their winter maintenance programmes, which finished around the beginning of March 2014.

Over the years, it has become customary for both the station commander and OC Operations Wing at Coningsby to volunteer as fighter pilots with the Flight. The station commander at Coningsby is Group Captain Johnny Stringer, who underwent the Flight's pilot training scheme under the watchful eye of 'Dunc' Mason during 2012/13 and completed his first full season during 2013. With Wing Commander Paul 'Godders' Godfrey having left Coningsby in September 2013, his role has been replaced by Wing Commander Justin 'Hells' Helliwell, and he was busy in the training cycle under the watchful eye of OC BBMF 'Dunc' Mason during the autumn and winter of 2013/14. 'Hells' Helliwell was expected to be ready to take his part in the April 2014 PDA exercise.

In 2014, the fighter pilots were:

- Squadron Leader Duncan 'Dunc' Mason – OC BBMF
- Flight Lieutenant Anthony 'Parky' Parkinson – adjutant, BBMF
- Squadron Leader Andy 'Milli' Millikin – OC BBMF designate
- Group Captain Johnny Stringer – station commander, RAF Coningsby
- Wing Commander Justin Helliwell – OC Operations, RAF Coningsby

ABOVE The BBMF fighter pilots for the 2014 season are seen here at Coningsby in September 2013. From left to right: Wg Cdr Justin 'Hells' Helliwell (OC Operations Wing, RAF Coningsby), Sqn Ldr Andy 'Milli' Millikin (OC BBMF designate), Sqn Ldr 'Dunc' Mason (OC BBMF), Flt Lt Anthony 'Parky' Parkinson MBE (operations officer) and Grp Capt 'Johnny' Stringer (station commander, RAF Coningsby). *(Crown Copyright/SAC Graham Taylor)*

All BBMF aircrew with the exception of 'Dunc' and 'Parky' are volunteers, and fly with the Flight in their own time. They all have day jobs in the Royal Air Force, flying in a variety of types including the Typhoon, Tornado, King Air, Sentinel, Voyager and AWACS.

Chipmunk tailwheel training

Training for the new fighter pilots starts on the venerable Chipmunk, a tailwheel training relic from the 1950s. 'Dunc' Mason describes the Chipmunk as, 'A great tailwheel trainer; simple to learn but it can bite if you are complacent, so it keeps pilots of any experience on their toes.' Training commences with a Chipmunk ground school, with a particular

BELOW Training for the new fighter pilots starts on the Flight's two Chipmunks. WG486/G retains the RAF black high conspicuity colours; WK518/C was repainted in 2011 into the silver and Day-Glo colours of the Hull University Air Squadron. Both aircraft were photographed in formation over Lincolnshire in December 2012. *(Keith Wilson)*

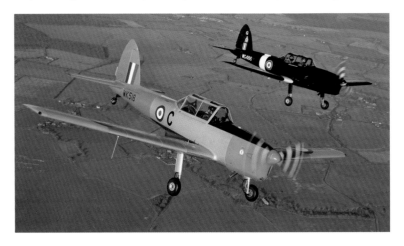

emphasis on tailwheel handling and propeller theory. It must be remembered that any fighter pilot joining the BBMF will have at least 2,500 hours on fast jets and will have been considered as 'above average ability' throughout their RAF career but – and it is a big but – they are unlikely to have sampled the delights of flying behind a piston-engined tailwheel aircraft, and therefore the training is carefully structured.

Next up is a walk around the Chipmunk, pointing out things like the fabric-covered wings and control surfaces – so big boots beware! Then, once strapped into the Chipmunk, the new pilot is introduced to all the switches and controls. This is followed by starting the engine, taxiing and actually flying the aircraft from the front seat – with 'Dunc', 'Parky' or 'Milli' usually occupying the rear seat. Most fast-jet pilots are considered to have 'concrete feet', feeling that the rudder pedals on fast jets are merely there as foot rests. In the Chipmunk, however, it is a completely different ball game! Keeping the aircraft straight with the rudder on take-off and then flying the aircraft in balance (with the balance ball within the turn coordinator firmly located in the centre of the instrument) can take some getting used to. Some slow flying, (including stalling the aircraft), an assortment of PFLs (practice forced landings) and a few emergency procedures complete the initial stage of training. Then there is the small matter of landing the Chipmunk, where once again the feet are absolutely essential in keeping the aircraft on the centre of the runway. Initially, a crosswind limit of just 10 knots is placed on the aircraft and student, but as training increases the limit is raised to 15 knots. One of the exercises involves practising crosswind landings, which involves locating an airfield that has a runway with a reasonable crosswind in place. On occasions, the Chipmunk flies to Wickenby where the main runway may be into the wind but the alternative runway has a crosswind to test the Chipmunk pilot. The relatively small rudder on the Chipmunk makes keeping the aircraft straight down the runway a little tricky, with the prevailing wind from the left or right side of the aircraft.

Once all the necessary skills have been demonstrated, the student moves to the back seat before once again demonstrating his skills here; this time with a significantly reduced field of view. The forward view is worse than from the front seat and more akin to the Hurricane and Spitfire, making landing especially difficult. Being able to see only what is alongside of you in your peripheral vision, but seeing little or nothing of what is actually in front of you – especially when the nose is raised and the tail is down for landing – takes some getting used to. Ideally a minimum of 5 hours' training is flown in the back seat, but 10 hours is the preferred time. Once the student has satisfied 'Dunc' of his basic skills, he is allowed to fly the Chipmunk solo.

The next stage of the working-up process takes the student on to a North American T-6, named 'Harvard' in RAF circles. The Harvard is a much heavier tandem, two-seat taildragger with a 600hp Pratt & Whitney R-1340-49 Wasp radial engine, variable-pitch propeller and retractable undercarriage – a complex, powerful aircraft.

Why a Harvard? Firstly, flying the Harvard teaches students to manage the inertia of the aircraft, control a large 600hp engine, fly with much heavier control forces and get used to the feeling of a bigger, heavier aircraft. Secondly, it puts the student into the correct mindset to make their first flight in a single-seat Hurricane – on their own, without having someone looking over their shoulder.

The first flight in the Harvard is made by the student from the front seat. He will receive a safety briefing and the location of all relevant controls and switches. But effectively, he is not actually being *taught* to fly the aircraft. While he will have an instructor in the rear seat (as a safety pilot) during his first flight, it is up to the student to demonstrate his ability to adapt to a completely new type of aircraft with minimum assistance, just as he will have to when making his first flight in a single-seat Hurricane or Spitfire. The student will fly at least an hour in the front seat of the Harvard and complete a number of fighter-style circuits, while demonstrating that he can actually *fly* the aircraft. Then he is moved into the rear seat and much of the flying is repeated; this time with the significantly reduced field of view that the rear cockpit permits. All of this is undertaken under the watchful eye of a current or former BBMF lead fighter pilot and an experienced warbird

pilot. Supervisory pilots in this role include both the current and previous BBMF bosses – 'Dunc' and 'Smithy' – along with Al Pinner and Cliff Spink.

Into the Hurricane

With the Harvard work having been satisfactorily completed, it is time for the student to fly the Hurricane. Initially, the Hurricane is moved on to the engine test run area and tied very firmly down to the ground. After a thorough cockpit and safety brief from 'Dunc', the aspiring fighter pilot gets to start the aircraft and then run through various checks while experiencing the extreme noise and heat levels in the cockpit – something all Spitfire and Hurricane pilots need to acclimatise to! Then, after a short time in the cockpit, they shut the engine down.

After removing the tie-downs, the next stage is to start the engine and taxi the aircraft around – something that needs to be experienced. 'Dunc' says, 'The method of braking takes some getting used to and the brakes themselves are bloody awful.' The brake lever is located on the top of the central control column; a small spade that is pulled towards you in much the same way as you would on an old-fashioned pedal cycle! To turn left, you need to apply full left rudder and then gently apply the brakes. Similarly, to turn right requires full right rudder and braking. To stop, you centralise the rudder pedal and then apply the brakes with the spade grip.

Once that has been accomplished, they are off on their own. 'Dunc' will always go to the control tower to monitor the flight and he is usually joined by a group of the Flight's pilots to witness the momentous occasion. No pressure on the first-time Hurricane pilot then!

The procedure is to take off (keeping it straight down the runway) and climb the Hurricane up to 7,000ft. Once at that altitude, you fly the aircraft to experience its handling characteristics and just soak up the initial pleasures of flying the Hurricane. Then the pilot explores its slow-speed handling and carries out a couple of stalls – the first clean (no flaps) and the second dirty (with full flap and undercarriage deployed, as in the final approach to land configuration). In each case the pilot

carefully monitors what the aircraft is doing and applies the correct recovery technique.

Next the pilot tries a high-speed dive to experience how the control forces become much heavier. This is followed by a full display practice – but not below 2,000ft (the absolute base is actually 1,500ft but pilots are encouraged to try the first one a little higher). Once complete, the pilot carries out a practice forced landing at Coningsby.

This is followed by a rejoin into the circuit at Coningsby, in the overhead, and the student conducts three circuits. If runway space permits, the first two can be touch-and-go landings, but it is essential that the correct take-off setting changes are made to the aircraft while rolling down the runway and before attempting to go around. These include ensuring you tighten the throttle friction, thereby making certain the throttle doesn't go back to idle power when you take your hand off it (quite a disturbing situation); and adjust the rudder trim to compensate for the significant take-off power you are about to introduce. The final landing is usually a full stop before taxiing back to the BBMF ramp. Each of the landings is debriefed over the radio by 'Dunc', from his position in the control tower before the next landing is attempted.

All that is left to do is for your colleagues to pull you out of the cockpit and present you with the customary bottle of champagne. You will have earned it!

Dunc adds, 'It is important that you are

quickly in tune with how to operate the aircraft with safety in mind. Your next display may be in front of 100,000 people and you are, after all, flying a very old, single-engine aircraft. It is imperative to keep one eye on the engine gauges and be cognisant of your position in space in relation to the crowd. It is always going through my mind as to the current energy state of the aircraft and where I could put it down if the engine stopped.'

Squadron Leader Andy 'Milli' Millikin fondly remembers his first solo in the Hurricane, which took place on 2 April 2012. He got his ground briefing from Smithy before being told to go and fly it. 'I hadn't felt such a weight of expectation anywhere else in my Air Force career. The weight on my shoulders was huge and I was concentrating so hard!' he recalls. 'After all, this is one of the nation's treasures and I had to bring it safely back. Smithy stood in the tower with all the remaining fighter pilots of the Flight watching on. I remember that taxiing it was the hardest thing to do, especially going around corners as the brakes were so bad!'

Since then, 'Milli' has flown more than 50 hours in Hurricane LF363/YB-W during 2012 and 2013. He has completed a large number of fly-bys and displays in the Hurricane, including the very prestigious flypast over Buckingham Palace for the Queen's Diamond Jubilee celebrations on Tuesday 5 June 2012; a flight undertaken in close company with the Lancaster and Spitfire.

Finally, the Spitfire

The new fighter pilot will fly 10 hours on the Hurricane before he is able to fly a Spitfire. When that day comes, it will usually be in the Mk IX, MK356, as it is deemed the 'easiest' (a relative term) of the Spitfires to fly. It has a lower-powered engine (especially compared with the Griffon-powered Spitfires), a relatively large rudder providing reasonably good directional control, and is considered to have the nicest handling characteristics of all of the Spitfires – although some pilots' opinions may differ here.

For 'Milli', the step from Hurricane to Spitfire was not as daunting as that from Chipmunk/ Harvard to Hurricane. 'I got a thorough briefing on the ground from Smithy. Once inside the aircraft, the systems are much the same, in fact some buttons and most of the instruments are identical,' he recalls. 'It didn't seem such a big step, and nor did anyone else as there was no one to greet me at the end of it!'

After the first flight, 'Milli' flew around 20 hours on the Mk IX, MK356, throughout the 2012 display season and thoroughly enjoyed it. With sufficient experience on the Spitfire Mk IX, 'Milli' was invited to fly the Flight's Spitfire Mk IIa P7350 on 4 September 2012. Once again, Smithy conducted the briefing before 'Milli' flew P7350. 'I had to be conscious of the cooling issues with the aircraft; it is prone to overheating due to the size and location of the radiator. It also has a very small fin and has just a 10 knot crosswind limit.'

After flying the Spitfire Mk IIa, 'Milli' said, 'P7350 is the last flying Spitfire that actually fought during the Battle of Britain and aside from the Apollo 11 command capsule, P7350 is probably the most valuable aircraft on the planet. And she is gorgeous!'

Once the fighter pilots have sufficient hours on the smaller Spitfires, they are allowed to sample the delights of one of the Flight's pair of Griffon-powered Spitfire PR XIXs. 'A very different aircraft and experience to the smaller Spits', was the view of 'Dunc'.

All fighter pilots are limited to a 10 knot crosswind component limit until they have reached 50 hours on the Flight's fighters. Then, the limit is increased to 15 knots.

Bomber crews

For the Lancaster and Dakota crews, things are very different. Both aircraft are involved in extensive maintenance work during the winter and are not usually available to fly until February/March at the earliest. Both aircraft will require post-maintenance air tests which, according to BBMF rules, have to be conducted by the trade leaders – flown by the bomber leader and accompanied by the navigator leader, engineering leader and air loadmaster leader. For the 2013 season, the bomber leader was Squadron Leader 'Russ' Russell – one of the Flight's navigators but a very experienced member of the flightcrew.

ABOVE After already having operated with the BBMF as a Dakota captain, Flt Lt Seb Davey was converted onto the right (co-pilot) seat of the Lancaster on 24 July 2013 by Flt Lt Roger Nicholls (left). This photograph was taken shortly after the successful conversion flight. Seb hopes to achieve his dream of flying the Lancaster from the left-hand (captain's) seat with qualification training scheduled for March 2015. *(Keith Wilson)*

Ahead of those flights, a bomber training day is organised and is attended by all pilots, navigators, engineers and loadmasters. Lectures are organised on allied technical subjects to enable all the crews to top-up their systems knowledge and limitations. An essential knowledge quiz (EKQ) is organised and everyone takes the test. In addition, some trades undertake training specific to their own unique roles.

In 2014, the bomber pilots were:

- Flight Lieutenant Roger Nicholls
- Flight Lieutenant Tim Dunlop (bomber leader 2014)
- Flight Lieutenant Loz Rushmere
- Flight Lieutenant Leon Creese
- Flight Lieutenant Seb Davey

Tim Dunlop then completes two practice displays at Coningsby, in front of the OC BBMF stationed in the control tower. The first display is made not below 500ft and, once the display routine is approved, Tim conducts the second display – this time he is cleared down to 100ft.

Tim is then considered 'current' for the display and sits in the right-hand seat while each of the remaining pilots conduct their own display practice – once again, with the first above 500ft and, if approved, the second down to 100ft.

With the Lancaster engineering flight test completed by the trade leaders, training can be conducted in parallel with the Dakota. However, the Lancaster is limited to just 100 hours per year, including training, so only 5 hours are allocated to the air test and PDA work. Consequently, each pilot on the Lancaster gets two training trips of just 30–40 minutes each. The engineers and navigators on the Lancaster are completing their training at the same time as the pilots. Dakota pilots can (and do) act as co-pilots on the Lancaster, but are not usually cleared to operate from the left-hand seat.

Despite the very limited training hours, all crew are considered 'current' once the training programme is competed. Over the winter period, training and tailwheel familiarity and continuity training is available in one of the Flight's two Chipmunk aircraft.

Public Display Authority

The Public Display Authority is issued following an inspection by the Air Officer Commanding 1 Group Royal Air Force. In 2013 – as for 2012 – the role was undertaken by Air Vice-Marshal Stuart Atha. Interestingly, Atha had served as station commander of RAF Coningsby in 2007 and 2008 and, as part of his duties, had volunteered to fly with the BBMF.

ABOVE Flt Lt Seb Davey's excitement after his successful conversion flight on to the co-pilot's seat of the Lancaster at Coningsby in July 2013 is apparent! Seb's day job is as a C-130J tactical flight instructor for 47 Squadron at RAF Brize Norton. *(Keith Wilson)*

RIGHT Sqn Ldr Ian Smith (the then OC BBMF) is in the Coningsby control tower to monitor the Flight's display routine in April 2012. It has become customary for pilots to wave towards the tower as they pass before their slot in the PDA routine. 'Smithy' responds in his own inimitable way! *(Keith Wilson)*

Consequently, he would know exactly what to look for!

The run-up to the 2013 PDA examination had not been easy. Reliability and maintenance issues had severely restricted the number of airframes available to the Flight and the weather had not cooperated, being predominately wet and very windy. The actual number of flying days available to practise was severely limited. Consequently, weekend working became an essential requirement for the engineers and practice flights were very much at short notice! Despite all the difficulties, when the day arrived for the actual PDA –

ABOVE Grp Capt Martin 'Sammy' Sampson taxies past the control tower at Coningsby in April 2012 and waves towards 'Smithy' ahead of his part in the Spitfire 'Tail Chase' routine. Sampson was in the silver Spitfire IXe, MK356, callsign 'Fighter 1', with Wg Cdr Paul Godfrey in Spitfire Vb, AB910, following behind. *(Keith Wilson)*

ABOVE Meanwhile, 'Smithy' assesses the height and accuracy of the Lancaster fly-by from his position in the control tower. *(Keith Wilson)*

BELOW Comparing notes. Sqn Ldr Duncan Mason (left), and Wg Cdr Paul Godfrey animatedly discuss another of the BBMF display routines. *(Keith Wilson)*

BELOW OC BBMF, Sqn Ldr Duncan Mason, addressed all the members of the BBMF aircrew ahead of the practice. According to his briefing, the aim of the practice PDA was 'a safe practice of all display serials' (routines). *(Keith Wilson)*

Wednesday 24 April 2013 – there was one of each type available to the team.

The team had two new Dakota captains, a new Lancaster captain as well as a new fighter pilot on its 2013 strength. Pilots new to display flying are more likely to feel the pressure of the PDA more than the experienced members of the team.

Just one day earlier, the team had conducted their practice PDA, which was blessed with fair weather. The aircraft behaved and the practice examination was completed without issue. All that was left was to repeat the exercise the following day, in front of Air Vice-Marshal Stuart Atha DSO. Without doubt, PDA day is the most important day in the Flight's calendar. Although conducted out of the public gaze, without approval there can be no display season.

Initially, the weather was proving a little uncooperative and the PDA was delayed by 3½ hours. Following the delay, the team gathered at the Flight's briefing room and proceedings commenced. Squadron Leader 'Dunc' Mason welcomed everyone to the briefing with a simple message: 'The aim of today is to safely execute all the BBMF display serials for the AOC's approval.'

Matters were opened with a detailed weather briefing by the station's met man; it looked like the weather would now cooperate. Air traffic

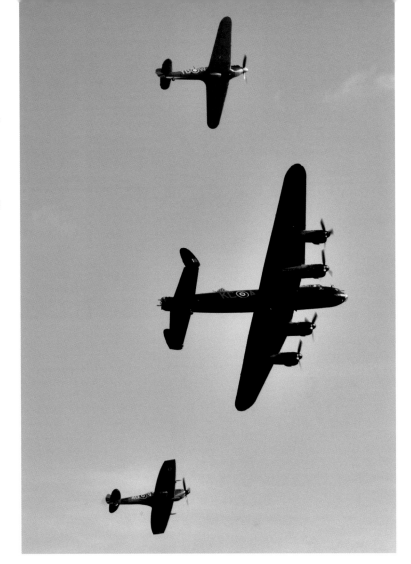

ABOVE The practice PDA opened with the traditional BBMF three-ship routine of Lancaster, Spitfire and Hurricane. Owing to some engineering issues before the PDA the Flight had only four serviceable aircraft: Lancaster, Dakota and Spitfire and Hurricane. Thankfully, they all remained serviceable for the practice, as well as the following day's actual PDA. *(Keith Wilson)*

BELOW The practice for the PDA examination took place at Coningsby on 23 April 2013. The display briefing commenced with a detailed weather assessment and thankfully the weather cooperated, but this was not the case the following day for the actual PDA, which was delayed by 3½ hours to allow conditions to improve. *(Keith Wilson)*

BELOW The briefing board ahead of the PDA examination on 24 April 2013. All the day's requirements are there. Sadly, the weather chose not to cooperate fully and the examination had to be delayed. *(Keith Wilson)*

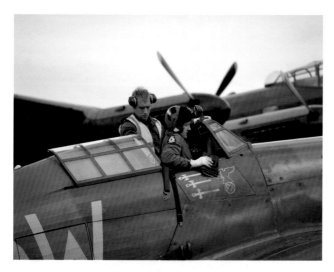

ABOVE Grp Capt Johnny Stringer straps into Hurricane IIb, LF363, assisted by SAC(T) Colin Bateman. *(Keith Wilson)*

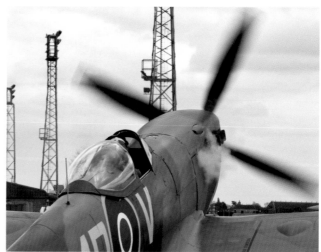

ABOVE Once strapped inside TE311, Mason starts the engine, which jumps into life with a puff of smoke. *(Keith Wilson)*

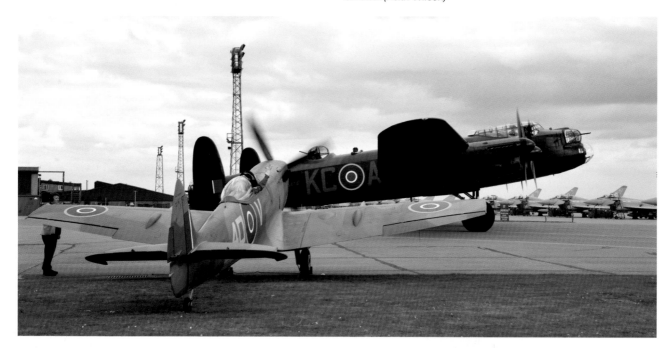

ABOVE First to taxi to the runway is the Lancaster, with Flt Lt Tim 'Twigs' Dunlop in the left-hand seat. The Spitfire and Hurricane will follow shortly behind the Lancaster. *(Keith Wilson)*

RIGHT Soon after the Lancaster, Spitfire and Hurricane trio have taxied to the start of the runway, Dakota ZA947 makes its way out. The wave from Sqn Ldr 'Sluf' Beresford (navigator leader 2013) in the right-hand seat was for the photographer! *(Keith Wilson)*

control conducted their briefing before OC BBMF 'Dunc' Mason took to the floor to brief everyone on radio frequencies, ground procedures, display order and timings. He concluded with some advice for the participating aircrew: 'Do not assume that this is "in the bag". Give yourself plenty of time and be prepared to be flexible on timing. Do not get distracted. I am looking for spirited but smooth flying, but don't change the display.' He added, 'Everyone should fly higher than the absolute minimum (100ft). There will be no complaints from the AOC if anyone is observed to be slightly high, but being below the safety minimum height might lead to an embarrassing failure.' He concluded the briefing with 'Let's have a good one.'

After his arrival at Coningsby, the AOC was escorted to the control tower from where he would have an excellent viewpoint. He was joined on the balcony by bomber leader Squadron Leader 'Russ' Russell and Wing Commander Paul 'Godders' Godfrey. 'Dunc' would join the AOC in the tower once his flying participation had concluded.

First up was the three-ship formation of Lancaster PA474, Spitfire TE311 and Hurricane LF363, flown by Flight Lieutenant Roger Nicholls, Squadron Leader 'Dunc' Mason and new boy Group Captain Johnny Stringer at the controls. After take-off, all three aircraft departed the airfield

to set up for the classic BBMF three-ship crowd rear arrival. Once the formation flying had been concluded, all three aircraft displayed individually before rejoining to conclude the display.

Next up were Dakota displays from both Flight Lieutenant Seb Davey and Flight Lieutenant Leon Creese, before a Spitfire and Hurricane 'Tail Chase' routine was flown by Group Captain Johnny Stringer (Spitfire) and Flight Lieutenant 'Parky' Parkinson (Hurricane). Having had a chance to change crews, the Lancaster returned

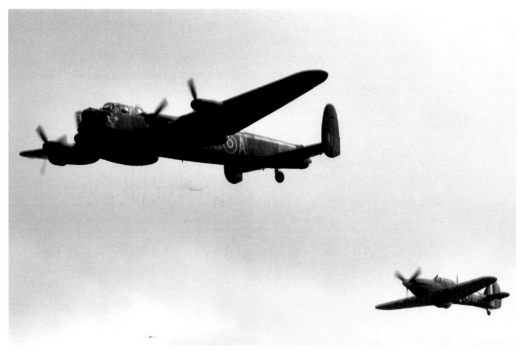

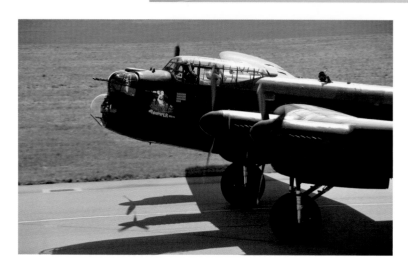

RIGHT As the Dakota completes its first routine of the day and moves on to the taxiway, the Lancaster taxies past the control tower towards its second display routine. *(Keith Wilson)*

to crowd centre with displays from both Flight Lieutenant Loz Rushmere and Flight Lieutenant Tim Dunlop. The final display was an exciting Spitfire and Hurricane act from Squadron Leader Andy 'Milli' Millikin (Hurricane) and Wing Commander Paul 'Godders' Godfrey (Spitfire). The whole programme had lasted almost 90 minutes, but was over by 18.25.

With all aircraft down and safely parked, OC BBMF conducted a short debrief before everyone – BBMF aircrew and engineers – gathered in front of the Lancaster, awaiting the arrival of AOC 1 Group with his verdict.

ABOVE As the Lancaster taxies past the control tower, this time with Flt Lt Roger Nicholls in the left-hand seat, Roger provides the customary wave. *(Keith Wilson)*

BELOW With their display routines completed, a number of the Lancaster aircrew return to the BBMF building. Judging from the smiles it must have gone well. From left to right are: Flt Lt Tim 'Twigs' Dunlop, Flt Lt Loz Rushmere, Flt Lt Roger Nicholls and Flt Lt Ady Hargreaves. *(Crown Copyright/SAC Graham Taylor)*

BELOW Air Vice-Marshal Stuart Atha carefully watches the proceedings of the 2012 PDA from Coningsby's control tower. Having served as station commander of RAF Coningsby in 2007 and 2008, part of his duties involved volunteering to fly with the BBMF. Consequently, he knew exactly what to look out for! *(Keith Wilson)*

Thankfully, he had been very impressed with the display, especially considering the engineering issues that had befallen the Flight leading up to the event. His conclusion was, 'From where I looked, I thought it was brilliant. So congratulations are in order. Having been on the Flight, I am deeply envious of what you do, but I do realise the weekends that you give up – it is probably the case that it is your families who suffer most.' A formal group photograph was taken with the Lancaster as a backdrop before everyone drifted off towards the BBMF HQ for a well-deserved, celebratory drink.

With the approval of the Public Display Authority, the 2013 air display season could formally begin for the Battle of Britain Memorial Flight and team members could proudly don their black display flying suits.

That was then. The team successfully obtained their 2014 PDA and enjoyed a full season performing at shows and displays across the country.

ABOVE Air Vice-Marshal Stuart Atha poses with all of the successful BBMF team underneath the Lancaster on the ramp at Coningsby, shortly after he had announced the favourable outcome of the PDA inspection in April 2012. Afterwards, the BBMF were cleared to fly for the 2012 display season. *(Keith Wilson)*

BELOW Following the 2013 PDA examination at Coningsby, Air Vice-Marshal Stuart Atha addressed the troops. Once again, the day had gone well and the BBMF were cleared to fly their 2013 display season. *(Crown Copyright/ Sergeant Pete Mobbs)*

BELOW The customary post-PDA photograph for April 2013. Air Vice-Marshal Stuart Atha poses with all the members of the BBMF underneath the Lancaster, following the successful conclusion of the 2013 PDA inspection. *(Crown Copyright/SAC Graham Taylor)*

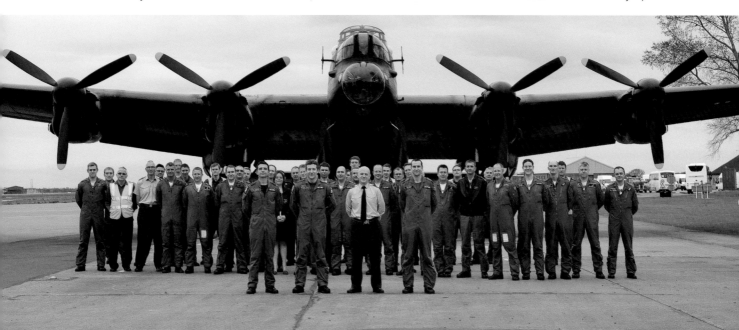

Engineering on the Flight

The Battle of Britain Memorial Flight operate a fleet of 12 rare and iconic aircraft – all are 'tail-draggers' powered by piston engines. Both the fighter and bomber crews are privileged in being able to fly these wonderful old aircraft. When you speak with the pilots, there is a healthy rivalry between bomber crews and fighter pilots. They each have their own personal favourite aircraft, but what they would all agree on is that without the small group of highly skilled and dedicated engineers, there wouldn't be any flying!

OPPOSITE The engineering scene at Coningsby in December 2013, during the middle of the winter maintenance programme. Undergoing scheduled maintenance are Spitfires IIa (P7350), LF XVIe (TE311), and PR XIX (PM631), while Lancaster PA474 can be seen in the background. *(Keith Wilson)*

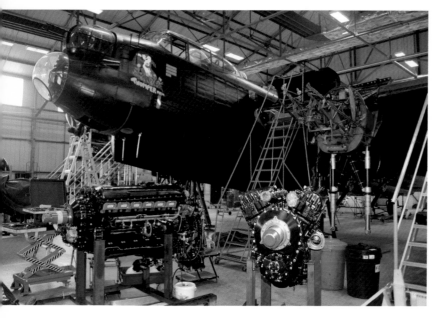

ABOVE In December 2013, both inboard engines on Lancaster PA474 were being changed as part of the scheduled maintenance programme as they had become life-expired. Two 'new' (overhauled and zero-lifed) engines can be seen waiting to be installed on to the aircraft. (Keith Wilson)

ABOVE After having successfully started the four Rolls-Royce Merlin engines on the Lancaster during the Public Display Authority (PDA) at Coningsby on 24 April 2013, SAC(T) John 'Luther' Bissett and Corporal Kelly 'Ned' Chamberlain are seen moving the trolley-acc from the vicinity with haste. (Crown Copyright/Sergeant Pete Mobbs)

At the time of going to press, the BBMF engineering team at Coningsby consisted of just 30 staff – a ratio of less than 3 engineers to

BELOW It takes five engineers to correctly position the heavy Rolls-Royce Griffon 58 engine on to its stand during an engine exchange on Spitfire PR XIX, PM631, at Coningsby on 29 April 2013. From left to right: SAC(T) Jay Billington, Corporal Mark Kirkpatrick, SAC(T) Ian Taylor, Corporal Carl Broomhead and SAC(T) Chris Cochrane. (Keith Wilson)

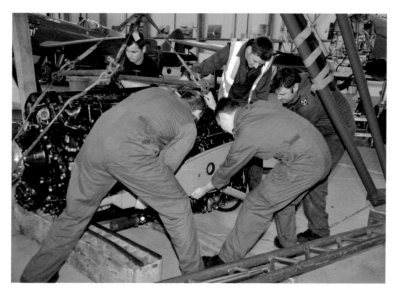

each aircraft. When compared with a Typhoon squadron, the ratio is more usually around 11.5:1, although the Tornado squadrons used to operate with a 10:1 ratio. It does clearly demonstrate the strength and ability of the small but dedicated team at Coningsby!

In addition, the technology these engineers are maintaining is not available anywhere else in the Royal Air Force. In fact, many of the skills are not even taught through engineering training within the RAF. Not only do the team have to maintain these aircraft utilising outdated technology, but they have to train all new volunteer (yes, you have to volunteer for a post with the BBMF) engineers in all the old skills and standard practices in-house. Sadly, by the time a new engineer is fully up to speed with the aircraft and systems, he is often 'spotted' within the RAF system and quickly moved on to a new unit on promotion or tour expired!

Thankfully, there are a few old hands with the important specialist engineering skills on historic airframes and systems, as well as large and powerful piston-powered engines, who will not be moved on – at least, not until they retire. And therein lies yet another problem for the team in the future!

SEngO

Leading the small but dedicated engineering team at the BBMF is Warrant Officer Kev Ball. He joined the Flight on 24 September 2012, just before the winter maintenance programme for the 2013 season – and a subsequent baptism of fire!

Kev had joined the RAF in 1980 as a direct entrant propulsion technician and after training at RAF Halton was posted to Waddington on Vulcan B2 and K2 aircraft, until the Vulcan was withdrawn from operations in 1984. Kev also did three years on the old Vulcan Display Flight before being transferred to the Nimrod AEW3. In 1989, he was posted to the Tornado Engine Bay at Woodhall Spa and then on to the Tornado F3 with 56(R) Squadron. A tour at RAF Cosford with the No 1 School of Technical Training (1 SoTT) followed, where he undertook the design and development of specialist trade training courses. A return to the Tornado followed with a posting to RAF Marham as propulsion specialist on the Tornado GR1/4 Aircraft Engineering and Development Investigation team, prior to being transferred to RAF Benson in 2004 to manage the bay support of mechanical components and engines for the Merlin HC3 and Puma HC1.

In 2007 Kev was posted to 41(R) Squadron, the Fast Jet and Weapons Operational Evaluation Unit, operating Tornado F3 and GR4 as well as the Harrier GR9/9A. In 2011, he was assigned to 32 (The Royal) Squadron at RAF Northolt to set up a Continuing Airworthiness Management Organisation for the Command Support Air Transport fleet of HS125, BAe146 and Augusta A109E.

Warrant Officer Kev Ball has completed operational tours in the Falkland Islands and Iraq and many detachments throughout Europe, the Mediterranean, the Middle East and the USA before his appointment as SEngO with the BBMF at Coningsby.

A difficult winter

During the long and difficult winter maintenance programme of 2012/13, every aircraft except PZ865 required at least an annual maintenance; while Hurricane LF363 needed a 'minor' to enable deferment of its 'major' for a further year. An undercarriage problem

LEFT Corporal Mark 'KP' Kirkpatrick receives assistance from SAC(T) Jim Baynes while removing the spinner from Spitfire PR XIX, PM631, during a primary service at Coningsby, 24 July 2013. *(Keith Wilson)*

was identified with Spitfire IIa P7350 that when diagnosed, resulted in a fleet-wide examination (and lots of extra work). The manufacture of a bespoke component for P7350 and subsequent reassembly and functional checks eventually meant that the aircraft was not ready to rejoin the fleet until August 2013.

Over the previous six months, the Flight had also suffered a very high turnover of SACs, which meant that experience levels were particularly low. Coupled with limited resources in the form of serviceable aircraft and a very high workload, this meant a cocktail of difficulties for the Flight!

By the time the Public Display Authority (PDA) was approaching in late April 2013, the Flight had one Spitfire PR Mk XIX and the Mk XVIe TE311 airworthy, along with Hurricane LF363, Lancaster PA474 and Dakota ZA947. Hurricane PZ865 had returned from its major maintenance at ARCo, Duxford, and was suffering from shakedown issues that eventually required an engine change. As the date of the PDA approached, the Spitfire PR Mk XIX fell over, with its Griffon 58 engine requiring change.

In addition to maintenance issues, there were two new bomber pilots who required the Dakota or Lancaster aircraft for training, along with a new fighter pilot and the new station commander requiring aircraft for their work-up.

On the day of the PDA, 24 April 2013, the BBMF fleet available to fly during the examination consisted of one Spitfire (TE311), one Hurricane (LF363), the Lancaster and the Dakota. All

RIGHT A number of heavy-duty jacks are put to good use to support the Lancaster while the undercarriage is removed for overhaul. *(Keith Wilson)*

ABOVE Another jack is located on the port side of the aircraft, in its assigned location on the jacking point. The leading edge skin has been removed to allow access to the various pipes and wires that service the control surfaces, hydraulics and fuel. *(Keith Wilson)*

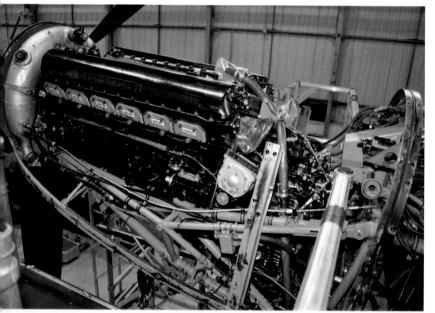

LEFT In December 2013, the starboard outer Merlin 25 engine on the Lancaster received its scheduled maintenance while remaining in-situ. Access to this height is obtained using special platforms. *(Keith Wilson)*

ABOVE On the same day the starboard inner engine had scheduled maintenance work carried out on the engine's magnetos. Here Corporal Dave Cockburn (left) and SAC(T) Phil 'Tank' Shawcroft are seen working on the wiring harness. *(Keith Wilson)*

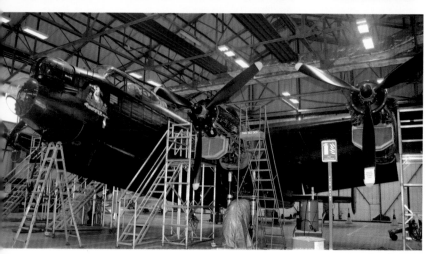

LEFT By 4 March 2014 both inboard engines had been refitted to the Lancaster and engine ground runs were carried out on 20 March. An air test was scheduled for late March and the aircraft was declared airworthy by the first week of April. *(Keith Wilson)*

four aircraft remained serviceable for both the practice as well as the actual examination and the PDA was awarded to the Flight on 24 April, as scheduled. According to Kev Ball, 'It was a close-run thing but they made it into the season. It was almost a case of the task exceeding the resource but we got there in the end!' That said, it was also a steep learning curve for Kev Ball.

Maintenance during the 2013 display season

With the 70th anniversary of the Dambuster Raid approaching, 2013 was always going to be a busy year for the Lancaster. It had two engines replaced during winter maintenance and then an engine block change in May. It was during this activity that a bigger problem was observed – the cylinder block nuts were cracking due to fatigue and this subsequently resulted in a fleet-wide check of all Merlin engines. In May, the Dambuster Raid celebrations were flown without a hitch and the Lancaster continued to prove reliable throughout the 2013 season.

Similarly, after suffering engine reliability issues in 2012, Dakota ZA947 remained serviceable until August 2013.

The fighters had a very mixed season. Spitfire LF IXe MK356 spent the winter having its coolant pipe system replumbed back to its original specification, a job that continued

RIGHT On 8 December 2013 the Flight's Dakota ZA947, normally positioned adjacent to the hangar doors, was wheeled outside to allow the engineers an opportunity to take other aircraft out into the open for engine runs. The level of the winter maintenance on the Dakota is obvious in this image. On this day, Spitfire LF IXe MK356 was moved outside for engine runs before both were returned to the hangar. *(Keith Wilson)*

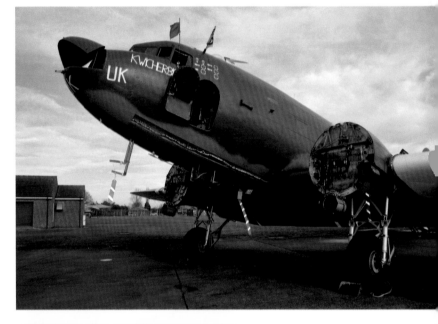

BELOW By 29 November 2013, both Pratt & Whitney R-1830 engines had been removed from the Flight's Dakota ZA947. Nearest the camera is a 'new' (actually overhauled and zero-lifed) No 1 engine in its engine stand waiting to be fitted back on to the aircraft. Just behind is the aircraft's No 2 engine, which will be refitted to the aircraft after it has received its scheduled overhaul from the Flight's engineers. *(Keith Wilson)*

LEFT While the engine ground runs were under way, adjustments were required to the vacuum pump. Here, Corporal Mathew 'Mazza' Marriott is seen making the adjustments while SAC(T) 'Sowdy' Sowden keeps a good grip on his vest to prevent any accidental movement towards the moving prop. *(Keith Wilson)*

RIGHT A good view of the jacks used to support the fuselage and undercarriage of Spitfire IIa, P7350, during its winter maintenance. With the main wheels completely off the ground, the undercarriage can be cycled or removed if required. (Keith Wilson)

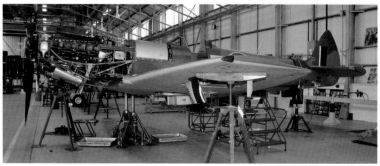

ABOVE Having made its first flight at Coningsby on 19 October 2012, Spitfire LF XVIe, TE311, joined the BBMF display team for the 2013 season, completing around 66 flying hours. It underwent its winter maintenance programme at Coningsby when it was photographed up on jacks with its undercarriage removed. (Keith Wilson)

BELOW Hurricane IIc PZ865 underwent a major maintenance with ARCo at Duxford and emerged in March 2012 painted in South East Asia Command colours as 'EG-S', representing HW840 of 34 Squadron. The engine was being test-run when a small problem with the priming pump caused a few flames on start-up, but which quickly cleared. (Keith Wilson)

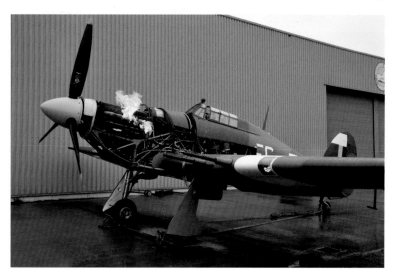

through until July 2013. Problems with the undercarriage down lock bracket continued to dog P7350 until August, when the aircraft was returned to service. Spitfire Mk Vb AB910 was already undergoing a major maintenance plus with ARCo at Duxford, having been flown there in October 2012. Thankfully, both PR XIXs and the 'new' Mk XVIe TE311 were operational for most of the season and did a lot of work. TE311 became the mainstay of the Spitfire fleet and accumulated 66 hours during the season.

As for the Hurricanes, 2013 was another mixed season. PZ865 had returned from ARCo at Duxford in early April, having completed a major maintenance plus lasting around 18 months. In early shakedown test flights, its Merlin engine suffered problems when the engine started 'hunting' and the oil pressure fluctuating at altitudes over 3,000ft, accompanied by problems with the engine's boost system. The engineers changed the carburettor and auto boost control, but no difference was noted. Next, the constant speed unit (CSU) was changed but, once again, without improvement. Next, oil and coolant leaks were noted, along with fuel leaking into the oil through the fuel pump. There was no alternative other than to replace the engine. On its first post-engine change flight test, the engine fluctuations remained, so the team looked at the pre-oiler system, which was disconnected in an attempt to eliminate it from the list of suspects. The fault appeared to go away and the decision was taken to operate for the rest of the season without it – not really a problem as the system is only used to prime the engine with oil prior to start on the ground. The winter maintenance programme of 2013/14 saw the problem resolved for the following season.

Meanwhile, Hurricane IIb LF363 had a good season and ran reliably throughout. It had accumulated 600 hours in the previous seven years and had run out of hours. Having undergone a minor maintenance during the previous winter, the aircraft was surveyed with a view to either carrying out an annual and deferring the major once again to extend the life of the aircraft for just one more season, or to carry out the major itself. The fabric was in good condition having been re-covered 15 years earlier (in 1998) but overall it was starting to

RIGHT At the end of the 2013 display season the Flight carried out a major maintenance on Hurricane IIb (LF363). The work was completed shortly after the start of the 2014 display season and represented a major success for the Flight's team of engineers. It may open the door to the Flight conducting future major maintenance programmes at Coningsby. *(Keith Wilson)*

BELOW With the fuselage fabric removed, along with the tailfin, rudder, tailplane and elevators, the internal structure of the Hurricane fuselage is clear and easily inspected. *(Keith Wilson)*

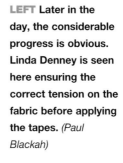

LEFT Later in the day, the considerable progress is obvious. Linda Denney is seen here ensuring the correct tension on the fabric before applying the tapes. *(Paul Blackah)*

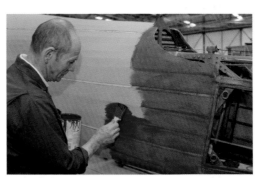

ABOVE By the following week, Clive and Linda Denney had completed the re-covering of the fuselage and had started to add red dope to the skin. *(Keith Wilson)*

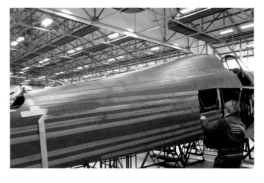

ABOVE By the following day, the first layers of dope had been applied to all of the new surfaces before further tapes were added to the surface of the fuselage. *(Paul Blackah)*

BELOW Clive Denney's unique way of ensuring that the correct number of coats of dope is applied – by keeping score on a piece of tape in the rear fuselage section. So simple, but effective! *(Paul Blackah)*

LEFT With all tapes added, further layers of dope are applied to the skin. By the end of the process no fewer than 17 coats of dope had been added. A complete respray in early April was followed by engine ground runs and an air test, with LF363 declared airworthy in May. Another great success story for the Flight's team of engineers. *(Paul Blackah)*

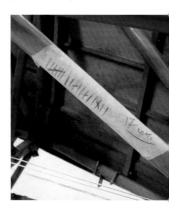

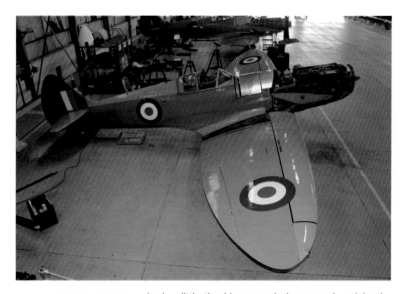

work progressed well. The maintenance work was completed and the aircraft was re-covered and repainted in new markings by the beginning of May 2013. The successful completion of the task represented another major achievement for the engineers on the Flight.

Fast flyers and slow flyers

In order to streamline the overall winter maintenance programme at Coningsby, a decision was taken to make the maintenance schedule biased towards flying hours rather than calendar life. Effectively, this means that an aircraft can be flown for two seasons after having an annual service, providing a relatively quick primary service is conducted in between. For example, Spitfire IIa P7350 had only flown 12 hours since its last annual maintenance, so only required a primary service to allow it to operate up to its designated 50 hours before the next check.

Working on this basis, three Spitfires (MK356, P7350 and PS915) along with Hurricane PZ865, became the fast flyers for 2014 with primary maintenance carried out over the winter maintenance period. The slow flyers, undertaking an annual service, were Spitfires PM631 and TE311. This change of process will allow a more cost-effective service routine and more closely match the task against the resources available to complete it.

ABOVE During the 2013/14 winter maintenance programme at Coningsby, Spitfire PR XIX, PS915, had the upper and lower surfaces of its wings repainted, in addition to a primary maintenance. By December 2013 the aircraft was reaching the end of its winter maintenance and after an air test in February 2014, PS915 was declared airworthy.
(Keith Wilson)

RIGHT Meanwhile, Spitfire PR XIX, PM631, was suspended on a pair of fuselage and wing jacks, along with a small jack under the tailplane; a couple of water containers provided ballast. In addition, all engine cowlings had been removed, along with all of the underwing inspection covers.
Keith Wilson)

look a little tired in several places and perished due to contact with oil and grease; this being quite normal for an operational Hurricane! With the Flight having managed the fleet in order to reduce the 2013/14 maintenance requirement, consideration was given to undertaking the major themselves, rather than subcontracting the task to a third party. With manpower practices and experience levels on the Flight having changed, this option became possible. Furthermore, with a major plus service due on one of the Spitfire PR Mk XIXs after the 2014 season and the Lancaster due a similar depth of maintenance in 2015, it was a case of 'now or never'! After a careful review, the decision was taken to undertake a major maintenance on LF363 at Coningsby over the winter and

AIRFRAME HOURS AND SCHEDULED MAINTENANCE PROGRAMME

The following are the total airframe hours as at the end of the 2013 display season, along with the scheduled maintenance programme conducted during the winter of 2013/14.

Aircraft Type & Serial	Total Airframe Hours	Proposed Maintenance Programme
Lancaster B.1 PA474	5,817.50	Annual. No 2 and 3 engines changed (life-expired)
Dakota III ZA947	15,880.40	Annual. No 1 engine changed (life-expired)
Spitfire Mk IIa P7350	1,795.05	Primary
Spitfire Mk Vb AB910	2,714.25	Undergoing major plus at ARCo, Duxford
Spitfire Mk IXe MK356	584.50	Primary
Spitfire Mk XVIe TE311	66.10	Annual
Spitfire PR Mk XIX PM631	2,934.05	Annual
Spitfire PR Mk XIX PS915	1,053.30	Primary
Hurricane IIb LF363	2,687.30	Major plus at BBMF
Hurricane IIc PZ865	2,568.45	Primary
Chipmunk T.10 WG486	8,151.45	Ongoing maintenance
Chipmunk T.10 WK518	12,258.35	Ongoing maintenance

The workforce and engineering trades

Of the 30 members of the engineering team at Coningsby, the skill sets are split between mechanical and avionics. The largest number of engineers (18) forms the mechanical team, which specialises in two main areas: aircraft structures and propulsion systems. Aircraft structures include all aspects of the airframe as well as the flying controls, hydraulics and pneumatic systems. Propulsion systems include all aspects of the engines and propellers, fuel, oil, ignition and cooling systems.

The avionics team is manned by just six engineers, and is responsible for the electrical and avionics systems on all the BBMF aircraft. In addition to maintaining existing equipment, the technicians are also responsible for introducing upgrades. The equipment they maintain ranges from simple emergency magnetic compasses to modern retrofitted equipment, such as the Mode S IFF transponder now fitted to all aircraft, as well as new radio and GPS systems along with P-FLARM (power flight alarm) – a traffic avoidance system.

Although the BBMF aircraft are not as electronic as modern RAF aircraft, the work on the BBMF is unusual in that it includes maintenance and repair on some items that previously would have been completed off the unit, often by a third-party specialist. Nowadays, the BBMF have their own bays for those purposes and the trades are involved in more levels of maintenance than is usual – particularly on key components including magnetos and generators.

With each member of the Flight having their own flying kit and helmet, a safety equipment fitter is on the team. The resident 'squipper' is Corporal Jim Blackburn, who joined the team in 2012.

BELOW One of the many information and progress boards in use by the engineers at the BBMF is this one located in the office of chief technician Paul Blackah MBE, the Flight's airframe specialist and engineering controller. *(Keith Wilson)*

The old hands

While most members of the BBMF engineering team are regular RAF personnel, five are full-time members of the RAF Reserve: two chief technicians (Paul Blackah, the airframe specialist and engineering controller, and Paul Routledge, who heads the training process at the Flight); they are joined by three corporals (Nigel 'Sticky' Bunn, the most experienced engine technician on the Flight, Andy Bale, a skilled avionics specialist, and Norman 'Norm' Pringle, an accomplished airframe repair technician). Between them, the five have a combined experience of more than 60 years on the Flight – know-how far too valuable to lose! They are all on a rolling four-year contract and do not get posted away from the Flight, thereby providing the long-term engineering stability and continuity that is required.

The remaining members of the engineering team comprise RAF regulars, who routinely and ideally complete between three- to five-year postings on the Flight, before they return to regular RAF operations. The entire BBMF groundcrew generally volunteer for their posts on the Flight and there is a long waiting list and selection procedure prior to drafting on to this prestigious unit.

A relatively new policy on the Flight is to accept a number of engineers direct from technical training at RAF Cosford. Currently, five SACs have come to the BBMF at this point in their careers. The Flight's own in-house training is used to develop the specialist skills they will require while working on the BBMF aircraft. The biggest advantage to this system, however, is that the engineers will remain with the BBMF for a complete tour, which in the long run will increase overall experience levels and retain

those all-important specialist skills for longer. An earlier policy had seen the very best SACs being selected and brought on to the Flight. Invariably, they were soon promoted and in no time posted elsewhere into the RAF system!

Paul Blackah MBE

Chief technician Paul Blackah MBE joined the RAF back in 1975 as an airframe fitter. Paul has served with 85 Squadron at West Raynham on Bloodhound missiles; Brize Norton on VC10s; and with 115 Squadron on Andover aircraft before joining the BBMF in 1993. He converted to full-time reserve service in 2001 and 2014 was his 21st season with the BBMF, where he serves as the airframe specialist and engineering controller.

Paul has extensive interests in historic aircraft. He was an important part of the team that restored Messerschmitt Bf109 G2, *Black 6*, to airworthy condition and was the mainstay of the team at the BBMF that brought Spitfire Mk XVI TE311 back to life after a 12-year restoration process. Paul is also a prolific writer, having written or co-authored a number of Haynes manuals on the Lancaster, Spitfire, Bf109, Hurricane and Dakota.

Paul was awarded the MBE in recognition of his work in maintaining the airframes on the BBMF's fleet of historic aircraft in the Queen's New Year's Honours of 2010.

Corporal Andy Bale

Andy joined the RAF in 1985. After completing trade training at RAF Cosford, he worked on the second line maintenance of McDonnell Douglas Phantom flight systems equipment at RAF Wattisham. In 1990, he was moved on to the first line maintenance of E-3D Sentry aircraft at RAF Waddington. Andy joined the BBMF in October 1999 and continues to serve with the Flight as an avionic specialist. At the start of 2007 Andy converted to RAF reserve service and 2014 was Andy's 14th season with the Flight.

Corporal Nigel 'Sticky' Bunn

'Sticky' joined the RAF in 1979 and after initial training was posted to RAF Linton-on-Ouse, working on Jet Provosts. He moved to Coningsby on the McDonnell Douglas Phantom and then to Lossiemouth on the Shackleton

before joining the BBMF in 1988. He is now a full-time reservist and is the BBMF's most experienced engine technician with 25 seasons to his credit. Aside from his outstanding engineering ability, 'Sticky' is best known for his love of practical jokes, which he likes to play on the rest of the Flight.

Corporal Norman 'Norm' Pringle

'Norm' joined the RAF in 1979 and, after initial training, has served at RAF Brize Norton, Valley, Abingdon and Coningsby. At Brize Norton Norman worked on VC10 aircraft and he was subsequently employed as a specialist airframe repair technician in various RAF second line bays servicing a variety of airframe systems components. In 1996, he joined the BBMF and in 2002, transferred to the full-time reserve; 2014 was his 19th season on the Flight.

Rapid turnover of engineering personnel

One of the major engineering issues on the Flight is the turnover of skilled engineers. All engineers volunteer to join the Flight and, once selected, have a steep learning curve to accomplish before they can be of greatest benefit to the team. At the end of 2013, all bar one SAC (11 out of 12) had been transferred off the Flight to join other front-line RAF units within the previous twelve months. Three out of eleven corporals have also left the team since August 2013. Finally, Flight Sergeant Dick Chaffey retired from the RAF in November 2013. Dick had been with the team for five seasons. Thankfully, the team was able to recruit another very capable and experienced engineer in Flight Sergeant Dean McAllister, who joined the BBMF in January 2014.

Dean joined the RAF in 1987 as an airframes and propulsion apprentice. Following three years of training at RAF Halton, he was posted to HQ SAR Wing at RAF Finningley, carrying out deep strip and rebuild maintenance on Sea King Mk 3 helicopters. It was a relatively short posting as HQ SAR Wing was relocated to RAF St Mawgan. After completing three tours to the Falkland Islands with 78 Squadron, life overseas beckoned again with a posting to IV(AC) Squadron at RAF Laarbruch with the Harrier Force. While with IV(AC) Squadron, Dean was lucky enough to enjoy deployments and detachments to Yuma in Arizona, Goose Bay in Canada, Bodo in Norway and extensive periods spent covering the conflict in the former Yugoslavia.

In June 2011, Dean joined the Typhoon Force with a posting to the Typhoon Propulsion Support Facility (TPSF) at Coningsby. Here, Dean ran the Royal Air Force element of the EJ200 engine bay, supporting the Typhoon Force in partnership with Rolls-Royce.

He was lucky enough to drive past the Flight each day on his way to the TPSF and admire the BBMF aircraft from afar. Dean was amazed and delighted when a post became available with the Flight – the prospect of working with such iconic pieces of British aviation was exciting and he jumped at the chance to return to 'hands-on' engineering. Dean recalls, 'I was elated when OC BBMF rang me to say that I had been selected for the post and I have not stopped smiling ever since; this is undoubtedly the pinnacle of my career.'

Training and standards cell

When engineers leave, they take with them the specialised skills that they have acquired during their time with the BBMF. New arrivals do not possess the specialist – and often obsolete by modern RAF standards – skills required to work on Second World War-era aircraft and engines. Consequently, the BBMF have their own in-house training and standards cell, which delivers essential training to the BBMF technicians on the Flight's five different types of aircraft. Both the mechanical and avionic trades provide manpower for the cell, which is managed by chief technician Paul Routledge.

Paul joined the RAF in 1986 and was initially

BELOW One of the training aids in use with the BBMF at Coningsby is this small stand displaying the four types of spark plugs used in the various types of aircraft engines on the Flight. *(Keith Wilson)*

posted on to the Lightning aircraft. His next tour was on Percival Pembroke aircraft with 60 Squadron at RAF Wildenrath. It was here that he gained his knowledge on piston-engine and prop-driven aircraft. After further training and a tour at Marham, he was posted to RAF Waddington to work on the E-3D Sentry. After gaining promotion to the rank of sergeant, a tour on 3 Squadron Harriers followed, and he served in Afghanistan. He was later called back to the Sentry fleet for crew chief training, undertaking the necessary training in all trade disciplines of the aircraft.

Paul left the RAF in 2010 where he took up a role as an instructor with BAE Systems, but after hearing the BBMF were in need of an instructor he successfully applied for the FTRS role of SNCO of the training world at BBMF, teaching aircrew and groundcrew the systems on all five of the aircraft types operated by the Flight.

According to Paul, 'The in-house training is paramount in getting our small team of engineers up to speed and providing maximum effectiveness quickly.' The training and standards cell on the Flight is responsible for teaching new engineers and aircrew the aircraft systems to enable them to carry out their roles at the BBMF. Recently, the course underwent a major modernisation in terms of both content and delivery, and this has resulted in the award of formal RAF-recognised qualifications – 'The BBMF Trade Q Annotation' – and the competence of the Flight is measured by it. Furthermore, 'The BBMF Trade X Annotation' is based on individuals' experience of the various aircraft types and systems on the Flight. The overall qualification is based on a combination of both 'Q' and 'X', along with the excellent line training provided on the Flight. Clearly, the very best engineers are 'Q', 'X' and line trained; although as Paul added, 'You must never stop learning!'

21st-century parametric data gathering

When Sir Sydney Camm designed the Hurricane, it did not have a determined or finite fatigue life. During the Second World War, the average life expectancy of a Spitfire or Hurricane was around 100 flight hours. At the time, no one could have imagined that two Hurricanes would still be flying more than 70 years later; in fact, the aeroplane was never designed to achieve it! Nor was it designed to be completely dismantled and subsequently rebuilt – but it has been. Consequently, maintaining these wonderful old icons has become so much more of a science than was originally envisaged.

The operation and maintenance of all RAF aircraft is now governed by Military Aviation Authority (MAA) regulation. The BBMF aircraft are not exempt from these regulations, nor do they receive any form of dispensation from them. A requirement of the regulations is to ensure 'an acceptable and demonstrable level of structural integrity' utilising operational load measurement (OLM).

To comply with this requirement – initially as a trial – Hurricane PZ865 has been fitted with a parametric data gathering (PDG) system during the recent major maintenance plus programme it underwent with ARCo at Duxford. Although it is not strictly an OLM system, it is hoped that, over time, the PDG system will provide an acceptable alternative; and that the data will significantly increase the understanding of fatigue exposure – thereby ensuring the long-term safety of the BBMF aircraft.

The state-of-the-art PDG system installed in PZ865 was designed by Cosworth and is similar to those currently used by Formula 1 racing teams to monitor car and engine performance. The system monitors and records data from a multitude of operations and systems. During flight, the system records control surface positions, applied stick forces and roll and pitch and yaw rates, while also monitoring the engine's temperatures and pressures, rpm and engine boost independently of the normal cockpit engine gauges. In addition, throttle position and cockpit conditions, including noise and carbon monoxide levels are all monitored.

A small warning or 'caution' panel has been installed in the cockpit – on the lower left-hand side of the instrument panel – in the form of four LEDs. These direct the pilot to an alpha-numeric display, where any particular fault is displayed in more detail.

One of the key components of the system is the IMU (inertial measuring unit), which is installed behind the instrument panel. It employs three rate

gyros that rapidly track all changes in orientation in 3D. It is supported by an internal low-power signal processor, its tri-axis accelerometers also provide monitoring of fatigue in the range of plus or minus 5 g in any axis.

This installation is not a short-term fix. The long-term data recording and information it is hoped will be provided should allow a far greater understanding of the stresses and strains that the aircraft undergoes during its life with the BBMF. The data will be gathered and collated year-on-year, to quantify what is the 'norm' and to understand the flight envelope better. Cranfield Aerospace are providing significant technical support and will review the data and help identify what, if any, actions may be required to support the ongoing flying of the aircraft.

The system is also available to the groundcrew who can interrogate the data to aid fault-finding, should the need arise.

The fitting of the PDG to PZ865 underpins the full operating safety case for the aircraft, and is a direct requirement of modern MAA regulations. The rather strange result is that one of the oldest aircraft in the RAF has now been fitted with one of the most modern data gathering systems in existence, a system that not even the RAF's Typhoon fleet benefits from!

BBMF SERVICING SCHEDULES

	Annual	Minor	Major
Spitfire	1 Year (70 FH)	4 Years (280 FH)	8 Years (560 FH)
Hurricane	1 Year (100 FH)	3 Years (300 FH)	6 Years (600 FH)
Lancaster	1 Year (120 FH)	4 Years	8 Years (900 FH)
Dakota	1 Year (200 FH)	5 Years	10 Years (2,000 FH)

(Source: WO Kev Ball, SEngO BBMF.) FH = Flying hours.

Notes to table

The service schedules indicated in green are generally carried out on the Flight at Coningsby, while those in red are done by a contracted maintenance organisation. That said, the current major maintenance on Hurricane LF363 is currently being completed by engineers on the Flight.

In addition, all aircraft have a primary that is carried out after 28 flying hours on the fighters and 56 flying hours on the Lancaster and Dakota. A primary consists of an oil change and replacing filters and spark plugs.

The other maintenance is an RCM (reliability centred maintenance) programme produced in the aircraft 5(A)1 Master Maintenance Schedule. This scheduled maintenance gets progressively more in depth as the aircraft's flying hours accumulate through to its major. This includes preventive maintenance and any emergent work that may be identified (corrective maintenance) and covers all requirements for structural, propulsion and systems integrity.

For the maintenance carried out by the Flight, the SEngO has the authority to apply a 25% maintenance latitude or extension. This provides the required flexibility in the programme for fleet management; ensuring that an annual may not always need to be carried out after every display season. This is nominally applied when the flying hours component of the maintenance periodicity has greater than 50% remaining.

The latest round of majors is referred to as a major plus. This is a major carried out in accordance with the major maintenance schedule with additional work to confirm a baseline standard or configuration. It also gives the Flight a better understanding and approval of repairs and modifications that may have been carried out during the aircraft's in-service life.

For the two Chipmunk aircraft in service with the Flight, both of which operate throughout the year, a slightly different maintenance programme is used:

	Bi-annual	Minor	Major
Chipmunk	2 Years (200 FH)	4 Years (400 FH)	8 Years (800 FH)

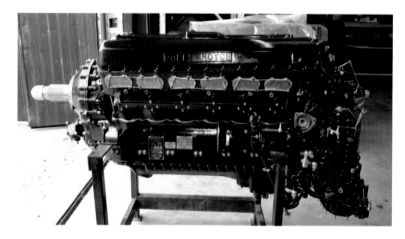

ABOVE A Rolls-Royce Merlin 3 engine at Retro Track and Air, awaiting delivery to the customer after being overhauled and zero-lifed. *(Keith Wilson)*

ABOVE A completely stripped Rolls-Royce Merlin 500 crankcase on its rotating jig. *(Keith Wilson)*

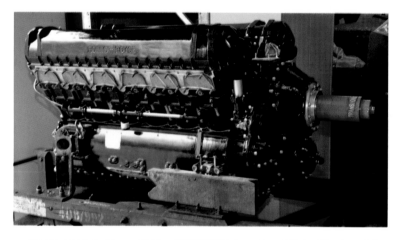

ABOVE A close-up of a Rolls-Royce Merlin 500 crankshaft. *(Keith Wilson)*

ABOVE A Rolls-Royce Griffon 58RG30SM-S engine at Retro Track and Air. This is the mark of Griffon engine that was originally manufactured for the Avro Shackleton but the BBMF's two Spitfire PR XIXs have been modified to accept this variant. In addition, the contra-rotating system on the engine has been removed and converted to a single prop, while clearance has been added to the supercharger to permit installation into the Spitfire. *(Keith Wilson)*

BELOW LEFT A Magnaflux magnetic particle inspection machine is used to check the crankshaft for any signs of fatigue cracking. The crankshaft is sprayed with a special green fluorescent, magnetic ink and once the white lights are extinguished and the object is subjected to ultraviolet light, any signs of fatigue cracks become visible. *(Keith Wilson)*

BELOW Steve Walker working on a Rolls-Royce Griffon rocker assembly. *(Keith Wilson)*

Retro Track and Air

Retro Track and Air (UK) Limited have supported the Flight for more than 15 years and during that time they have completed in excess of 40 engine overhauls of both Rolls-Royce Merlin and Griffon types. To date, Retro has completed more than 100 engine overhauls for clients worldwide, including Rolls-Royce plc and many overseas air forces.

The RAF Battle of Britain Memorial Flight has several engines currently in the process of being overhauled. With so many flying hours being clocked up each season, it is no mean feat to support these hugely important and iconic aircraft.

In addition to the continuous supply of fully tested and overhauled engines, Retro furnishes the Flight with many additional parts. The supply of parts has become increasingly difficult over

the years and this situation will only become worse. Consequently, Retro have invested much time and resources into being able to reverse-engineer many new parts, including Merlin cylinder heads and Rotol/de Havilland propellers, to name but two.

Backed with its A8-20 and A8-21 accreditations, Retro is one of very few organisations that have the ability to design and manufacture in-house, enabling them to take complete control of the entire design and manufacturing processes.

Re-covering and painting

Based on the delightful airfield at Audley End, Vintage Fabrics Limited have been undertaking fabric and doping work for the

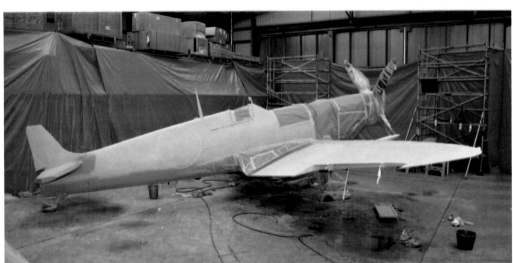

RIGHT The next stage was the painting of the grey undersides. Before this could be accomplished, the undercarriage legs and bays had to be completely masked. *(Keith Wilson)*

FAR RIGHT Next, the grey fuselage undersides were painted. *(Keith Wilson)*

RIGHT Before any paint is added, the undersides are carefully treated with tack rags to remove any remaining dust from the surfaces. Here Robert Turpin is seen working on the starboard wingtip. *(Keith Wilson)*

RIGHT The grey paint is mixed in a ratio of 5:1:1. Andrew Denney then adds one part of hardener (seen here) before one part of thinners goes into the mix. Finally, a small quantity of 'Speed' – System 20 Rocket – is added to accelerate drying in a cool environment. *(Keith Wilson)*

BBMF for 30 years, and painting their aircraft for almost as long. The first BBMF aircraft they ever worked on was the Devon VP981, which was completed in August 1984. Since then, they have completed fabric, doping and painting work on six of the Flight's Spitfires, two Hurricanes and two Chipmunks, as well as some work on the Lancaster flying surfaces.

Clive Denney also specialises in the detail paintwork. This can range from nose art and squadron motifs to stencils. Examples of Clive's artwork can be seen on many static and flying aircraft around the world. His most recent work for the BBMF includes the *Thumper Mk III* nose art on Lancaster PA474, as well as all the details applied to Spitfire MK356 during its recent repaint.

On the fabric front, they have become specialists in covering in Irish linen, although other coverings such as ceconite and cotton can be applied using traditional covering methods.

Vintage Fabrics specialise in aircraft from the First to the Second World War, and not only in terms of fabric and painting. Having been granted CAA Approval A8-20, Vintage Fabrics are able to undertake the complete maintenance and restoration of a variety of aircraft, although they do seem to specialise on warbirds – especially the Tiger Moth and Chipmunk. Their customer base is worldwide.

More recently, they have undertaken specialist work on aircraft fuel tank repairs, including some completed for the BBMF during the current major maintenance on Hurricane LF363.

For further information on Vintage Fabrics, please visit their website at www.vintagefabrics.co.uk.

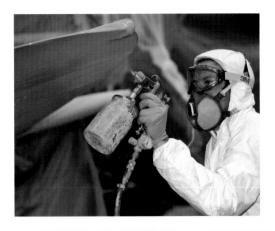

FAR LEFT Andrew Denney, suitably masked and protected, starts to paint the first coat of grey on to the wing undersides. *(Keith Wilson)*

LEFT Access to the more difficult under-wing locations is alleviated by using a trolley board, especially when access to the undercarriage bay is demanded. *(Keith Wilson)*

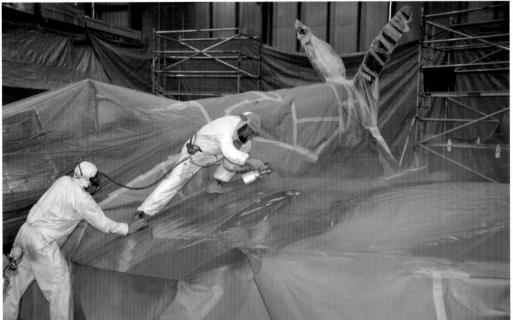

LEFT By 9 October the undersides had been completed, along with the fuselage camouflage and roundels. Clive Denney is seen painting the first coat of camouflage on to the starboard top wing using a technique called 'wet on wet'. Operating in this manner, and regularly changing from one colour to another, the camouflage is completed while all colours are wet, which provides a feathered effect to the colours. *(Keith Wilson)*

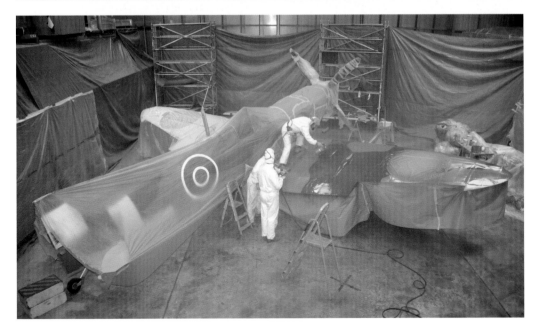

LEFT With the large green spray can fitted to the gun, Clive Denney fills in the areas of green. Andrew Denney keeps the hose away from the wet paint while David Dawnay holds on to the remaining spray cans. Once the layers of paint have been added to the top wing, a light coat of thinners is sprayed on to the paint to ensure nice, smooth lines between the camouflage colours. *(Keith Wilson)*

ABOVE Once the paint has dried and hardened on the starboard wing, the masking tape and paper are carefully removed from the adjacent areas. In some situations a scalpel is used to remove small pieces of masking tape. *(Keith Wilson)*

ABOVE With the starboard wing completed, the port wing is masked using brown paper and tape. A skirt is also arranged around the wing to prevent any overspray getting on to the undersides of the wing. Andrew Denney and David Dawnay are seen here adding the skirt. *(Keith Wilson)*

RIGHT With the wing suitably masked and with sheets of polythene used to protect any other exposed areas from overspray, Clive Denney starts work on the port wing camouflage. The different colours are not masked. Instead Clive works freehand, using colour drawing guides supplied by the BBMF. *(Keith Wilson)*

ABOVE RIGHT All fixings have to be painted the correct colour. To achieve this, they are mounted on to sheets of cardboard. *(Keith Wilson)*

RIGHT By 14 October, all the camouflage paint had been completed and the black and white invasion stripes added to the undersides of the wings and fuselage. *(Keith Wilson)*

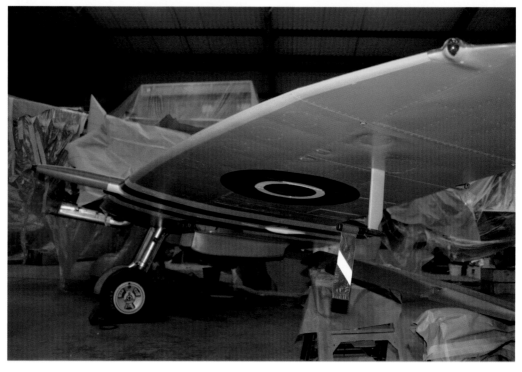

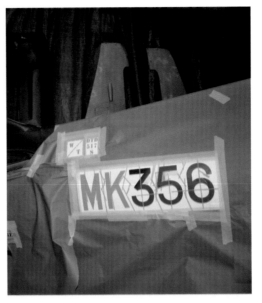

FAR LEFT Next, all the small details are painted using stencils. *(Keith Wilson)*

LEFT Once applied, the stencils have to be carefully masked to ensure the black paint is not transferred anywhere else. *(Keith Wilson)*

BELOW Some of the tiny, intricate details take an inordinate amount of time to achieve! The name 'Kay' and the kills are added to the port side fuselage adjacent to the cockpit using stencils. Here, Clive Denney is seen positioning the stencils into place. *(Keith Wilson)*

LEFT Very narrow masking tape is used to ensure the correct size and position of each individual kill. *(Keith Wilson)*

FAR LEFT Then, the area is completely masked to protect the paint underneath. *(Keith Wilson)*

LEFT Black paint is used from special spray cans. Afterwards, the paint is allowed to dry and harden. *(Keith Wilson)*

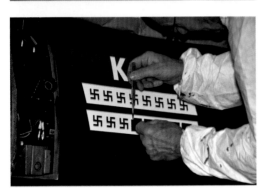

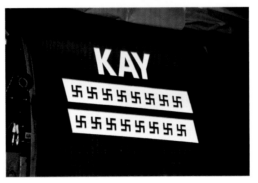

FAR LEFT A small scalpel is used to carefully remove unwanted parts of the stencil . . . *(Keith Wilson)*

LEFT . . . revealing a neatly painted row of kills to the white areas. *(Keith Wilson)*

ABOVE Following the end of the 2012 display season, Spitfire Vb, AB910, was flown to ARCo at Duxford to undergo a major maintenance plus. The aircraft arrived at Duxford on 7 October, and by the 18th, all the systems had been checked for correct operation prior to strip by the ARCo engineers, and the dismantling had commenced. *(Keith Wilson)*

BELOW By May 2013, the aircraft had been completely dismantled and all of the surface paint had been chemically stripped from the fuselage's external surfaces. *(Keith Wilson)*

BELOW RIGHT This image, taken in May 2013, shows some of the 'green' magnesium alloy rivets that were discovered after the paint had been stripped from the fuselage. All had to be removed and replaced. *(Billy Fletcher)*

Aircraft Restoration Company

The Aircraft Restoration Company (ARCo) has provided in-depth maintenance support to the BBMF since 2002. The core work involves carrying out major maintenance, which is the deepest level of maintenance in the MoD maintenance schedule.

For the Spitfire aircraft this occurs every eight years; however, these aircraft are now approximately seventy years old, and during this time may have required many repairs and other solutions to keep them flying. In recent years the Engineering Authority for the BBMF aircraft have requested that a major plus is carried out. This,

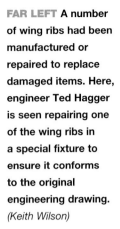

in addition to the major, includes an extensive survey of the aircraft to identify and review the repairs and solutions that the aircraft may already have needed. Additionally, there has been a requirement to introduce modifications to enhance the safety and airworthiness of the aircraft. ARCo has designed, developed and assisted with the approval and embodiment of these modifications.

With regard to Spitfire Mk Vb AB910, this aircraft has flown over 2,700 hours, including 143 combat sorties. During her life, AB910 has also suffered landing accidents and has also been involved in a serious head-on collision during a take-off run. Consequently, the major plus reviewed all the repairs that

had been completed in the past while the opportunity was also taken to carry out extensive refurbishment of the fuselage, tail section, engine bearer and mainplanes. The refurbishment is carried out as sympathetically as possible, retaining as much of the original components and structure as feasible.

The modifications being designed and embodied include P-FLARM (power flight alarm – an aircraft collision avoidance warning system), plus the fitting of a parametrics data gathering system (see p. 110) similar to that used on Formula 1 racing cars, fire-proof sleeve protection of hoses carrying flammable liquids in the engine bay, a pre-oiling system for the engine valve-gear and an improved oil filtration system.

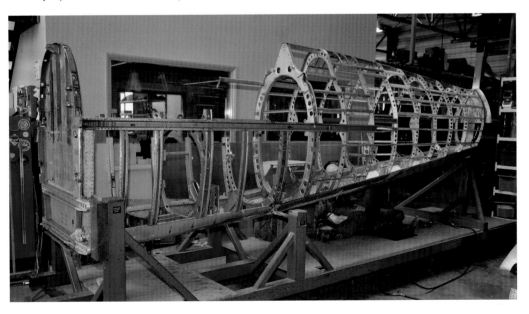

RIGHT Engineer Brian Lock painstakingly de-riveting a skin from a bottom longeron. The original design used rivets made from an aluminium alloy with a high magnesium content (commonly called 'greens' due to their colouration); however 'greens' are susceptible to corrosion. Therefore, these are replaced with more durable Hiduminium rivets, known as 'purples' because of their colouration. The knack is to carefully drill the rivet head until it becomes detached from the shank, then remove the remainder of the rivet with a punch. This prevents the holes becoming oversize and the need to fit oversize rivets. *(Keith Wilson)*

RIGHT This image, taken in July 2013, shows the starboard side of frame 12 (just aft of the fixed transparency behind the canopy). In the past, oversize rivets had been fitted and then the skin had been replaced, but due to the oversize rivets, additional holes had been drilled to take the standard size rivets, consequently the frame was like a Swiss cheese! This was not discovered until the skin had been removed from the frame. *(Billy Fletcher)*

BELOW By July 2013, the wing spars had been remanufactured and the repaired leading edge ribs were being fitted. Here, engineer Dave Oxley is seen trial-fitting the ribs to the spar. *(Keith Wilson)*

BELOW By late October 2013, new fuselage skins were being fitted to the frame while still in its jig. Note the new 'purple' Hiduminium rivets. The name Hiduminium is derived from that of High Duty Aluminium alloys – a product developed for aircraft use by Rolls-Royce before the Second World War. *(Keith Wilson)*

BELOW RIGHT At the same time, frame 5, which takes the load of the engine bearer, mainplane front spars, plus the fuselage datum and bottom longerons, was being extensively repaired by engineer Tony Duffin. Here we see him riveting, while another engineer (out of view) is holding a reaction block against the rivet tails. *(Keith Wilson)*

ABOVE Items conditioned as unserviceable are rectified as required. Here is the forward elevator bell-crank and mounting assembly. The green label denotes it is now serviceable and ready for fitment. The plastic bag with the red unserviceable label contains the original attaching fasteners for reference when the item is refitted. The serviceable items are stored by system on the dedicated racking, awaiting fitment. *(Keith Wilson)*

ABOVE **By March 2014 work had progressed on the fuselage. This view shows a skin that was replaced due to oversize rivets, dents, cracks and the fact that it did not conform to the original design skin pattern. This skin should continue to one frame past the access hatch. The original has been laid up alongside the new fuselage for comparison purposes.** *(Billy Fletcher)*

Summary

What a difference twelve months can make! At the time of the PDA in April 2013, only four airframes (Lancaster, Dakota, Spitfire TE311 and Hurricane LF363) were serviceable. By mid-March 2014, all but four aircraft had already been flight tested and declared serviceable. By PDA in April 2014, all aircraft except Hurricane LF363 (undergoing major maintenance at Coningsby, including a re-cover and repaint, which was completed by the beginning of May 2014) and Spitfire AB910 (undergoing major plus and not expected back at Coningsby until 2015) were serviceable and available to the Flight.

It is testimony to the dedication, skill and endeavour of all of the current Battle of Britain Memorial Flight engineering team who have made this happen.

BBMF maintenance situation as at 18 March 2014

Aircraft Type and Serial	Current Flying Hours	State and Forecast	Comments
LANCASTER B Mk I PA474	5,817.50	U/S 31 March 2014	Annual. Panels fit. EGRs. Air test.
SPITFIRE Mk IIa P7350	1,795.25	S	Passed air test 27 February 2014.
SPITFIRE Mk Vb AB910	2,714.25	U/S September 2014	Major plus at ARCo, Duxford.
SPITFIRE LF Mk IXe MK356	584.50	S	Passed air test 17 December 2013. Four further flights.
SPITFIRE LF Mk XVIe TE311	66.10	U/S 7 April 2014	Annual. Undercarriage functionals. Windscreen crack repair. Lower cowl crack repair. Panels fit. EGRs. Air test.
SPITFIRE PR Mk XIX PM631	2,934.40	S	Passed air test 27 February 2014.
SPITFIRE PR Mk XIX PS915	1,054.05	S	Passed air test 10 February 2014.
HURRICANE Mk IIc LF363	2,687.30	U/S 5 May 2014	Major at BBMF.
HURRICANE Mk IIc PZ865	2,569.25	S	Passed air test 23 January 2014. Two further flights.
C47 DAKOTA ZA947	15,881.00	S	Passed air test 19 March 2014.
CHIPMUNK T.10 WG486	8,159.45	S	
CHIPMUNK T.10 WK518	12,274.50	S	

(Source: WO Kev Ball, SEngO BBMF.)
U/S = Unserviceable (date indicates when aircraft is expected to be serviceable)
S = Serviceable
EGR = Engine ground run

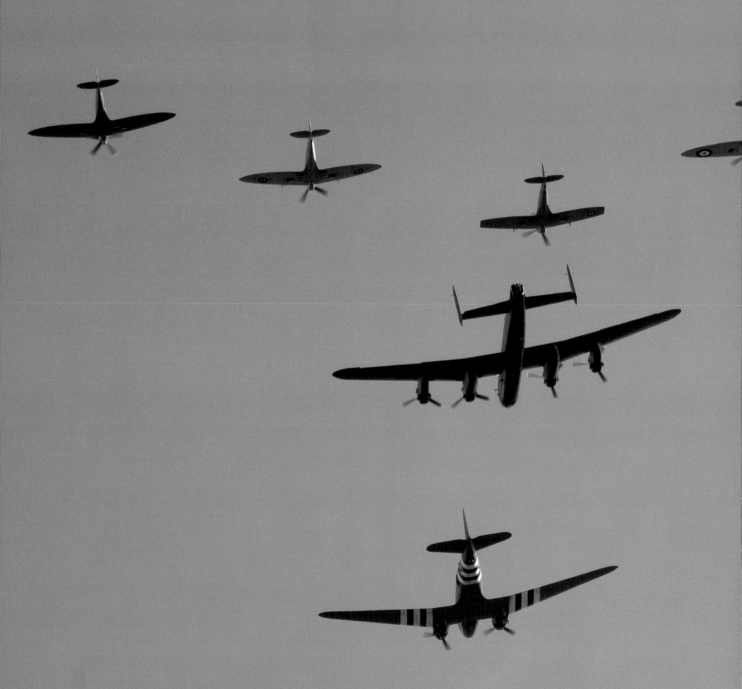

Chapter Seven

Showtime

When Air Vice-Marshal Stu Atha declared the Battle of Britain Memorial Flight fit to fly on 24 April 2013 and signed off the all-important Public Display Authority documents, all of the team members were able to don their all-black commemorative flying suits and prepare for another busy season ahead.

OPPOSITE The Lincolnshire Lancaster Association Day at Coningsby is usually the Flight's last major display programme of the season. As a consequence, the team like to present something a little 'unusual' to the invited audience. Held on 29 September 2013, the Lincolnshire Lancaster Association Day produced this spectacular seven-ship formation of Dakota, Lancaster and all five of the Flight's then airworthy Spitfires. *(Oliver Wilson)*

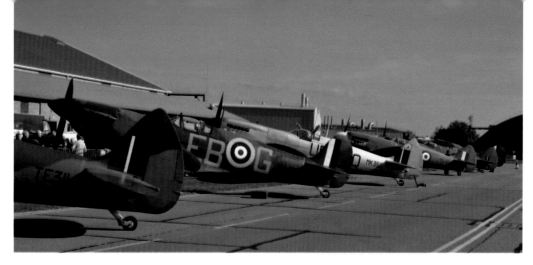

RIGHT Five of the BBMF's Spitfires line up alongside the fence ahead of the Lincolnshire Lancaster Association Day. Interestingly, all five aircraft flew in formation during the afternoon's display. The only Spitfire missing for the occasion was AB910, which was at ARCo, Duxford, undergoing a major maintenance. *(Keith Wilson)*

Throughout the year, air show and event organisers are able to make a bid for an appearance from the BBMF through an internet site managed by the events team at RAF Northolt. It may be a request for a single aircraft fly-by at a small country event; it may be a request for the hallmark three-ship Lancaster, Spitfire and Hurricane display at one of the large air shows; it may even be a request for one of the major 70th anniversary celebratory events regarding D-Day or Arnhem. Whatever the request, the application is made in exactly the same way. The decision on what flies where is based upon a number of factors, although the recruitment impact is considered by the events team as a major priority.

Around the beginning of November, the events team notifies the BBMF administration team of around 600–700 requests for displays and fly-bys that meet their criteria. Against this, the BBMF have to weigh up the number of fighter and bomber hours each aircraft is allowed to fly (see p. 126). Working in conjunction with OC BBMF, the admin team complete the detailed and meticulous planning process. For 13 seasons, up to 2012, the team was led by Flight Lieutenant Jack Hawkins, a former Victor pilot. On Jack's retirement, the position of operations officer was filled by Flight Lieutenant Anthony 'Parky' Parkinson MBE, who was already a fighter pilot on the Flight.

The initial task for 'Parky' is to create an outline programme for the year. Once these have been established, he is able to consider the numerous requests for fly-bys that may be possible en route as well as on the way home from the display. If a major air show has requested the three-ship formation of Lancaster, Spitfire and Hurricane, it is very likely that the aircraft will not fly directly to the display in formation – especially bearing in mind the types, differing cruise speeds and ranges. It is more likely that the fighters will take off together (or perhaps even separately) and perform a series of fly-bys to and from the rendezvous point (RV), ahead of the main three-ship display.

BELOW At the BBC Children in Need air show, held at Little Gransden on 25 August 2013, the BBMF Lancaster, Spitfire and Hurricane all appeared – although not together. Early in the programme the Spitfire LF XVIe (TE311) and Hurricane IIb (LF363) performed their 'Duo' programme, while the Lancaster performed on its own later in the day. At the time, the team were operating from nearby Cambridge airport and the aircraft had commitments at various locations, which prevented them from displaying together at Little Gransden. *(Keith Wilson)*

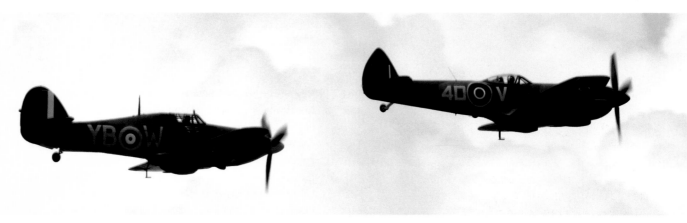

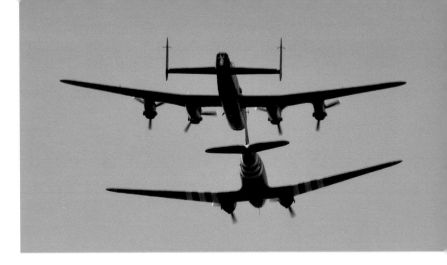

Similarly, the Lancaster may manage a couple of fly-bys on its route to the RV. Once at the RV, at the appointed time, the three aircraft join up and display together. They *may* return to Coningsby together; alternatively, they may separate and perform as individual aircraft on their way home. Generally, 'Parky' is able to consider up to seven fly-by venues; each aircraft can perform at up to five fly-by sites en route. It is their fuel duration that decides the number of appearances. The Lancaster operates with a fuel duration of around 4 hours but the Spitfires and Hurricanes usually operate with just a 1 hour and 45 minute availability – so that dictates what is achievable.

The availability of crews and their permitted flying hours are also a restriction. At the time of writing (2014), there are five fighter pilots able to operate the five Spitfires and two Hurricanes currently airworthy (Spitfire AB910 is currently undergoing a major maintenance plus at ARCo, Duxford), and just five bomber pilots able to fly the Lancaster or Dakota, although that number increased by one during 2014. Then there are the individual flying hours restrictions: for the OC BBMF that number is 80 hours in any one year; for all the other mainly volunteer pilots, the limit is just 55 hours and that includes the training and working-up hours flown.

A separate planning folder is created for each and every location, containing all the relevant timings, site details and crowd lines for any given sortie. Ahead of the actual day, the fighter pilot or bomber navigator assigned to the task will collect all the relevant folders. Sometimes, it can be as many as 16 folders in use on any one trip! The fighter pilot or bomber navigator will then plan the exact sortie using the in-house advanced mission planning aid facility. This capability refines all timings, turning points and key navigational locations ahead of the actual sortie, as well as producing detailed maps and charts for the pilots on the day.

Flexibility is essential on the Flight and bad weather is its biggest enemy; 2012 was a particularly bad year, with only 10% of the trips working to plan. Crosswinds seriously affect planning issues due to the very tight (but necessary) limits imposed on both the aircraft and individual pilots. Thankfully, the weather in 2013 was much kinder to the Flight.

ABOVE The unusual two-ship display of Dakota and Lancaster was featured during the Lincolnshire Lancaster Association Day. *(Oliver Wilson)*

BELOW Another view of the spectacular 'Balbo' at Coningsby during the Lincolnshire Lancaster Association Day. *(Keith Wilson)*

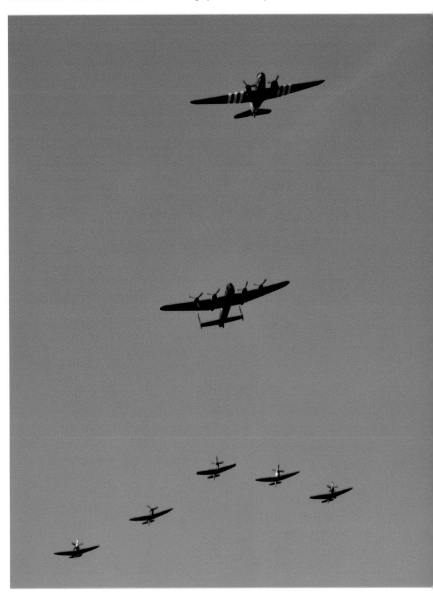

The BBMF backroom staff

Operations officer

Currently, the operations officer on the Flight is Flight Lieutenant Anthony 'Parky' Parkinson MBE. Parky joined the RAF at 18 and has been flying ever since. He was the very first pilot to gain 1,000 flying hours on the RAF's latest fighter – the Typhoon. He has also flown over 1,000 hours on three other types – the Phantom, Tornado F3 and Hawk T1. 'Parky' was selected to fly with the Red Arrows, where he flew as Red 2 (2001), Red 4 (2002) and Red 8 (2003). He also flew the F-16 with the Royal Netherlands Air Force for three years. To date, he has achieved well over 6,000 flying hours in total; 2014 was his ninth year with the Flight and he still flies the fleet of fighters regularly.

Operations assistant

Jim Stewart joined the Flight in the new post

of operations assistant back in 2004. He had previously served in the RAF for 37 years as an MT driver and transport manager, retiring as a warrant officer. He provides assistance to the operations officer and is specifically responsible for supplying accurate and up-to-date flight planning information, and for the smooth running of the Flight's operations room.

Public relations officer

Yvonne Masters joined the Flight in the post of public relations officer in June 2008. This is Yvonne's second tour at the BBMF, having been the administration assistant from 1992 until 1997. Yvonne has worked for the MoD for nearly 20 years, including posts at RAF Coningsby, RAF Wittering and RAF Waddington. She is responsible for the coordination of all PR activities through various media outlets, Flight visits, and the BBMF website where she is normally the first point of contact for telephone enquires. Yvonne also manages the RAF BBMF Twitter and YouTube accounts. The year 2014 was Yvonne's sixth season with BBMF.

Counting the hours

In order to maximise the valuable engine and airframe life of each BBMF asset, there are specific limitations placed on each aircraft. The Lancaster is permitted to fly just 104 hours per year, although in 2012 it was slightly lower due to an overfly of hours from 2011. The Dakota is limited to just 180 hours per year and was under pressure in 2014 as the year represented the 70th anniversary of both D-Day and the Arnhem landings, so it was in great demand.

A combined total of 200 hours is permitted on *all* of the Spitfires on the Flight. In 2012, the fleet had just five Spitfires available. However, in 2013 TE311 joined the fleet but AB910 was lost to a major plus service at ARCo, Duxford. At some stage in 2015, the Flight will have all six Spitfires airworthy and available to fly, but nevertheless the combined total hours of the fleet will remain at 200 even if all six Spitfires are available. Another factor to consider is the maintenance cycle on each aircraft and, as a consequence, the hours are not equally divided across the fleet. Instead the engineers will decide to overfly an aircraft that might have

extra hours available before going for major servicing, usually at the end of a display season. Equally, they might deliberately hold the hours back on another Spitfire if it came up late in a display season, in order to reduce the level of winter maintenance required to continue its airworthiness for the following season. In 2013, Spitfire IIa P7350 suffered with continuing problems to its undercarriage down lock bracket, which continued until August. As a consequence, the aircraft was unable to rejoin the fleet until late in the display season. It had flown very few hours since its last annual maintenance, so only required a primary service to permit it continued operations up to its designated 50 hours before the next check was required. Because of this, it was decided to actively minimise the hours flown in the remainder of 2013 and a total of just 12 were made.

For the Hurricanes, a combined total of 120 hours is permitted on *both* airframes. However, during 2011 and 2012 the Flight only had one Hurricane available to it as PZ865 was undergoing a lengthy major plus at ARCo, Duxford. The Flight could not afford to put 240 hours on to LF363 over the two-year period, as she would have run out of hours before her next major service. As a result, LF363 flew around 160 hours over the two seasons, with a view to flying her less in 2013 after PZ865 had returned from service and was expected to fly a little more.

As 'Parky' explained: 'It is complicated, but essentially the hours are budgeted and managed to ensure we can fly these beautiful old aircraft indefinitely. The fighter aircraft are booked in for major maintenance every 500 hours – which usually works out around every seven years. The recent major maintenances completed on the fighters have essentially been full rebuilds, although this has varied to a certain degree on just how tired they are on inspection. PZ865 was essentially stripped back to component parts at the end of the 2010 season for the first time since being built in 1944! Previous winter maintenance and the overhaul work completed on her before she was donated to the Flight back in 1972 was nothing like as intrusive. Hopefully, when she is then examined for her next major in 500 hours or seven years' time, she won't require such extensive levels of engineering work to keep her in the air.'

Flying the Lancaster

Flight Lieutenant Tim 'Twigs' Dunlop joined the Flight in 2009, initially as a Dakota captain and then as a Lancaster co-pilot halfway through the season. By the end of the 2011 season he become a Lancaster captain. He flew the Lancaster during both the 2012 and 2013 seasons before his appointment as bomber leader for 2014 was announced at the end of the 2013 season.

The following is Tim's personal reflection on why he applied to join the BBMF and on flying the iconic Lancaster:

Four Tornado GR1s thunder down the valley; later a Mosquito does several passes down the same valley. Then, the lady we have all been waiting for arrives. The Lancaster banks hard to the left and passes over Derwent Dam to mark the 50th anniversary of the famous Dambuster Raid. It is Sunday 16 May 1993. I have driven across to Derbyshire with my father – along with several thousand others – to watch the RAF recreate the practices for the Dambuster Raid. I could never begin to imagine that, 20 years later, I too would be the Captain of the Lancaster flying over the same dam, commemorating the 133 brave airmen of 617 Squadron who took part in Operation Chastise in 1943.

In 2000, I was in flying training on 45(R) Squadron with my primary instructor, Flight Lieutenant Merv Counter who, along with the standards instructor, Squadron Leader David Thomas, had decided to give me a taste of what was to come. Both men were pilots with the Battle of Britain Memorial Flight so, in between training on the Jetstream aircraft, they would disappear over to RAF Coningsby to fly the Lancaster bomber. I was immensely envious of the two men, while being proud that they both taught me how to fly.

Nine years later, having completed work-up as a Dakota captain, I was sat in the Lancaster bomber for the first time, now as a member of BBMF. I was giddy with excitement as the four Merlin engines roared into life and the aircraft rose gracefully into the air. Trip one on the Lancaster places you well away from the controls, sat in the mid-upper position; I was there to listen to the checks and to

BELOW Later in the
2013 Lincolnshire
Lancaster Association
Day programme the
Lancaster was joined
by Spitfire LF XVIe
(TE311) and Spitfire
IIa (P7350) for the
traditional BBMF
three-ship display.
On this occasion no
airworthy Hurricane
was available. The
'baby' Spitfire (P7350)
was being flown by
the outgoing OC
Operations Wing at
RAF Coningsby, Wg
Cdr Paul Godfrey.
(Keith Wilson)

absorb the experience of the aircrew on the flight deck. I doubt I learned very much that day – I was far too excited – but I was extremely aware of just how lucky I was to be sitting in one of only two airworthy Lancaster bombers left in the world. At the front was Flight Lieutenant Ernie Taylor, under the instruction of Squadron Leader Stu Reid. Ernie was on his final check flight as part of his Lancaster captaincy training; later in the sortie Ernie would fly the Lancaster as aircraft captain for the very first time. Stu would go on to teach me how to be a Lancaster co-pilot and it was Ernie who would later complete my captaincy conversion.

My first flight in the Lancaster in the left-hand (captain's) seat was from Bournemouth on 19 August 2011. Ernie Taylor was instructing me that day and we flew up to White Waltham to complete a flypast and back again. It was a surreal experience sitting in the seat I had long coveted. I had studied hard to ensure that I was as well prepared as I could be, but as a co-pilot you do not get to handle the Lancaster on take-off or landing. I remember her yawing slightly to the left as we

accelerated down the runway, just as Ernie had briefed me that she would; the forward push on the control column was much greater than I had expected in order to fly the tail and then after a pull-back on the column, she was flying. The airborne elements were as I had expected, I had handled her many times before, just from the other seat, but soon it was time to return to Bournemouth. As I lined up with the runway, I took a sharp intake of breath and attempted my first Lancaster landing! On this occasion, I guided the aircraft down to a smooth touchdown, but that isn't always the case, even with added experience. I have certainly had my fair share of bounces, which in the Lancaster are always heart-stopping moments!

The Lancaster, compared to modern aircraft, is noisy; she vibrates and she can be a handful to fly. Tipping into a display with a Spitfire on one wing and a Hurricane on the other, while sitting in a piece of the nation's aviation heritage, brings a huge grin across my face. However, at the end of every trip you know that you have to bring her back down to the ground. In the back of your mind you are

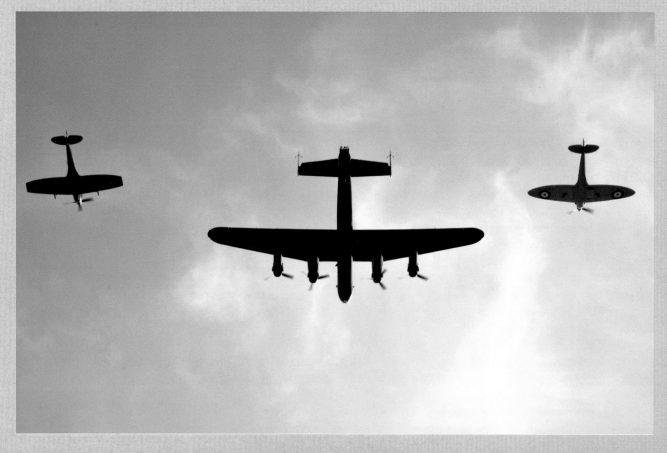

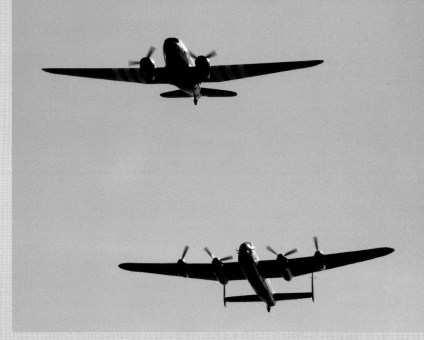

always saying to yourself – 'Don't mess this up!' Never more is this true than the first flight of the season. You may have got comfortable flying the Dakota first, but you know that you only have to misjudge the landing by a couple of feet and the Lancaster will remind you who is boss! A misjudged landing will result in a series of bounces down the runway, which could potentially damage the aircraft. Combined with the bounce there is the potential for the aircraft to ground-loop (tail-dragger aircraft have the potential to turn through 180°). The last time the Lancaster was nearly ground-looped was at the Mildenhall Air Fête in 1992. The pictures make uncomfortable viewing, but it is difficult not to think about those images just before she touches down. Flying the Lancaster is a double-edged sword; the fantastic feeling of displaying such an iconic aircraft combined with the utter terror of damaging her!

In some ways the Lancaster's vices are also her pleasures – if you get it right, she can be very rewarding. It is pure piloting, not affected by systems that make modern aircraft much easier to fly. Get it right and it is all down to the pilot, which is very satisfying; get it wrong and the Lancaster will always remind you that there is something more to learn! One thing is certain, the pilots always sign the aircraft back over to the engineers with some relief that we have safely returned her in one piece!

Without a doubt, my biggest highlight to date is captaining the Lancaster over Derwent Dam on 16 May 2013, to commemorate the 70th anniversary of the Dambuster Raid. Just prior to climbing aboard the aircraft at Scampton, Squadron Leader 'Dunc' Mason (current OC BBMF) handed me Wing Commander Guy Gibson's cigarette case inscribed with the code words 'nigger' and 'dinghy'; what a moment to catch in my throat! The commemorative flypast started with Squadron Leader Andy Millikin running down the valley in the PR XIX Spitfire; then it was our turn. It was a challenge to get the aircraft down into the valley and I have huge respect for the skills that were required to attack the dams and accurately drop the Upkeep weapon. Descending into the valley with the cigarette box in my breast pocket, it felt like the spirit of those brave men were with me. As I approached the dam, on the right I saw the

spot I had stood at 20 years ago, and I couldn't help but smile. The Tornado GR4s followed us down the valley before we returned for another couple of passes. We would then go on to display to the crowds at Chatsworth House and over Eyebrook Dam, which had also been used to train the 617 Squadron crews. On landing, the crew and I were privileged to then meet the 617 Squadron veterans Tony Iveson, Johnny Johnson and Les Munro. The men are national heroes and the country will always be in debt to their bravery; the experience finished a day I will never forget.

As I write this, I am about to embark on my first season as bomber leader. I don't think any of my predecessors on the BBMF would admit to having completely mastered the Lancaster; she always has the ability to surprise you. I am excited that soon I will be flying the Lancaster again as bomber leader, but this season I get to worry about my next landing, and those of the other pilots on the team!

In summary, it is an immense honour to fly the Lancaster. I cannot even begin to imagine how the men of Bomber Command felt every night climbing aboard the aircraft to take the battle to Nazi Germany during the Second World War; they were able to fly the aircraft with significantly less flying experience than I have had, at night, during wartime operations. They are true heroes and I am immensely proud to have met some of them personally – thankfully the only thing I have to worry about shooting at me is a camera lens!

ABOVE This image from the 2013 Lincolnshire Lancaster Association Day was the unusual pairing of Dakota and Lancaster, seen in formation just after passing over Coningsby. (Oliver Wilson)

ABOVE Electric locomotive No 91110 carries a specially designed livery featuring the aircraft and insignia of the BBMF. Its commemorative livery was unveiled in a spectacular ceremony which launched a nine-day celebration of the railways at the National Railway Museum in York in June 2012. No 91110 operates on the East Coast Main Line and since the ceremony has been seen almost daily travelling from London King's Cross up to the north of England and into Scotland, before returning back to the capital. On all of these journeys, the locomotive passes through Lincolnshire – aptly named Bomber County – and close to RAF Coningsby. It was photographed heading north through Huntingdon on 13 June 2012 with the BBMF crest on the front and the Lancaster artwork and key message 'Lest We Forget' prominent along the side of the train. *(Keith Wilson)*

BBMF on the railway

On 2 June 2012, TV star Carol Vorderman officially opened the Railfest 2012 event at the National Railway Museum in York. As part of that ceremony, she also unveiled a Class 91 locomotive, No 91110, named the *Battle of Britain Memorial Flight*, in a specially designed livery featuring the Flight's aircraft, badge and logo. Using the famous *Countdown* clock to time the unveiling of the event, as the curtain came down on the side of the locomotive revealing the spectacular new colour scheme, the BBMF formation of Lancaster, Spitfire and Hurricane flew overhead.

Locomotive No 91110 was chosen for the honour because it currently holds the UK national speed record for electric trains,

awarded when it ran at 162mph along Stoke Bank, north of Peterborough, on 17 September 1989. Interestingly, this is the same stretch of line used by *Mallard* to set her steam speed record of 125.88mph back on 3 July 1938.

Shortly after the ceremony, No 91110 was returned to the East Coast Main Line, where it was seen almost daily operating from London's King's Cross to York and Edinburgh, before returning to the capital.

After 19 months of continuous service she was given a makeover – her livery having been completely renewed as part of a major servicing programme carried out at the Wabtec engineering works in Doncaster. The commemorative plates which mark the loco's unique place in railway history have also been cleaned and refreshed.

As the finishing touches were applied to No 91110, a brief ceremony of rededication and a blessing were conducted by railway chaplain the Revd Dr Stephen Sorby, watched by representatives from Wabtec, the East Coast Main Line and the BBMF. Among them was Squadron Leader Stuart Reid (Retired) who flew the Flight's Lancaster bomber for the last 11 years of his career, and who first put forward proposals for the original train naming in early 2012.

After the ceremony, Stu Reid commented: 'This locomotive takes one of the key messages of the RAF BBMF along the East Coast Main Line – to recognise and commemorate the

selfless acts of bravery of over 100,000 RAF airmen and airwomen who have defended our freedom over decades, many making the ultimate sacrifice. The teams at East Coast and Wabtec, and the livery's designer Paul Gentleman, have done an excellent job in ensuring that this special locomotive will continue to turn heads, including through Lincolnshire where many of the 55,573 men of Bomber Command took the offensive to Germany and never returned. This record-holding loco is a fitting symbol in honour of them all.'

BBMF roadshow

With busy weekend and weekday display schedules, organising the engineering and roadshow support is quite a task. The Lancaster requires at least three engineers, while each flight needs one. With the Spitfire and Hurricane also to contend with, the Lancaster usually carries at least five engineers on board if it is landing away from home. This is in addition to its normal complement of four flightcrew. Thankfully, as members of the RAF, the Lancaster is permitted to carry out its display of flypasts with the engineers on board – and often does.

Occasionally, extra teams of engineers may be required to supplement the on-board engineers and these are usually positioned to the appropriate location using one of the team's Sherpa vehicles. During a very busy weekend, it may necessitate two teams of engineers – at more than one location – being required to meet all of the maintenance requirements on the trip. Very occasionally, when something goes wrong, the Sherpa is dispatched with a team of engineers, along with the replacement parts to fix any snags.

The BBMF has its own sales caravan, suitably decorated with the team's iconic aircraft on the sides. It attends the larger events and is very popular with the visiting public. Occasionally it is manned by civilian volunteers, but on other occasions it is manned by some of the engineers on duty at the show or event. This allows the members of the public to meet and greet the engineers and share their enthusiasm and knowledge. Each engineer gives up his own time to volunteer for the weekend work.

LEFT A group of younger visitors were seen taking one of the regular guided tours of the BBMF hangar at Coningsby in April 2013. Visits from school parties are actively encouraged at the visitor centre, provided that an advance booking is made. *(Keith Wilson)*

CENTRE A group of younger visitors (aged between five and seven) from the Hillcrest Early Learning Academy at Gainsborough visited the BBMF on 12 March 2014 and were able to watch Clive and Linda Denney from Vintage Fabrics hard at work on Hurricane LF363. *(Keith Wilson)*

Visitor centre and guided tours

A partnership between the Royal Air Force and Lincolnshire County Council provides the public with access to the home of the BBMF at RAF Coningsby. Since opening its doors in 1986, the BBMF visitor centre has welcomed over 300,000 people. Entry to the car park, exhibition centre and a well-stocked souvenir shop is free. You can take a guided tour of the BBMF hangar, lasting around an hour, for which a small charge is made. Visitors are led around the hangar by well-informed volunteer guides and are given an opportunity to view the BBMF aircraft at close quarters and observe the small but dedicated team of engineers preparing the aircraft for the next display. Outside, there is a small viewing area where visitors may watch aircraft being prepared for display, or undergoing routine maintenance – such as engine test runs.

The visitor centre is open every weekday, from 10am to 5pm, with the exception of public holidays and for two weeks over Christmas. Guided tours run every 30 minutes, depending upon demand, starting at 10.30am and finishing with the last guided tour which starts at 3.30pm. The address for the visitor centre is RAF BBMF visitor centre, Dogdyke Road, Coningsby, LN4 4SY. For more information, contact the visitor centre on 01522 782040, or visit the website at www.lincolnshire.gov.uk/bbmf.

RIGHT A unique partnership between the Royal Air Force and Lincolnshire County Council provides the public with a gateway to the home of the BBMF at RAF Coningsby. A sign in the car park shows visitors the layout of the site. *(Keith Wilson)*

LEFT A specially prepared Rolls-Royce Griffon 57 engine is available for inspection by visitors to the BBMF hangar at Coningsby. *(Keith Wilson)*

BELOW LEFT The clever use of cutaways on the Rolls-Royce Griffon 57 engine makes understanding the complexity of the engine just a little easier! *(Keith Wilson)*

BELOW An exhibition case in the visitor centre displays an RAF jacket and leather flying jacket, as well as a variety of radio and communications equipment from the Second World War period. *(Keith Wilson)*

LEFT The well-stocked shop provides visitors with a good variety of books, gifts and souvenirs of their visit to the Flight. *(Keith Wilson)*

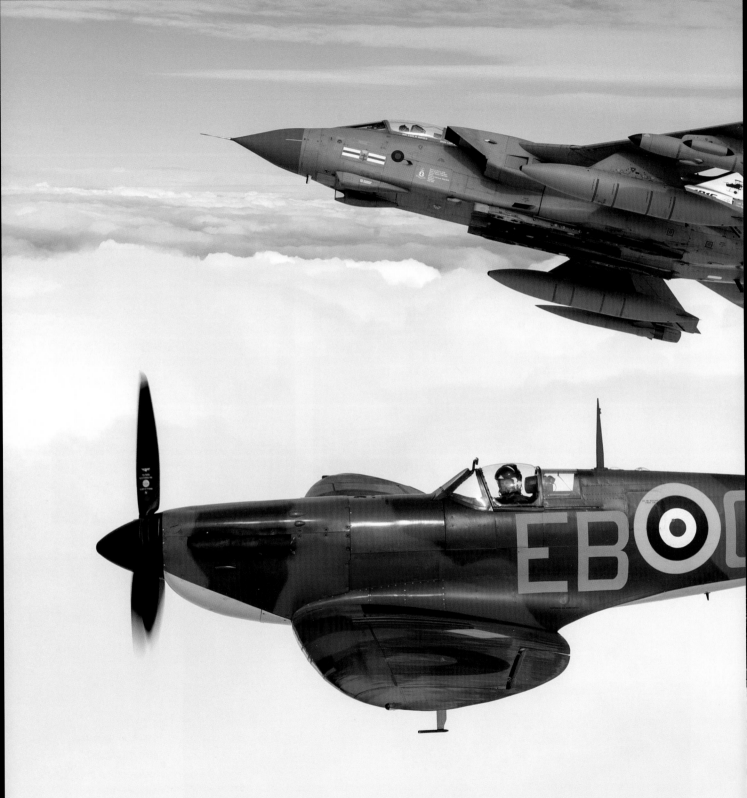

Chapter Eight

Famous locations and formations

In the years immediately following the Second World War, it became traditional for a Spitfire and Hurricane to lead the Victory Day flypast over London. There was a strong belief among some in the RAF that the service's greatest battle honour should continue to be commemorated in a fitting fashion and the best way to achieve that was to keep the last remaining examples of the legendary fighters which had won the Battle of Britain – the Hurricane and Spitfire – in the air.

OPPOSITE No 41 Squadron celebrated its 95th anniversary in 2011. For the occasion, one of the squadron's Tornado GR4s, ZA600/'EB-G', was painted in special markings and is joined by the BBMF's Spitfire IIa (P7350/'EB-G', also in 41 Squadron markings), for a photo-shoot close to Coningsby on 8 September 2011. The BBMF Spitfire is flown by Flt Lt Anthony Parkinson and the GR4 by Wg Cdr R. Davies and Sqn Ldr M. Elsey. *(Geoffrey Lee/Planefocus GLD-118903)*

135

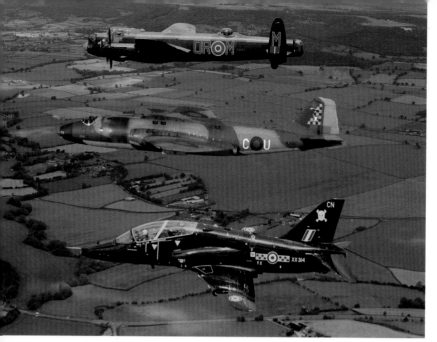

ABOVE To celebrate the 85th anniversary of 100 Squadron in 2002, a special formation and photo-shoot was organised. The BBMF's Lancaster PA474, painted as *Mickey the Moocher*, leads a 100 Squadron Canberra B2 (WJ682/'CU') and Hawk T1 (XX314/'CN'). *(Geoffrey Lee/ Planefocus GL-020515)*

From this event evolved the idea, driven by Wing Commander Peter Thompson DFC, to form a historic collection of flyable aircraft, initially to commemorate the participation by the Royal Air Force in the Battle of Britain and, later, to honour the RAF's involvement in all the campaigns of the Second World War.

The Historic Aircraft Flight was formed at Biggin Hill in July 1957, equipped with three former THUM Flight Spitfire PR XIXs alongside the former Biggin Hill Station Flight Hurricane IIb LF363. Shortly afterwards, three Spitfire Mk XIVs were added and a volunteer programme commenced to keep as many of these aircraft in the air as possible. Sadly, it was not always possible.

In September 1957 – just a few months after the official creation of the HAF – Wing Commander Peter Thompson led the Victory Day flypast in Spitfire XIV TE476, accompanied by Hurricane IIb LF363. The remaining aircraft available to the HAF were not in great condition and the decision was taken to place one of the PR XIXs on permanent gate-guard duties while work continued on the other airframes. Perhaps unsurprisingly, air show appearances by the Flight's aircraft in the formative years were somewhat infrequent.

HAF suffers major setback

Sadly, on 28 May 1959, Spitfire Mk XIV SL574 was involved in a flying accident at Martlesham Heath. Later that year, on 10 September, Spitfire Mk XIV TE476 was

involved in another accident – this time the pilot apparently returned to the airfield after suffering a radio failure and failed to lower the undercarriage. The powers that be took a dim view of these events and decided that the flypast scheduled for 29 September 1959 would be the very last occasion that single-engine fighters like the Spitfire and Hurricane would participate in the annual Battle of Britain Day flypast over London.

With hindsight, it was probably a good decision! During that flypast, SL574 suffered a complete engine failure shortly after crossing the City of London. Prime Minister Harold Macmillan had just left Westminster Abbey at 4.30pm, following the service of remembrance for 'The Few'. Leading the flypast were Spitfire SL574 and Hurricane LF363. After passing Horse Guards Parade, the Spitfire's engine failed and the pilot, Air Vice-Marshal Harold Maguire, was forced to find somewhere to put the aircraft down. He chose what he thought was an empty sports field in Bromley. Fortunately, the OXO cricket team and their opponents, Old Hollingtonians, were having tea. The Spitfire had just 200yd to stop. After hitting the grass, one of its wingtips took out the set of stumps before it skidded 60yd on to the outfield and came to rest.

Newspaper reports of the time made a great deal out of this, with headlines such as 'The last Spitfire prangs', and the writing was somewhat sensationalist. The accident and its subsequent reporting did little to further the cause of the Historic Aircraft Flight. SL574 was once again sent to 71 MU at Bicester for repairs, but was eventually relegated to guard duties on the gate at RAF Bentley Priory.

In the following years, the availability of spare parts became a major cause of problems to the Flight, which resulted in a further reduction in the number of appearances by the fighters.

In 1968, the Flight's aircraft were used in the filming of the classic *Battle of Britain*. Involved with filming from Monday to Friday – in a variety of markings – they then carried out their display duties at weekends. Aircraft often appeared still wearing their film markings, providing visitors with an opportunity to see them in unusual combat liveries. After the filming was completed, Spitfire IIa P7350 – the world's oldest airworthy Spitfire – was presented to the Flight.

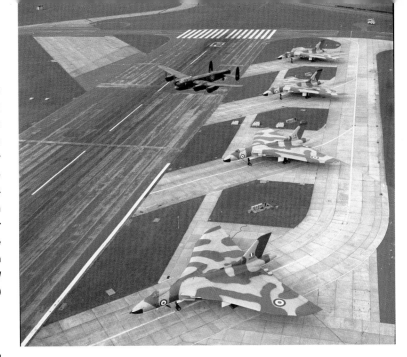

RIGHT Avro Lancaster B.I, PA474/'KM-B', flies over four Avro Vulcan B.2s of 230 Operational Conversion Unit on the operational readiness platform at RAF Waddington in April 1968. The flight was made to mark the merger of Bomber and Fighter Commands into the new RAF Strike Command on 1 April 1968. At the time, PA474 was officially on the books of 44 Squadron (also based at Waddington) and was flown for occasional commemorative flypasts before joining the Battle of Britain Memorial Flight in November 1973. *(Crown Copyright/Air Historical Branch image T-8296)*

In 1969, an agreement was reached for the Battle of Britain Memorial Flight to be established on a formal basis at RAF Coltishall. This major change also meant that the Flight was to have its own dedicated servicing personnel. The announcement also stated that the Waddington Lancaster (as PA474 was termed at the time) would continue to be maintained in flying condition at RAF Waddington until the end of 1969. A contemporary engineering policy directive stated that, 'The Battle of Britain Memorial Flight (BBMF) is to be established at Coltishall with Hurricane and Spitfire aircraft. Its duties are to mount flypasts and flying displays on suitable formal occasions.'

By 1973, the fighters had performed at 80 displays throughout the country. November 1973 saw the arrival of a new and significant type to the BBMF when Lancaster PA474 was officially transferred from RAF Waddington, where it had been maintained by station personnel. Since the transfer, the Lancaster has had a major impact on the Flight – with particular reference to the three-ship BBMF display of Lancaster, Spitfire and Hurricane that has now become the Flight's hallmark formation display.

In 1976, the BBMF moved from Coltishall to

RIGHT The BBMF Dakota ZA947/A1 leads a Hercules C3 (XV188) and a Hercules C5 (ZH887) over the Wiltshire countryside on 1 September 2005 to celebrate the 90th anniversary of 24 Squadron. All three types have served with 24 Squadron at some time during their lifetime. *(Geoffrey Lee/Planefocus GLD-055778)*

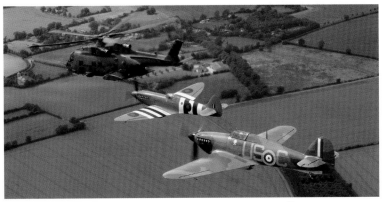

ABOVE Almost a Merlin moment! An unusual formation combining fixed and rotary wings: a 28 (AC) Squadron Merlin HC1 from RAF Benson in formation with a Hurricane IIb (LF363/'US-C') and Spitfire PR XIX (PM631) from the BBMF while in transit from Lowestoft to RAF Coningsby on 29 July 2005. The Merlin is being flown by its display pilot, Sqn Ldr Mark Beardmore, the Spitfire by Sqn Ldr Clive Rowley and the Hurricane by Wg Cdr Russ Allchorne. *(Geoffrey Lee/Planefocus GLD-4473)*

ABOVE On 6 June 2007, 5 (AC) Squadron was presented with a new standard. To celebrate the occasion, one of the squadron's Sentinel R1 aircraft (ZJ690) flies in formation with a 25 Squadron Tornado F3 (ZE342/'FG') and the BBMF's Hurricane IIc (PZ865/'JX-E'). Both the Hurricane (from July 1943 to September 1944) and the Tornado F3 (from January 1988) were types that had operated with 5 Squadron. *(Geoffrey Lee/ Planefocus GLD-072170)*

Coningsby. The move, along with continuing financial constraints, brought forward a major review of the Flight that had originally been scheduled for 1978. In the review it was noted that an estimated total audience of 2½ to 3 million people had watched the BBMF in 1976 – quite a remarkable number! The report also

BELOW Five BBMF Spitfires in formation is something which is not seen very often! At the Lincolnshire Lancaster Association Day at Coningsby on 29 September 2013, all five of the Flight's airworthy Spitfires performed together. The only missing Spitfire from the formation was AB910, which was undergoing a major maintenance at ARCo, Duxford. The sound of three Merlin and two Griffon engines was quite extraordinary! *(Oliver Wilson)*

noted that participation by the Royal Air Force in public events fulfils two primary purposes:

1. To foster a more appreciative public awareness of the RAF, its role and purpose.
2. To promote recruitment to the Service.

The report went on to note that, 'Flying displays are the most popular and impressive form of RAF participation permitted by security and available resources', while 'the BBMF combines to a notable degree the public appeal of a flying display with a reminder of the part played by the RAF in the defence of the country. It is worth reflecting on what an advertiser would have to pay for the media coverage given to a single historic aircraft flying over London – at least twice the current annual running cost of the Flight.'

The report also reflected on the possible closure of the Flight and dismissed it, adding, 'Disbandment would also attract the widest public dismay.' It concluded by stating, 'The BBMF represents a cheap and effective means of achieving the two principal purposes of our participation programme, and is good value for that reason alone.'

Changing colours

Another policy being reviewed at around the same time was that of colour schemes and markings carried by the Flight's various aircraft. Up until then, no formal MoD policy had been established. Following the Air Force Board's review, the report concluded that it was

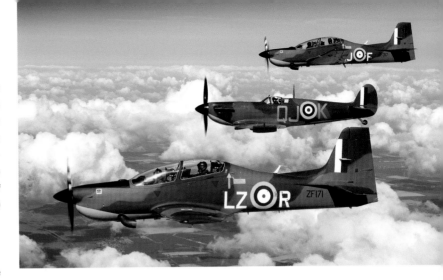

best to operate the BBMF aircraft with periodic changes of aircraft markings, thereby being able to honour a variety of individuals and squadrons who so rightly deserved the recognition. At the time (1976) the cost of changing the markings on a Spitfire or Hurricane was estimated to be just £1,200, while the Lancaster was around £4,000. In 2014 it cost £8,000 to change the Lancaster markings to *Thumper Mk III* and £14,000 to re-spray Spitfire MK356 into its D-Day markings. A complete re-spray for the Lancaster would now cost at least £20,000.

It was decided that the best, most cost-effective way of dealing with this, was to change the markings when the particular aircraft underwent a refurbishment programme (when each aircraft is given a partial repaint at four-yearly intervals in conjunction with its major servicing programme). With major servicing of the entire fleet carefully managed, it effectively meant that three aircraft underwent a change of colours every two years – thereby raising the public profile of the individual aircraft upon completion. Shortly afterwards, in 1977 and 1978, Spitfire IIa P7350 appeared wearing the QV-B codes of 19 Squadron while Hurricane PZ865 appeared as JU-Q of 111 Squadron – representing the very first squadron to take delivery of the Hurricane.

This programme continues today as Lancaster PA474 was repainted in September 2012 in the colours of 617 Squadron Lancaster B.1 DV385. It carries the nose artwork of a 1942 Walt Disney cartoon rabbit 'Thumper Mk III' applied to DV385 when the aircraft had been delivered to 617 Squadron as a replacement for aircraft used on the Dambuster Raid in 1943. In 1944, the aircraft was retro-fitted with bulged bomb-bay doors to enable it to carry a 12,000lb Tallboy 'earthquake' bomb internally, and it initially wore the code letters KC-A as it is depicted on PA474 today.

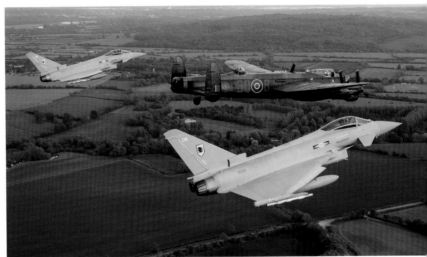

ABOVE To celebrate the re-forming of XI(F) Squadron at Coningsby in March 2007 as the second front-line Typhoon squadron, the BBMF's Lancaster was joined by a pair of Typhoon FGR4s (ZK323/'DN' and ZK305/'DE') for a celebratory photo-shoot. *(Geoffrey Lee/Planefocus GLD-128820)*

BELOW During the 2014 display season the Canadian Warplane Heritage Museum's Lancaster crossed the Atlantic and performed at a number of airshows in the UK during August and September in company with PA474. *(Oliver Wilson)*

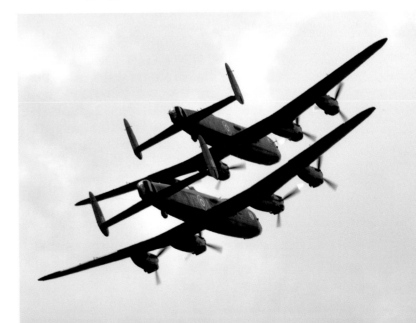

A change of policy

By the mid-1980s and with the Lancaster now part of its regular display routine, the BBMF continued to increase it appearances across the UK. Unfortunately, the ban imposed in 1959 on its single-engine aircraft was still in effect and prevented it from operating the Spitfires and Hurricanes over London. In 1986, however, that was to change.

At precisely 11.00am on 5 March 1986, Squadron Leader Paul Day flew PM631 across London and alongside Big Ben. It was the 50th anniversary of the first flight of the Spitfire, which had taken place at Eastleigh, near Southampton, on 5 March 1936. The time of 11.00am was chosen as a tribute to 11 Group, which had borne the brunt of fighter operations during the Battle of Britain and was now the controlling authority of which the BBMF were a part.

Battle of Britain 50th anniversary

To celebrate the 50th anniversary of the Battle of Britain, a major celebratory event was organised for 15 September 1990. It featured a static display of aircraft and equipment on Horse Guards Parade and a march of RAF personnel from Horse Guards Parade to Buckingham Palace. The highlight of the event was a flypast by 168 aircraft over the Mall, led by five Spitfires and two Hurricanes of the BBMF. The permission required to carry out this formation of single-engine aircraft over central London emphasises the importance given to the event. Spitfire IIa P7350 – a true Battle of Britain veteran – led the formation, with Air Vice-Marshal W.J. Wratten at the controls. It was joined by PR XIX PM631 (Squadron leader Paul Day), Mk Vb AB910 (Wing Commander Dave Moss), PR XIX PS915 (Squadron Leader Chris Stevens) and PR XIX PS853 (Flight Lieutenant Jim Wild). The two Hurricanes – IIb LF363 (flown by Group Captain Dave Widdowson) and IIc PZ865 (Squadron Leader Allan Martin) – completed the formation.

The various formations that followed consisted of current RAF aircraft. At the rear of the formation was Lancaster PA474 (with Squadron Leader Colin Paterson as captain).

After passing over Buckingham Palace, P7350 and LF363 returned to the rear of the formation and joined up with PA474 before flying towards the RAF parade, and carried out a break in front of Buckingham Palace – providing a fitting conclusion to the event.

50th anniversary of VE Day and VJ Day

In 1995, to commemorate the 50th anniversary of VE Day (Victory in Europe) and VJ Day (Victory in Japan) there were two flights organised over Buckingham Palace. The VE Day celebrations ran from 6 to 8 May, and featured a large static display in Hyde Park consisting of both real and replica aircraft. Interestingly, this included the RAF Exhibition Flight's Spitfire XIV TB382, which later joined the BBMF, albeit on a short-term spares reclamation basis. The BBMF provided a three-ship flypast on the evening of Saturday 6 May, when the Lancaster, Spitfire AB910 and Hurricane PZ865 made two passes over Hyde Park.

On Monday 8 May a huge crowd gathered at Buckingham Palace, just as it had done 50 years earlier. The same BBMF trio joined the flypast over the palace.

To commemorate the 50th anniversary of VJ Day in 1995, the Lancaster carried out one of its poignant poppy drops along the Mall and over Buckingham Palace on 19 August. Towards the end of a two-minute silence, the Lancaster appeared over Admiralty Arch at the top of the Mall. It approached the drop point at 500ft with its bomb doors open before discharging one million poppies.

Funeral of Her Majesty Queen Elizabeth the Queen Mother

The funeral of Her Majesty Queen Elizabeth the Queen Mother was held in London on 9 April 2002. Although outside the Flight's normal operating window (the Flight's principal operating season is from May through to September), a spell of unseasonably good weather had allowed Squadron Leader Paul Day, OC BBMF, to offer the Lancaster and a

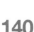

pair of Spitfires when approached by 1 Group on 4 April. The Flight was in the midst of their pre-season work-up period, and the Lancaster had undergone a successful air test that very day. Two Spitfire PR XIXs – PM631 and PS915 – were to join the Lancaster.

The formation was led by Squadron Leader Paul 'Major' Day in PM631, and he was accompanied by Squadron Leader Clive Rowley in PS915. The Lancaster was crewed by Squadron Leader Stuart Reid (captain), Flight Lieutenant Andy Sell (co-pilot), Squadron Leader Brian 'Brain' Clark (navigator) and Flight Sergeant Ian Woolley (air engineer). In addition, the Coningsby station commander, Group Captain Phil Goodman, was also on board.

Initially it was planned for the formation to pass over Parliament Square at exactly 11.21am, but following a meeting with the royal family on 6 April, it was requested that the flypast should coincide with the funeral cortège being halfway down The Mall.

Following the funeral service it should have taken the funeral cortège precisely 7½ minutes to reach the halfway point in The Mall, where the flypast was due to coincide with it. However, with no guarantee as to precisely what time the hearse would leave Westminster Abbey, a 1 Group staff officer on the ground was in radio communication with the formation to give them their cue. As it happened, the procession ran slower than anticipated, and when the Flight reached their position, with precise timing to the second, the cortège had only reached Admiralty Arch. Lancaster captain Squadron Leader Stuart Reid takes up the story:

Along the final run the timing appeared to be spot on and the fighters established themselves in a nice, tight formation. All the usual visual features, the Barbican Centre, the Thames and Charing Cross station were clearly identified in good time and I could see Buckingham Palace and the vicinity of The Mall some distance ahead.

With the royal parks on the aircraft nose, I could start to make out the pink granite colour of The Mall road surface but, to my utter dismay, I could also see that it was devoid of any vehicles and there was no sign of the funeral cortège, as had been anticipated. Even at this stage, the funeral cortège should have

been through Admiralty Arch and starting to make its way along The Mall, so it was evident that something was wrong.

A whole series of expletives came to mind. Here we were in the most iconic aircraft to have graced British skies, in front of the world's media on a royal flypast and there had been an almighty, and what appeared to be a very public, cock-up! I asked 'Brain' to confirm that the timing was accurate and he verified that it was. I was gutted, how could we have failed to have achieved the objective? My professional pride was in tatters. Anyway, despite the almost unbearable humiliation, we continued along the Mall and over the palace before starting the turn onto a northerly heading when Andy Arnold, who was in the tail gunner's turret, exclaimed over the intercom 'She's just entering The Mall now!'

Now, it is worth reiterating a point in the brief – only a single overflight of The Mall had been authorised and a second pass was not permitted.

Following Andy Arnold's exclamation, I and another voice said, 'We could always go around again', to which the station commander replied 'Do it!' I said, 'about 2 minutes ought to do it', so we continued the right turn. Meanwhile 'Brain' transmitted words to the effect that the formation was going round again. The transmission provoked a garbled response from one of the Spitfires, whom I guessed was 'Major' saying something along the lines of 'What are we doing?', which was followed up by further dialogue between 'Major' and 'Brain' to which I was not paying much attention as I was now focusing on the turnabout for a second pass. Unbeknown to me, 'Major' was allegedly thinking 'That's it, we're [the BBMF] finished.'

As we continued the turn, someone asked me if I knew where I was going, which, for a few seconds, did cause me some anxiety but, to my relief, seeing Paddington station passing below, I confirmed that I did.

You see, the London landmarks are not as obvious as you would expect them to be when viewed from above. Many of the landmarks need to be skylined to be visible; for example, Nelson's Column – which is highly visible when viewed from the ground in Trafalgar Square – is not only dwarfed by the clutter of buildings around it when viewed from above, but it is also very well 'camouflaged'. It means that larger,

flatter structures, such as railway stations, are more useful to assist with positioning. Having grown up in the London area, I know the relative locations of London's railway stations very well, so I used them to maintain an awareness of our position in relation to The Mall.

Routing east from Paddington, past Euston to St Pancras and King's Cross, another right 180° turn was commenced, at which point I was able to see Hungerford Bridge which adjoins Charing Cross station on the north side of the Thames. Charing Cross is adjacent to Trafalgar Square, which is, in turn, adjacent to Admiralty Arch and The Mall. It was, therefore, relatively straightforward to bring the formation back around for the second pass.

This time, as the formation came around to line up with Admiralty Arch, I was able to see clearly the funeral cortège which, by now, was almost two-thirds of its way up The Mall. Still unaware of why the cortège was not in the Mall on the first pass, it was, nonetheless, with satisfaction and relief, that the BBMF formation was able to pay tribute to Her Majesty the Queen Mother as the cortège passed directly beneath us on our second pass along The Mall.

We were all very proud of what we had done, but there remained some trepidation about having executed the second pass along The Mall in contravention of the brief. However, we were unanimous that, under the circumstances, it had been the right thing to do. Moreover, that evening the TV news coverage of the event showed HRH the Duke of Edinburgh beckoning to HM the Queen to look upward through the glass roof of the royal car, which was following directly behind the hearse bearing the coffin of the Queen Mother, as the BBMF formation flew overhead. If ever there had been 'top-level' endorsement that going round again was the right thing to do – that was it!

On the day, large crowds had gathered at Coningsby, both to wave the Flight off and to greet them on their return, many of them patriotically waving Union flags. As is customary with the Flight, the crews took time to speak with the visitors gathered outside the perimeter fence after the flypast. The Queen Mother was synonymous with a time when people refused to leave London during the Blitz, instead offering her support to the victims. The appearance of the Flight in their historically significant aircraft added a special tribute to her. All of the Flight's personnel are rightly proud of the part they played in such a historic occasion.

60th anniversary of D-Day

In June 2004, the Flight's part in commemorating the 60th anniversary of D-Day was broadcast live on national television. It involved a complex five-day operation including the Lancaster, Dakota as well as Spitfires AB910 and MK356 – both of which had actually taken part in D-Day operations, making their return particularly poignant. On 4 June, the Lancaster and two Spitfires set off from Coningsby to position at Southampton airport. Meanwhile, the Dakota positioned to RAF Lyneham. On the morning of 5 June the Lancaster and Spitfires carried out a display over Portsmouth Harbour, from where a flotilla of vessels set sail to Normandy, in a symbolic crossing of the English Channel. On the same morning, the BBMF Dakota headed to Le Havre, where the Flight would be based for its detachment, ready to load paratroops for a scheduled para-drop later in the day.

In the afternoon, the Lancaster and Spitfires carried out a display at Sandown, on the Isle of Wight. At the conclusion of the display, all three BBMF aircraft flew towards the MV *Van Gogh* for the scheduled poppy drop over the vessel. On board the *Van Gogh* were 450 veterans who took part in a memorial service en route to France. As the ship approached the French coast, at 15.00 the service of preparation was broadcast live on television. The service included a two-minute silence and culminated with wreaths being laid in the Channel from the ship's side. At 16.30, the Lancaster – accompanied by a Spitfire on each wing – dropped a million poppies from its bomb bay on to the ship below.

On the same afternoon, the Dakota led a stream of aircraft for a para-drop over the Ranville DZ (drop zone). On board the Dakota were the paratroops, in authentic para seats that had been obtained from the US in time to be fitted into the aircraft for the special occasion.

On 6 June, the actual anniversary of D-Day, all four of the Flight's aircraft were involved in the main anniversary ceremony at Arromanches. In attendance at the ceremony were seventeen heads of state, including Her Majesty Queen Elizabeth II.

National Commemoration Day

National Commemoration Day on 10 July 2005 was the culmination of a week-long programme of events and commemorations to mark the 60th anniversary of the end of the Second World War. Although of no real historical significance, the date was chosen as it fell mid-way between VE Day and VJ Day. It is estimated that around 250,000 people came together to honour those who had fought in the conflict.

The celebrations began with a service of thanksgiving at Westminster Abbey at 11.00am, which was attended by Her Majesty Queen Elizabeth II. Later, around 2,000 veterans lunched in the grounds of Buckingham Palace.

At 14.30 there was a Reflections of World War Two commemorative show on Horse Guards Parade, again attended by HM the Queen. After the show, Her Majesty addressed the nation with a speech that not only honoured the veterans but also the victims of the suicide bombings that had occurred in the capital just three days earlier. A parade of more than 700 banners and standards followed the Queen in an open-top Range Rover down the Mall and into the forecourt of Buckingham Palace, before the police allowed the masses of spectators to gather around the Queen Victoria Monument.

Just before 17.00 the royal family gathered on the balcony to watch the grand finale of National Commemoration Day – a flypast of historic aircraft in a scene reminiscent of the Victory Parade in 1946.

A total of nineteen aircraft in five waves overflew the Palace at 1,000ft. Flypast aircraft included five de Havilland Dragon Rapide aircraft, a Lockheed 12A, Avro Anson, Avro 19, Consolidated Catalina and a formation of three Douglas Dakotas led by the Flight's ZA947. Finally, two Boeing B-17s and two North American B-25 Mitchell bombers completed the show.

Exactly to the second, PA474 appeared with Spitfire P7350 to port and Hurricane LF363 to starboard – interestingly, the only two single-engine aircraft permitted to participate in the flypast. The captain on board the Lancaster was Squadron Leader Stuart Reid, along with Flight

BELOW The traditional BBMF formation of Lancaster, Spitfire and Hurricane photographed as they approach Buckingham Palace on 10 July 2005 during National Commemoration Day. Shortly after this picture was taken, the Lancaster dropped one million poppies. *(Crown Copyright/SAC Scott Robinson)*

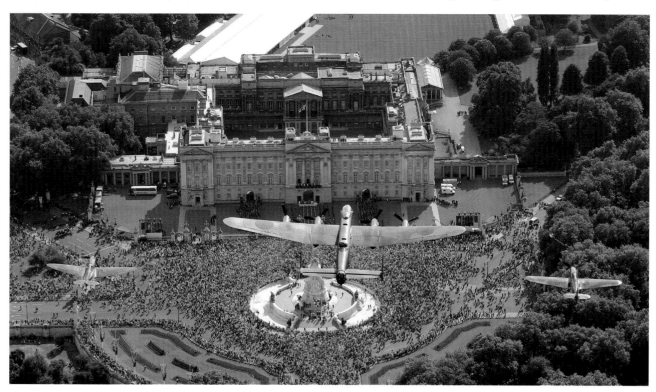

Lieutenant Mike Leckey (co-pilot), Squadron Leader Dick George (navigator) and Squadron Leader Ian Morton (air engineer). Also on board the Lancaster was Marshal of the Royal Air Force, Sir Michael Beetham, by then 82 years old, and who had flown a Lancaster over London as part of the 1946 Victory Parade.

When the formation reached the monument, a cloud of bright red poppy petals fell into the sky behind the Lancaster. As the aircraft made their way over the Palace, the poppies fell into a neat stream along the Lancaster's flightpath before fluttering down on to the crowd below – for many, a moving experience they will never forget.

Operation Market Garden commemoration

‚ Of all the events in which we participate as members of the BBMF flightcrew, the commemorations of celebrated major Allied operations that took place during the Second World War are among the most important and poignant.'

In September 2009, Stuart Reid had the good fortune to participate in the 65th anniversary of Operation Market Garden – the ill-fated operation in 1944 that involved an airborne assault on some of the bridges over the major rivers bordering Holland and Germany. One of these was at Arnhem, as commemorated in the epic film *A Bridge Too Far*. The bridges were crucial in enabling the Allies to maintain their advance into Germany following the D-Day invasion on 6 June 1944.

The BBMF contribution to the commemorative events at Ginkelse Heide (Ginkel Heath), near the Arnhem Bridge, was the Dakota ZA947, which would lead a re-enactment of the airborne assault that took place on 17 September 1944. Stuart recalls his involvement:

I believe it was General Eisenhower who said that there were four things that won the war for the US forces: the bazooka, the Jeep, the atom bomb and the C-47 Dakota. Very much eclipsed by the more charismatic fighter and bomber aircraft types, the C-47 Dakota nonetheless brought a revolutionary support capability to aerial warfare in terms of payload, flexibility and airborne assault.

To participate in the event, which took place on 19 September 2009, ZA947 deployed to Eindhoven airport in Holland from where it operated for the next three days. Being one of the only airworthy Dakotas to carry RAF wartime insignia, ZA947 was given pride of place in leading two Royal Air Force Hercules from RAF Lyneham and four USAFE C-130s from Ramstein AFB, Germany; each carrying a contingent of paratroops that would participate in a re-enactment of the airborne assault. ZA947 would drop 12 paratroops in two sticks of six and to assist the BBMF crew with their drop, we were joined by a small team from the Joint Air Delivery Test and Evaluation Unit (JATE) at RAF Lyneham.

The dropping of parachutists from the Dakota is not especially hazardous in itself, but there are specific speed and configuration criteria that must be observed to ensure that the jumpers exit the aircraft with minimal risk of injury. All parachutists exit the Dakota from a removable hatch, incorporated within the forward main door structure, on the left side of the fuselage, aft of the wing.

Another feature of the Dakota cabin that reveals its pedigree as a para-dropping aircraft is the static line attachment cable that runs the full length of the aircraft in the top of the cabin. One of the immediate threats to parachutists exiting the aircraft is the aircraft itself. The Dakota has a very low-set horizontal stabiliser and it was not unknown for wartime paratroops to be injured as a result of impacting the stabiliser following their exit from the aircraft. Although the paratroops assumed the correct posture for their jump, it is possible for the slipstream to 'carry' the jumper up into the path of the stabiliser on exit from the aircraft. To mitigate the risk of injury, the Dakota speed is reduced to 90 knots IAS and flaps set at ¼ ('Flap One') for the drop itself.

On the day of the event, we attended the main briefing for the flypast and the dropping of the paratroops. The weather was forecast to be ideal with bright, partly cloudy skies and light winds. The route to the drop zone was straightforward and ZA947 would fly to the drop area and enter a timing hold before commencing the first run through the drop zone. On the first run over the drop zone, six parachutists would exit the aircraft, some

wearing period battle dress for the event, which would be watched, not only by many hundreds of veterans and other spectators on the ground in the vicinity of the drop zone, but also by many people around Holland as the event was broadcast live on television.

On completion of the first run, ZA947 would return to the holding area and be followed by the RAF and USAFE C-130Js which would release a further hundred or so paratroops in a unique aerial spectacle to re-enact the wartime drop. On completion of the para-drop from the C-130s, ZA947 would run through the drop zone again, allowing the second batch of six paratroops to jump, after which the C-130s would themselves run through for a second re-enactment of the wartime drop.

It was an impressive spectacle to see hundreds of paratroops massing on the military dispersal at Eindhoven before boarding their respective C-130s.

After carrying out the pre-flight check and embarking our JATE team and the 12 paratroops aboard ZA947, we started, and taxied ready for departure. The departure was uneventful and the en route checks, which set the engines at 2,050rpm, 29.5in manifold pressure and mixture control to auto-lean, were completed as we transited to the holding area which was in the vicinity of Deelen Air Base to the east of the drop zone and some 10km north of the Arnhem Bridge. Having confirmed the surface wind conditions in the drop zone, the JATE team ensured the calculations for the timing to the drop point and for the jump itself were accurate. Having commenced the run-in and with clearance to drop, the carburettor mixture controls were selected to auto-rich, while maintaining 2,050rpm aside, and throttles manipulated to reduce the airspeed to 90 knots IAS with 'Flap One' (¼) selected. The paratroops had by now moved to the floor of the cabin to complete their final safety checks and the first 'stick' to jump attached their static lines in readiness for their drop.

Approaching the drop point, flare smoke was visible on the surface adjacent to the drop zone datum. The aircraft was stabilised to maintain an accurate track, speed and altitude inbound to the release point. With the first stick poised to jump, the call 'Red on' is heard over the

intercom and the light control switch set to the caution position illuminating the large red light to the right of the forward door inside the cabin. What seemed no more than a second or two later, the 'Green on' call is made and the selector switch moved to the jump position, illuminating the large green light immediately below the now-extinguished red light.

Maintaining steady flight as the paratroops exit the aircraft, we are aware of 'juddering' through the airframe and the need for a slight pitch trim change to maintain level flight. The loadmaster confirms all jumpers are away, after which the throttles are opened to accelerate to the normal cruising speed, the flaps retracted and the en route checks repeated to return the engines to the cruise configuration. ZA947 was flown to the holding point to await the C-130s following behind to complete their first run on the large-scale re-enactment of the airborne assault in 1944.

After a further time in the hold, ZA947 was flown over the drop zone for the second time to allow the second stick of paratroops to exit the aircraft. On completion of the second drop, ZA947 returned to Eindhoven.

Queen's 80th birthday

To celebrate Her Majesty Queen Elizabeth II's official birthday on 17 June 2006, the largest RAF flypast over Buckingham Palace for many years was staged. The flypast, featuring almost 50 aircraft, was led by the Battle of Britain Memorial Flight.

In the first wave the Flight's Lancaster was flanked by two Spitfires and two Hurricanes. Once again, the Lancaster was flown by Squadron Leader Stuart Reid, while OC BBMF Squadron Leader Al Pinner MBE was in Spitfire Mk Vb AB910, Wing Commander Russ Allchorne in Spitfire IIa P7350, Squadron Leader Clive Rowley MBE in Hurricane IIa LF363 and Squadron Leader Ian Smith in Hurricane IIb PZ865.

'Memorial Flight' arrived over the palace precisely on schedule at 13.00, with all the aircraft flying at 1,500ft. They were followed one minute later by 'Windsor Formation', comprising eight separate elements that overflew the palace at 40-second intervals. In total, there were 49 aircraft of 15 different types.

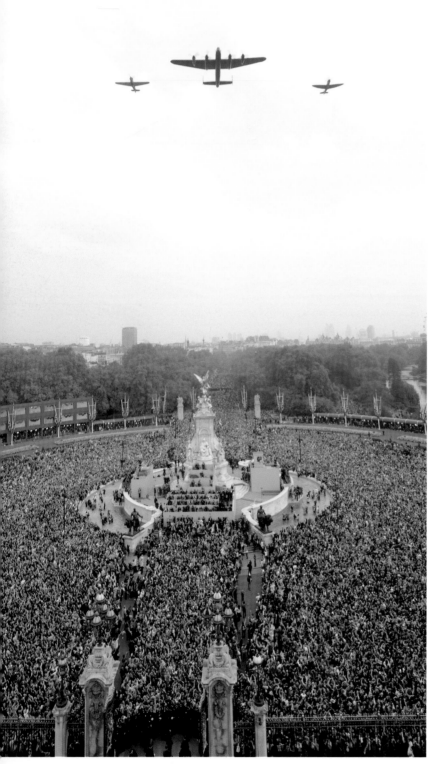

HRH Prince William and Catherine Middleton's wedding

The Battle of Britain Memorial Flight were called upon to lead a small flypast over Buckingham Palace on 29 April 2011, shortly after the wedding ceremony of HRH Prince William and Kate Middleton had taken place at Westminster Abbey.

After the ceremony, William and Kate were joined on the Buckingham Palace balcony by senior members of the royal family as the Lancaster PA474, accompanied by Hurricane LF363 and a Spitfire PR XIX, flew over to the obvious delight of the royal couple. A pair of Typhoons and Tornado aircraft completed the short flypast over the palace.

Bomber Command Memorial

Her Majesty Queen Elizabeth II formally unveiled the Bomber Command Memorial in Green Park, London, on 28 June 2012. The memorial commemorates the personnel of Bomber Command who flew operations during the Second World War, some 55,573 of whom lost their lives. The memorial was officially opened in the presence of Bomber Command veterans and family members of personnel from all over the world.

The Lancaster completed a flypast and poppy drop over the memorial. The captain on board the Lancaster that day was Flight Lieutenant Roger Nicholls, with his crew of Flight Lieutenant Loz Rushmere (co-pilot), Squadron Leader 'Russ' Russell (navigator) and MACR Brendan O'Sullivan (flight engineer).

Operation Chastise

The plans for the 70th anniversary of the famous Dambuster Raid (Operation Chastise) in May 2013 pointed towards a very busy spell for the BBMF Lancaster and her crew. RAF Media Communications had intended to ensure the event would be very high profile and involved the present-day 617 Squadron in a four-day programme of

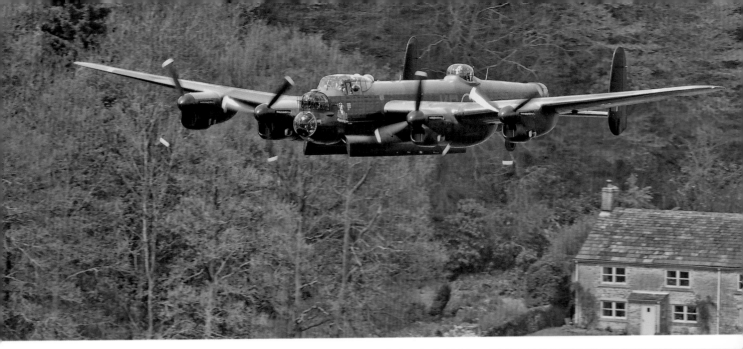

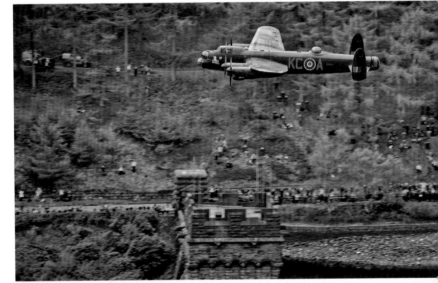

events that would appropriately remember the operation and the brave souls who lost their lives in the attacks.

Things didn't start well for the event. Bad weather and niggling problems with the Lancaster's winter maintenance programme delayed its flight test, preventing it from participating in 617 Squadron's 70th anniversary celebrations at Lossiemouth. Meanwhile, 617 Squadron had painted a pair of Tornado GR4 aircraft in special commemorative schemes.

It transpired that the Lancaster would be taking part in both flypasts of the dams used for training by the Dambusters in 1943 and at the parade and sunset ceremony at RAF Scampton. The BBC covered many of the events with one of their presenters – Dan Snow – being on board and broadcasting live from the

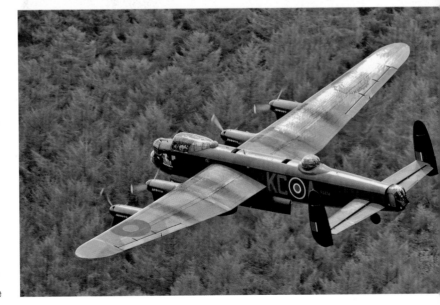

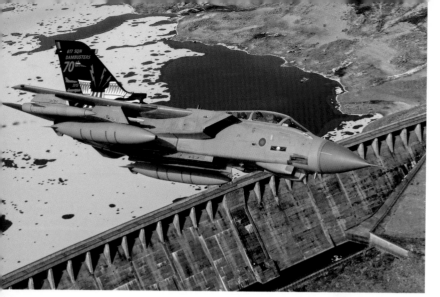

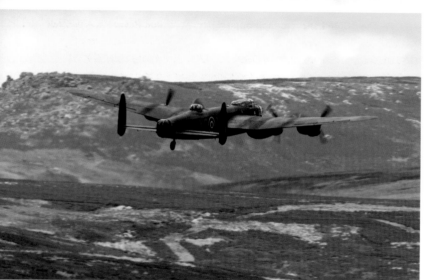

Lancaster. However, this BBC activity meant a considerable amount of additional work for the Flight's SEngO, Warrant Officer Kev Ball, and his team of engineers!

The first event was a flypast over a special screening of the original epic film *The Dambusters* at a cinema in Woodhall Spa during the evening of 15 May 2013. Both the Lancaster and the two Tornado GR4s were on time. After the flypast, the Lancaster landed at Scampton – the airfield from which the original raid had been launched 70 years earlier.

The following morning, the Lancaster, captained by Flight Lieutenant Tim 'Twigs' Dunlop, departed Scampton accompanied by

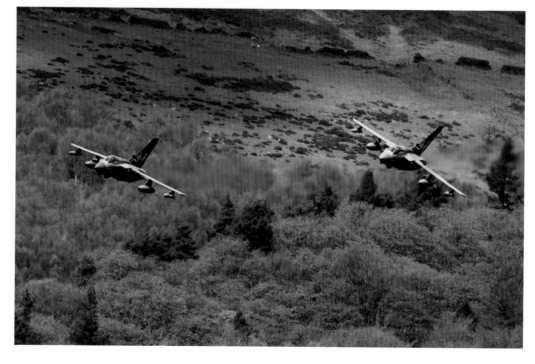

Spitfire PR XIX PM631, with Squadron Leader Andy 'Milli' Millikin at the controls. The route took in flypasts at both Cosford and Chapel-en-le-Frith before the Lancaster entered the valley at Ladybower for a flypast over the Derwent Dam. 'Twigs' Dunlop had to manoeuvre the Lancaster into the steep valley down to 250ft above the lake, while trying to maintain 150 knots to permit the bomb doors to be opened just before the dam. Just two minutes later, a pair of Tornado GR4s, callsign 'Gibson 1' and 'Gibson 2', roared over the target and once they were clear, the Lancaster and Spitfire did a further run down the valley before heading off for a flypast at Chatsworth House.

As the formation of Lancaster and Spitfire PR XIX approached Melton Mowbray, a second Spitfire (TE311) joined up and led the flypast of the Eyebrook Reservoir and its dam, another location used by 617 Squadron in 1943 to practise for the raid. The two Spitfires made a couple of 'sporty' passes over an invited audience positioned adjacent to the dam wall, before the Lancaster appeared, low and slow, as it made the first of two welcome passes – excellently flown by 'Twigs' Dunlop. Finally, the two specially painted 617 Squadron Tornado GR4s arrived on scene and completed a pair of low, fast and very loud passes, before roaring off back to Scampton.

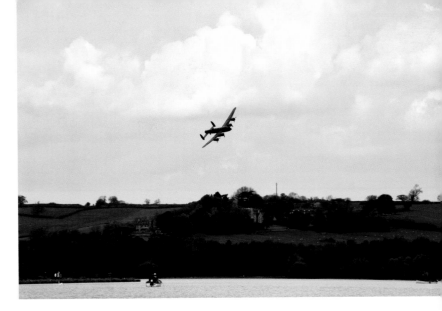

ABOVE The BBMF Lancaster approaching the Eyebrook Reservoir – another location used by the crews for training for the Dambuster Raid back in 1943. Initially, two of the Flight's Spitfires – LF XVIe (TE311) and PR XIX (PS915) – made a couple of formation passes over the reservoir before the Lancaster arrived. PA474 then made two low passes over the water (and lots of fishermen in boats) before crossing the dam watched by a very large audience on the ground. Afterwards, PA474 returned to RAF Scampton for the remaining celebrations. *(Keith Wilson)*

BELOW After the flying was completed on 16 May, the BBMF Lancaster and a pair of Spitfire PR XIXs were joined at RAF Scampton by the two specially painted Tornado GR4s. A sunset ceremony had been planned, featuring the Central Band of the Royal Air Force, in front of a large invited audience, including some of the remaining Dambuster veterans. *(Crown Copyright/ Gordon Elias, RAF College Cranwell)*

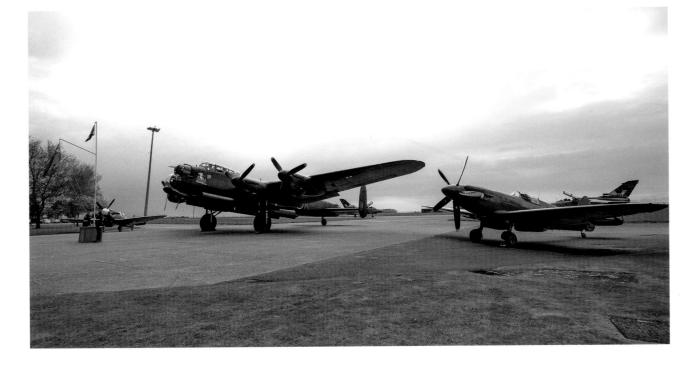

That evening, Scampton became the backdrop for an hour-long live BBC outside broadcast, which was watched by an audience estimated at over 2.5 million. The show and sunset ceremony were superbly choreographed and received universal acclaim as a fitting tribute to a spectacular event that had occurred 70 years earlier. On 16 May 1943, 133 brave men had taken part in the Dambuster Raid, with 53 of them losing their lives during the operation.

Next day, the Lancaster and two Spitfire PR XIXs were flown to Biggin Hill for another BBC programme. After refuelling, all three aircraft were joined by the two Tornados to overfly Lincoln Cathedral following the special Dambusters commemorative service.

Finally, on Sunday morning, the closing commemorative event saw the Lancaster and two Tornado GR4s overfly the unveiling of a new memorial to 617 Squadron at Woodhall Spa. The town, which was the wartime home to the squadron from January 1944, is already the location for the magnificent 617 Squadron war memorial that takes the form of a breached dam, the walls of which bear the names of those members of the squadron who gave their lives during the Second World War. The new memorial is a gleaming 3m-high black granite pyramid and pays tribute to the lives lost during operations and training accidents since the end of the Second World War. The service was attended by Dambuster veterans 'Johnny' Johnson and Les Munro.

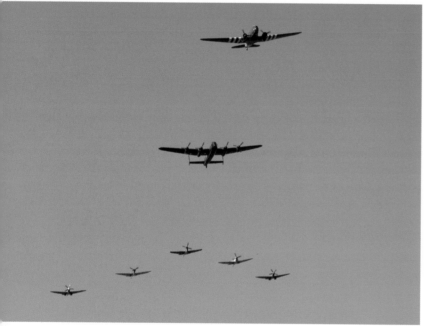

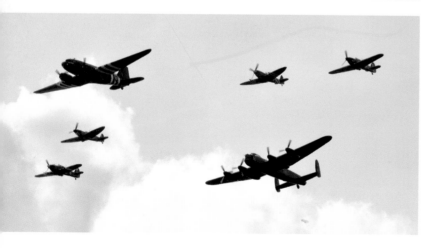

For Squadron Leader 'Russ' Russell, the bomber leader for 2013, much of the responsibility for the success of the events fell firmly on his shoulders. How did he feel after the celebratory events had concluded? 'Fantastic! It was the highlight of my career. Flying down the dams at low-level, in company with the Spitfire and Tornado GR4s was fantastic, as were the trips over Chatsworth House and Eyebrook Reservoir. It brought out what the Flight is all about.'

'Russ' considers that much of the success of the event was down to the use of the Typhoon Advanced Mission Planning Aid (TyAMPA), a computer-based mission planner that allows users to design a route by 'dragging and dropping' turning points and targets on maps of varying scales. He feels it ensured the pinpoint accuracy on the day. 'The timing for the event was crucial and we were spot on at Ladybower.' Russ added, 'We were low, but it was done much lower in 1943, and at night, with people shooting at you before dropping the weapons. Those men were so brave!'

Spare a thought . . .

Next time you are at an air show or see one or more of the iconic Battle of Britain Memorial Flight aircraft, do look skyward and savour the moment; but, at the same time, spare a thought for the brave souls who gave their lives to save others.

'Lest we forget'

BELOW BBMF Hurricane IIb, LF363/'YB-W' and Spitfire PR XIX, PS915, fly alongside the camera while Lancaster PA474 starts to move into position to join the formation over southern England on 11 August 2012. PS915 is marked 'The Last!' as it was the last of the type to make an operational flight with the THUM Flight on 10 June 1957. *(Keith Wilson)*

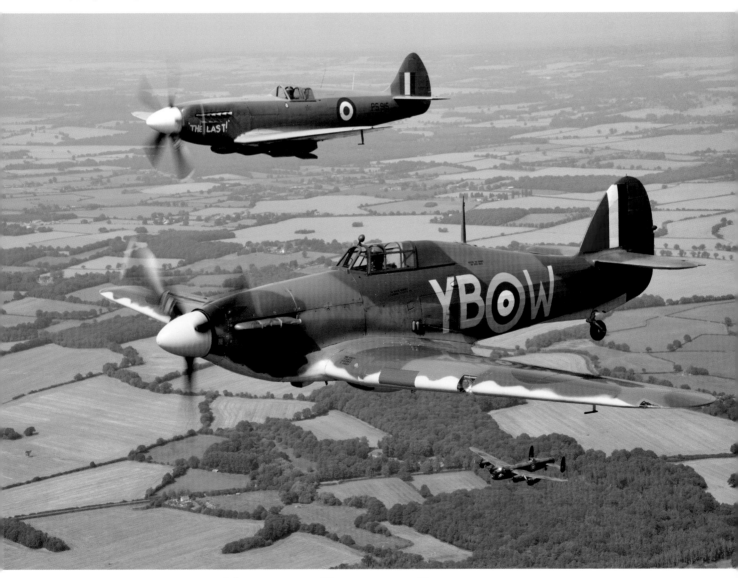

Appendix 1

Aircraft of the Flight

Serial	Type	Arrival Date	Comments	Current Yes/No	Disposal Date/ Struck off Charge
LF363	Hawker Hurricane Mk IIb	June 1957	Originally on strength with the Station Flight, Biggin Hill.	YES	
PM631	V-S Spitfire Mk XIX	11 July 1957	Ex-THUM.	YES	
PS853	V-S Spitfire Mk XIX	11 July 1957	Ex-THUM. Struck off charge and placed on gate-guard duties on 1 May 1958. Later returned to Flight in April 1964. It was later sold at auction at Sotheby's for £410,000 to pay for the restoration of Hurricane LF363.	NO	26 November 1994
PS915	V-S Spitfire Mk XIX	11 July 1957	Ex-THUM. Transferred to West Malling for gate-guard duties on 8 August 1957. Returned to the Flight from the Central Fighter Establishment in April 1964. Rebuilt to airworthy condition by British Aerospace at Samlesbury and donated to the Flight on 7 April 1987.	YES	
TE330	V-S Spitfire Mk XVI	August 1957	Ex-Royal Tournament 1957. First flight after restoration 8 September 1957. Later donated to the United States Air Force Academy in ceremony at Odiham on 2 July 1958.	NO	14 May 1958
TE476	V-S Spitfire Mk XVI	August 1957	First flight after rebuild 10 December 1957. Transferred to gate-guard duties at Neatishead 31 January 1960. Now forms part of Kermit Weeks's Fantasy of Flight collection at Polk City, Florida.	NO	January 1960
SL574	V-S Spitfire Mk XVI	August 1957	First flight after rebuild 23 February 1958. Crashed at Bromley on 20 September 1959. Rebuilt but placed on gate-guard duties at Bentley Priory on 30 November 1961. Later transferred to the San Diego Air and Space Museum, California.	NO	November 1961
AB910	V-S Spitfire Mk Vb	September 1965	Donated to the Flight by Vickers-Armstrong Siddeley Aviation.	YES	
P7350	V-S Spitfire Mk IIa	8 November 1968	Presented to the Flight after appearing in the classic film *Battle of Britain*.	YES	
PZ865	Hawker Hurricane IIc	30 March 1972	Presented to the Flight by Hawker Siddeley.	YES	
PA474	Avro Lancaster B.I	November 1973	Ex-Henlow (for RAF Museum) and 44 Squadron, RAF Waddington.	YES	
WP855	de Havilland Canada Chipmunk T.10	1975	Transferred to No 1 AEF, Manston.	NO	1983
WK518	de Havilland Canada Chipmunk T.10	April 1983	Ex-No 1 AEF, Manston.	YES	
VP981	de Havilland Devon C.1	April 1985	Sold to Air Atlantique, Coventry.	NO	1998
WG486	de Havilland Canada Chipmunk T.10	June 1995	Ex-Gatow Station Flight.	YES	
MK356	V-S Spitfire LF IXe	14 November 1997	Rebuilt to flying condition 1992–97, utilising the wings of SL674.	YES	
TE311	V-S Spitfire Mk XVIe	January 2001	Held in storage at Coningsby from October 1999. First flight after rebuild 19 October 2012.	YES	
TB382	V-S Spitfire Mk XVIe	January 2001	Held in storage at Coningsby from October 1999. Later dismantled for spares and struck off charge.	NO	2002
ZA947	Douglas Dakota III	20 July 1993	Ex-RAE West Freugh, later Defence Research Agency.	YES	

Appendix 2

Roll call – the Battle of Britain Memorial Flight 2014

(correct as at 1 January 2014)

Fighter Pilots:	
Squadron Leader Duncan Mason	OC BBMF (2013–15)
Squadron Leader Andy Millikin	OC BBMF Designate (2015)
Flight Lieutenant Anthony Parkinson MBE	Operations Officer
Group Captain Johnny Stringer	Station Commander, RAF Coningsby
Wing Commander Justin Helliwell	OC Operations Wing, RAF Coningsby
Bomber Pilots:	
Flight Lieutenant Roger Nicholls	
Flight Lieutenant Tim Dunlop	Bomber Leader 2014
Flight Lieutenant Loz Rushmere	
Flight Lieutenant Leon Creese	
Flight Lieutenant Seb Davey	
Navigators:	
Squadron Leader Tony Beresford	Navigator Leader 2014
Flight Lieutenant Ady Hargreaves	
Flight Lieutenant James Furness	
Flight Lieutenant Rich Gibby	
Flight Engineers:	
MACR Archie Moffat	Engineering Leader 2014
MACR Gavin Ovenden	
Flight Sergeant Martin Blythe	
Flight Sergeant Mark Fellowes	
Sergeant Jon Crisp	
Air Loadmasters:	
Squadron Leader Pete Appleby	
Flight Sergeant Paul Simmons	Leader 2012–14
MACR Craig Bampton	
MACR Brian Handforth	
MACR Dino Hempleman	
Engineering Staff:	
Warrant Officer Kevin Ball	Senior Engineering Officer (SEngO)
Flight Sergeant Dean McAllister	Flight Sergeant BBMF
Chief Technician Paul Blackah MBE	Airframe Specialist and Engineering Controller
Chief Technician Paul Routledge	Senior NCO Training Cell

Sergeant Gary Millman	Mechanical Trade Manager
Sergeant Adrian Smith	Deputy Mechanical Trade Manager
Sergeant Justin Staveley	Avionics Trade Manager
Sergeant Alan Butterfill	SNCO BBMF Logistics
Corporal Nigel Bunn	JNCO Mechanical Technician (FTRS)
Corporal Norman Pringle	JNCO Mechanical Technician (FTRS)
Corporal Andy Bale	JNCO Avionics Technician (FTRS)
Corporal Carl Broomhead	JNCO Mechanical Technician
Corporal Mark Kirkpatrick	JNCO Mechanical Technician
Corporal Ned Chamberlain	JNCO Mechanical Technician
Corporal Mathew Marriott	JNCO Mechanical Technician
Corporal Adam Walster	JNCO Mechanical Technician
Corporal Richie Kear	JNCO Training Cell
Corporal Dave Hopkins	JNCO Training Cell
Corporal Dave Cockburn	JNCO Avionics Technician
Corporal Gareth Thomas	Supplier
Corporal Jim Blackburn	Safety Equipment Fitter
SAC(T) John Bissett	Avionics Technician
SAC(T) Dave Murphy	Avionics Technician
SAC(T) Phil Shawcroft	Avionics Technician
SAC(T) Martin Alcock	Mechanical Technician
SAC(T) Colin Bateman	Mechanical Technician
SAC(T) Jim Baynes	Mechanical Technician
SAC(T) Pete Harrison	Mechanical Technician
SAC(T) Liam Rose	Mechanical Technician
SAC(T) Ian Taylor	Mechanical Technician
SAC(T) Mike Willcox	Mechanical Technician
SAC(T) Mark Sowden	Mechanical Technician
SAC Rhys Fitzgerald	Supplier
Mr Rod McDonald	Supplier
Mrs Julie Fletcher	Supplier
BBMF Headquarters Staff:	
Yvonne Masters	Public Relations Officer
Jim Stewart	Operations Assistant

Appendix 3

Officers Commanding the Battle of Britain Memorial Flight

Squadron Leader Ken Jackson AFC	1977–81
Squadron Leader C.S.M. Anderson	1981–84
Squadron Leader Tony Banfield	1984–87
Squadron Leader Colin Paterson	1987–91
Squadron Leader Andy Tomalin	1991–94
Squadron Leader Rick Groombridge	1994–96
Squadron Leader Paul Day OBE AFC RAF	1996–2003
Squadron Leader Clive Rowley MBE RAF	2003–06
Squadron Leader Al Pinner MBE RAF	2006–09
Squadron Leader Ian Smith	2009–12
Squadron Leader Duncan Mason	2012–14

Notes
Although the Flight was officially formed in 1957, the post had been a secondary duty taken on by many of the relevant base officers, such as the OC Operations or earlier OC Flying. The list represents officers who have actually been formally in the post as Officer Commanding BBMF.

On a board displayed at the entrance to the BBMF Operations Building at RAF Coningsby is recognition of the significant part played by Wing Commander Peter Thompson DFC, who founded the Flight in 1957.

Bibliography

Blackah, Paul, Lowe, Malcolm V. and Blackah, Louise, *Hawker Hurricane – Owners' Workshop Manual* (Haynes Publishing, 2010).

Blackah, Paul and Louise, *Douglas DC-3 Dakota – Owners' Workshop Manual* (Haynes Publishing, 2011).

Bowman, Martin, *The Immortal Few* (Halsgrove, 2010).

Cotter, Jarrod, *The Battle of Britain Memorial Flight – 50 Years of Flying* (Pen & Sword Books, 2007).

Cotter, Jarrod and Blackah, Paul, *Avro Lancaster – Owners' Workshop Manual* (Haynes Publishing, 2008).

Ellis, Ken, *Wrecks & Relics* (Crecy Publishing Ltd, 2008).

Fisher, M.D.N., Brown, R.W. and Rothermel, T., *Chipmunk – The First Fifty Years* (Air Britain (Historians) Limited).

Jackson, A.J. (updated by R.T. Jackson), *De Havilland Aircraft Since 1909* (Putnam, 1987).

Jefford, Wing Commander C.G., MBE RAF, *RAF Squadrons* (Airlife Publishing Ltd, 1988).

Price, Dr Alfred and Blackah, Paul, *Supermarine Spitfire – Owners' Workshop Manual* (Haynes Publishing, 2007).

Taylor, Bill, *The Battle of Britain Memorial Flight* (Midland Publishing Limited, 1995).

Thetford, Owen, *Aircraft of the Royal Air Force Since 1918* (Putnam Aeronautical Books, 1988).

Winslade, Richard, *The Battle of Britain Memorial Flight* (The History Press, 2007).

In addition to the works listed above, use has been made of the *Battle of Britain Memorial Flight Official Yearbooks* for the years: 1982, 1983, 1984, 1986, 1987, 1989, 1990, 1991, 1992, 1993, 1995, 1998, 1999, 2000, 2001, 2002, 2003, 2004, 2005, 2006, 2007, 2008, 2012 and 2013.

Index